HPBooks®

Pro Techniques of Landscape PHOTOGRAPHY

Josef Muench

with Vernon Gorter

NOTICE: The information contained in this book is true and complete to the best of our knowledge. All recommendations are made without any guarantees on the part of HPBooks. The author and publisher disclaim all liability in connection with the use of this information. All photographs copyright 1985 by Josef Muench.

Published by HPBooks, Inc., P.O. Box 5367, Tucson, AZ 85703 (602) 888-2150
ISBN:0-89586-418-5 Library of Congress Catalog No.85-80585
©1985 HPBooks, Inc. Printed in U.S.A.
1st Printing

Publisher: Rick Bailey
Editorial Director: Theodore DiSante
Editor: Vernon Gorter
Art Director: Don Burton
Book Design: Kathleen Koopman
Typography: Cindy Coatsworth, Michelle Carter
Director of Manufacturing: Anthony B. Narducci

FOREWORD

Josef Muench has photographed the beauty of Arizona for nearly 50 years. As one of the first regular contributors to *Arizona Highways* magazine, his brilliant color photography helped that publication grow from very provincial beginnings to its current world-wide renown.

Although this Californian is perhaps one of the best ambassadors Arizona has ever had, his photography extends far beyond the boundaries of the Grand Canyon State. He has photographed around the world, and his work has been published just as widely.

In a sense, Muench is the ultimate environmentalist. By showing us the incredible natural beauty we have inherited, he inspires us to care more deeply for our world and its natural treasures.

As a longtime admirer of Muench's work, I salute this book and wish it good fortune. If it helps produce more photographers like Muench, so much the better!

Bruce Babbitt
Governor of Arizona

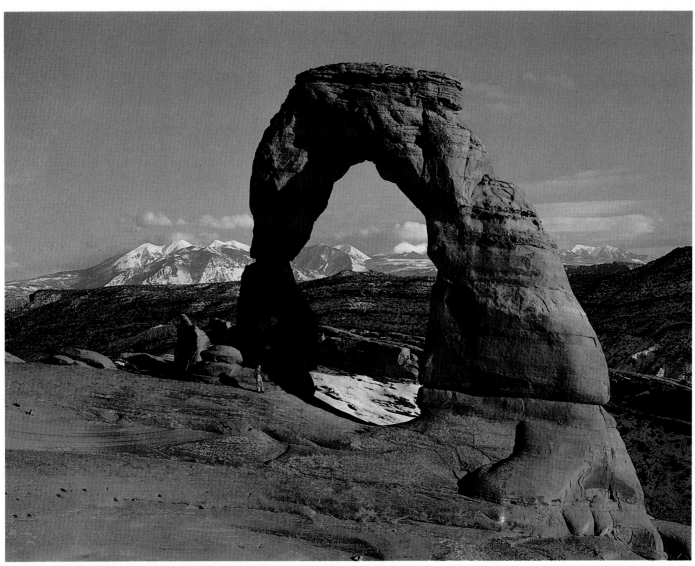

Arches National Park, Utah, with La Sal Mountains in background

Contents

Introduction

I have always loved nature. As a youth, I served an apprenticeship as a landscape gardener and then worked in that occupation for several years. Much of what I learned then has helped me in the photographic career I was later destined to follow.

A garden is nature after the intervention of the creativity of man. When man creates a garden, he turns wilderness into orderliness. He carefully calculates where to plant certain shrubs and bushes, which areas should be lawn, and whether paths should run in a winding fashion or diagonally.

A landscape photograph is also nature after the intervention of man. Rarely can you simply point your camera, shoot, and expect a fine image. You must recognize beauty when you see it. You must record it in the best possible way, choosing viewpoint, lighting and objects of foreground interest very carefully.

The gardener must satisfy and please his client. The photographer must please the viewer of the photo—who is often not familiar with the actual scene.

Photography, like gardening, is a very practical activity. In this book, I'll tell you about my experiences and describe my practical working techniques. You can learn about the theory of photography and its vast range of *equipment* in many other books.

This book will help to make you aware of the difference between a snapshot and a photograph. A snapshot involves just *one* thought: you would like a record of a special event, person or place. With a photograph, that's just the *first* thought. To complete the creative process of making a photograph that will please you and impress others, you must consider many things. Among the most important are light quality and direction, composition and color control.

A snapshot, as the name implies, is made in a fraction of a second. A good photo may also be made in a moment, but it is likely to take longer—sometimes much longer. This is especially true in landscape work, where success depends not so much on *creating* the right conditions but on anticipating and *recognizing* them.

You don't need elaborate equipment to make good landscape photographs. The basics are a camera, two or three lenses, an exposure meter, a tripod and a selection of filters. Don't buy more equipment than you need, just to keep up with your photographer friends. Buy it when you truly feel you need it and feel limited without it.

This book is intended mainly for the user of 35mm SLR cameras. I use one of these in much of my work. However, the bulk of my work is done with a 4x5 camera. Essentially, with the excellent lenses and high-resolution films available to the 35mm user today, the format size makes little difference. Basic technique with either format is the same.

The majority of photos in the portfolio section of this book could just as well have been made with a 35mm camera. Many could have been made more easily, because of the compactness and light weight of that equipment.

I'm a creature of habit and so continue to use my trusted old 4x5. Also, the editors who have worked with me for a long time have come to expect the larger format from me. It makes picture evaluation and selection easier for them.

Sometimes nature just shouts out to be photographed. Heed that call and be ready. Nature is changeable and rarely repeats itself in exactly the same way. I wish you good shooting. You'll bring home much more than fine landscape photographs—you'll gain a whole new way of seeing this wonderful world! □

Why Landscape Photography?

I was born in Bavaria, that beautiful state in the south of Germany. From as early as I can remember, my parents took us children out for long country hikes on weekends and holidays. From the age of 12, I had a trusted companion on all of these excursions—a simple Agfa camera. To obtain film for the camera, I earned a little money each week doing a variety of chores.

That was the beginning of my life-long love affair with nature and with recording it through photography. When I came to the United States, I worked in a Detroit auto plant for a time. But it wasn't the place for me. As soon as I had saved enough money to buy one of the Ford cars I was helping to manufacture, I moved out.

I headed west. When I saw the land between the Rocky Mountains and the Pacific Ocean, it was love at first sight. I've loved and photographed it ever since.

MY LOVE FOR NATURE

I am often asked who influenced me most in my decision to enter and stay in landscape photography. The expected answer is generally a list of famous names. However, the one factor that played the greatest part in my choice of my ultimate profession was my parents' love for nature and the way they shared this with me.

My parents' appreciation of nature was a pure one. There was nothing philosophical or intellectual about it. I inherited this trait. I photograph what I see as well and effectively as I can, but I make no comment beyond that.

To be a good landscape photographer, your love and respect for nature must come first—even before your enthusiasm for photography. To convey to others what you feel about a scene, a natural phenomenon or an atmospheric condition, you must be truly in love with nature. You must be at one with it.

If you're a good friend to your dog, he will repay you many times over. The payment you get from nature at large for being its friend is perhaps more subtle, but just as real. I have often been alone in the vast expanse of the Arizona desert, but I have never felt lonely there.

In today's hectic world, a respect for nature can have many important effects. It can give us a greater awareness of how our own bodies work and can help to reduce many of our excesses and stresses. A respect for nature—as displayed through photography—can also make a significant impact on public awareness of the importance and frailty of our global ecology.

PHOTOGRAPHY IS MY SPORT

I've always had an impish notion that landscape photography should be listed among the major outdoor sports. Most of my friends played soccer, skied or participated in bicycle races. I had just as much fun with my camera—and got a lot of invigorating exercise. My need for equipment was almost nil. All I required was film and a little extra cash for processing and prints.

Even so, I don't like to look at photography as a *competitive* "sport." I've never been much of an enthusiast of photo contests. However, I look at my photography as being self-competitive. Even today, I always attempt to outdo myself by making my next picture the best of all.

AIM FOR THE BEST

I do landscape photography professionally. You may want to do so, too. If so, you must satisfy others in addition to yourself. You must satisfy clients, editors, art directors and, ultimately, readers. You must be prepared to always learn.

Learn from other photographers and their work, but don't try to emulate them. Do your own thing. Strive to gain control of technique and you'll be surprised that, quite naturally, you'll develop your own unique style.

You must learn about new technical developments in films, cameras, lenses and filters. You must study publications to learn what kinds of photos their editors buy. You must be up to date on current esthetic and graphic trends. You must be familiar with the work of contemporary photographers—but resist the temptation to copy even the best of them.

Where there's a will, there's a way. If you want better color in your pictures than you've been getting, you'll make the effort to learn about alternative filters and films. If you don't have as much control as you would like of pictorial composition, it may be time to think about getting another lens of different focal length.

If you have the opportunity to go to a good photography school, all the better. Get all the technical know-how you can. But keep your individuality—your own way of seeing things.

When I first started, I had access to no photography schools, camera clubs, photo magazines and very few technical photo books. Essentially, I learned from personal experience, from instructional product literature and from a few like-minded photographers. Of course, when good literature became available to me, I took advantage of it. But, essentially, I'm still a pragmatist and continue to do most of my learning from practical experience.

tive addition on your part, each holds the potential for a fine image.

City parks, fall colors on pumpkins, local hills and fields, the nearest beach, lake or stream, majestic trees—these are the basic elements of landscape photographs anyone can take.

If you were interested in photographing beautiful women, you wouldn't give up simply because you don't have access to Miss America or the latest Hollywood starlets. You would find lots of beauty right in your own neighborhood. You can do the same with landscapes.

When you make a portrait of someone, you endeavor to show the best angle of the face, in the most flattering light, with the most pleasing expression. As a popular song says, "*Everyone* is beautiful!" It's the same with nature. Bring out the best and avoid what you consider ugly. In the long run, *everything* is beautiful!

Don't confuse ruggedness and a weathered look with ugliness. The worn rocks of the Grand Canyon and the gnarled trunk of an old tree may not have the beauty of an orchid, but they have a very special dignity and grace that's well worth photographing.

Beauty is, indeed, everywhere. In your own home town, you have sunrises and sunsets, thunderstorms, rainbows and full moons. Go hunting with your camera. Please yourself.

resources to enable you to travel the world at will. But you still have weekends, early mornings, evenings and vacations—and a camera over your shoulder.

MAKE A STATEMENT

I love landscape photography because it allows me to make pictorial statements about my environment and our ecology. I'm not a politician. I speak only through my pictures—or rather, I let my pictures speak for themselves.

When I photograph an idyllic scene, I wish it could stay that way forever. However, I am also a realist and know that, with the current population growth and industrial proliferation, this is an idle hope.

I don't want a luxury hotel to spring up in a redwood forest. If it does, I'll tell photographic fairytales: I'll photograph the scene as best I can, carefully avoiding any sign of the intrusion of civilization. By not showing ugliness and inappropriate intrusions into natural scenes, my pictures keep alive in the viewer the appreciation of unspoiled beauty and the need to preserve our natural heritage as much as possible.

Besides fostering an appreciation of nature and ecological awareness, landscape photography can be extremely satisfying when it has social or cultural impact.

Learn from other photographers and their work, but don't try to emulate them. Strive to gain control of technique and you'll quite naturally develop your own unique style.

BEAUTY IS EVERYWHERE

I'm fortunate in having succeeded at a profession that takes me to famous and beautiful places all over the world. If you're an enthusiastic amateur who can't travel to the Grand Canyon or Yosemite National Park at the drop of a hat, look around your own neighborhood, your local park and even your own back yard. You'll never exhaust the pictorial possibilities right there.

There is no such thing as *just* a tree, *just* a stream or *just* another hillside. Each is unique. From the right angle, in the right lighting, with a little crea-

When you're pleased with the photos you produce, others will be pleased, too.

If you want to create the illusion of wide-open spaces in an urban area, just eliminate the elements you don't want to show. Choose a viewpoint that shows no houses or roads. Take close-ups of nature's fine detail, such as plants, flowers, leaves, rocks and animals.

Use a wide-angle lens to emphasize size and distance—but be careful to avoid the signs of civilization, such as houses, cars and billboards.

You may not have the time or

MAKING A DISCOVERY

In 1938, on one of my early trips to Monument Valley in northern Arizona, I met a Mr. Harry Goulding, who ran a trading post for the Navajo Indians. Goulding wanted to find some way to improve the economic condition of the Indians as well as of his store.

Having read that Hollywood movie director John Ford was planning to make Western movies, Goulding decided it would be a good idea to try to make Ford aware of Monument Valley—as yet relatively unknown—as an ideal shooting location.

Goulding told me that he seriously considered traveling to Hollywood to attempt to interest the movie people in the valley. As he said this, he showed me a series of photos. They were of the valley, but they were small and poor in quality—no more than snapshots.

I told Goulding in very plain terms

that, if he wanted to impress John Ford—assuming that he ever got to see him—he'd have to do better than that. I made up for him an album of large, well printed black-and-white enlargements of my own photographs of various aspects of Monument Valley. I told him to take *that* to Hollywood.

Goulding went off to California. He had not contacted anyone in Hollywood in advance and had no appointment. All he had was my picture album and a lot of enthusiasm for the valley and his Navajo friends.

Of course, he had great difficulties getting to see Ford. However, displaying my enlargements to studio staff guarding Ford's office created enough enthusiasm so that Goulding eventually *did* meet Ford.

Ford was highly impressed and soon thereafter went to Monument Valley to inspect the location. As a result, *Stagecoach,* a movie that was to win an Oscar and begin John Wayne's stardom, was shot in Monument Valley. Later, Ford made *She Wore A Yellow Ribbon* in the same location. This was followed by numerous other Western movies, by other directors.

Today, Monument Valley is a familiar sight to moviegoers and photographers around the world. The valley attracts tourists from all over the United States and abroad. And it all began with my album of photos—which I still have!

SHOWING THE WORLD TO THE WORLD

Photography has played a major part in familiarizing the public with our national parks and other scenic areas, and in encouraging a lively tourist industry throughout the country.

Those who don't have the opportunity to travel, can at least see the wonders of the country—and the world—through pictures. Locations as diverse as the Eiffel Tower, the Taj Mahal and Mount Rushmore are familiar to millions who have never been there.

I get enormous satisfaction from photographing spectacular scenic views. I want the viewer of my pictures to get the same sense of awe and wonder—as far as this is possible within the confines of a photographic frame.

If you want to get your pictures published, study the potential market carefully. If a publication uses photographs by staff photographers only, you may waste your time submitting your material. Don't submit a picture or picture sequence to a publication that has recently used something similar. If a magazine specializes in people and action, don't submit pure landscapes.

Spend time at your local library and look at all the magazines you can find. Study the content and style of each

> *There is no such thing as just a tree, just a stream or just another hillside. From the right angle, in the right lighting, with a little creative addition on your part, each holds the potential for a fine image.*

NO ARTIFICIAL TRICKS

Because landscape photography is, to me, a pure and direct communication with nature, I do not like or use artificial graphic techniques. For example, I won't use image sandwiching or double printing. My equipment does not include split-field, rainbow or star filters. The closest I may come to artificiality is to enhance a sunset with a yellow or orange filter.

HOW TO REACH VIEWERS

I reach viewers around the world in many ways. I sell my pictures to magazines, textbook publishers and greeting-card manufacturers. My photos are used on posters, for travel brochures and for publicity and informational purposes. I use my slides to give lectures.

publication. Make notes. Then submit your work accordingly. Once an editor has used one or several of your pictures, you have your foot in the door. Keep producing good and appropriate photographs, and you'll get more sales.

CONCLUSION

Landscape photography is one of the simplest and yet most satisfying activities. It costs little to appreciate nature, which is all around us. It costs only a little more to record it on film. And, if you're ambitious, the possibilities are endless.

Why landscape photography? My answer is simple: "Go and try it! You're not likely to turn back!" □

Two
What's Worth Shooting?

The words *life* and *motion* are almost synonymous. It is readily evident to all that a ski jumper, gliding gracefully through the air, is very much alive. His motion is very fast. Through photography, we can capture a brief moment of that action on film. If we are skillful photographers, we can even convey the reality of the original activity in the "frozen" image.

NATURE IS MOTION

A tree also displays motion. Look at pictures of the same tree, made at intervals of several months. You'll see that a lot of motion and activity takes place during the cycle of spring, summer, autumn and winter. The motion is much less rapid than that of the ski jumper, but it is still there. And you can capture an instant of it on film, too.

To be successful in landscape photography, you must first realize that—contrary to common belief—a landscape or natural scene is never static. It is always in motion. In your photography, you reveal—however subtly—some of that motion.

Some motion is fast and, therefore, readily evident to the eye. Gravity allows water to descend, creating fast-moving, roaring waterfalls. Wind also moves water, creating ripples, waves and surf. Similarly, wind moves clouds and the branches of trees.

Some motion is extremely slow. However, we are almost instinctively aware of it and attracted by it. A fossil is much more fascinating to us than a man-made brick, and we find a piece of petrified wood much more interesting than a beam of lumber shaped by man. Why? Because of the capricious shapes and patterns produced by nature's constant motion.

The Grand Canyon is not a static hole of rocks. If it were, I doubt that it would have attracted the world's interest and fascination. Size alone is not enough. The attraction is the motion we see there. Wind and water have shaped the Grand Canyon—and all the other great geophysical structures of the world—over millions of years.

THE CHALLENGE—CAPTURE MOTION ON FILM

Henry David Thoreau, one of our early environmentalists, said that "The finest workers in stone are not copper or steel tools but the gentle touches of air and water, working at their leisure, with a liberal allowance of time."

It is the landscape photographer's challenge and delight to capture on film some of the sense of this continuous motion. You can do it by carefully choosing your viewpoint, awaiting the right lighting and atmospheric conditions and making an effective graphic composition. Depending on the structure you're photographing, you may want to emphasize texture, tonal differences, wetness or cracks and erosion.

On a rugged coastline, high in the mountains, or in open desert, you'll sometimes encounter trees that have been misshapen by the wind. Through this continued, agelong "motion," a tree reveals its long struggle for survival.

Don't mistake this ruggedness and dignity for ugliness. Photograph it from the most effective angle, and in the most advantageous light. Use direct side light to bring out texture; photograph it in a light mist to emphasize its isolation; or with a background of storm clouds to show the conditions that have led to its present appearance.

Look for the evidence of movement in nature—no matter how slow that movement may be. Without some movement, the scene isn't likely to *move* you. If it doesn't move you, don't expect others to be moved—and don't photograph it!

WE ALL HAVE A FAVORITE LOCATION

My favorite location has always been the southwestern part of the United States. Arizona is perhaps my favorite state, and I have illustrated it for *Arizona Highways* magazine for decades. You may not be interested in the West or have easy access to it. Your interest may lie in the vast prairies of the Midwest, the coastline of New England or the Everglades of the South.

Wherever your interest lies, I think I should tell you why I have my own

preferences. This may help you to better see the peculiar beauty and charm of your own "backyard."

LOOK AND YOU WILL SEE

I have been to the Grand Canyon more than 250 times, and I have seen it in more than 250 different ways. I have visited Monument Valley nearly 200 times, and each time I experience it in a new way. On each visit I get a slightly different viewpoint, different lighting conditions, the effect of mist or haze, different cloud formations.

The seasons provide very different lighting, contrast and color. And, there's the additional bonus of a good thunderstorm or snowfall from time to time.

It may sound ironic, but even the modern industrial haze that infiltrates virtually all areas from time to time can provide an attractive lighting and color effect—although, all things considered, I would rather do without it.

On each trip I notice different things in the foreground: different plants and, of course, different people.

If you keep your eyes wide open and your mind alert, you'll see a similar kaleidoscope of effects in your own home environment.

WHY I LOVE THE DESERT

I like the desert because it separates and emphasizes nature. An isolated plant, surviving and thriving in the arid earth, can arouse more respect and admiration in me than a garden full of cultivated roses. A lonely ranch, surrounded by open land as far as the eye can see in all directions, makes me realize the daily struggles of life more readily than a view of a densely populated area.

I like the rawness, the lack of "polish" and the openness of the desert. And I love to photograph it. *Arizona Highways* has regular subscribers throughout the nation and the world. They all want to see photos of that area although they may not necessarily want to live there.

There's a lesson to be learned here: The grass does tend to look greener on the other side of the fence. People living in the West also love to see pictures of New England foliage in the fall, fishing in the lakes of Minnesota, the rolling, green hills of Appalachia and the mighty Mississippi flowing toward New Orleans.

LOOK FOR THE UNUSUAL

Take advantage of the seasons and different weather conditions. Go out and shoot after a snowstorm, just before a thunderstorm reaches you, in mist and fog. Of course, you must protect your camera from rain and dampness. Often, you can shoot from an overhanging protection, such as just inside a barn or under a bridge. You can even persuade someone to come along with you and protect you and your camera with an umbrella.

Take your camera out early in the morning or in the evening. Besides giving you an opportunity to shoot sunrise or sunset pictures, those are the times of day when the light is generally best for landscape photography. Low sun is generally more flattering to a scene than midday sunlight.

Early or late sunlight is soft and has a warm, reddish glow. Morning is also often accompanied by mist that provides fine photographic possibilities. In the evening, at sunset, you'll often experience impressive cloud formations.

WHAT YOU SHOULD AVOID

This essay deals with the basic question, "What's worth shooting?" A very important part of the answer must be contained in another question: "What's *not* worth shooting?"

tend it isn't there—you have to eliminate it.

You can eliminate an undesirable element in various ways. You can choose a viewpoint that doesn't include it in the picture area at all. Or, you can use a lens that excludes it from the picture. Alternatively, you can select a camera viewpoint or camera height that hides the unwanted element behind something else. For example, an ungainly mailbox in front of a house might be concealed by a camera viewpoint that places the box behind a bush.

You can avoid a fence by getting close to it or climbing onto it or over it. Generally, you should also be concerned about avoiding roads in the foreground and telephone poles and wires in a scene.

If you can't totally eliminate an unwanted element, subdue it as much as possible.

I'll discuss this selectiveness more fully in the next essay, on *Composition*. In the meantime, just remember that a good landscape photograph often demands that certain elements be left out.

KNOW YOUR LIMITATIONS

What's worth shooting must be within the capability of your photographic equipment. If you want a detailed shot of a castle on a hill but a river separates you from the castle by

I advise you to be a photographer "of few words." If something doesn't help a picture tell its story or produce the intended impact, leave it out.

You've heard the expression, "A man of few words." It generally describes someone who says precisely what he means, without ambiguity or excessive elaboration. I advise you to be a photographer "of few words." If something doesn't help your picture tell its story or produce the intended impact, leave it out.

Leaving things out is not as easy for the photographer as the painter. The painter begins with a clean canvas. He can paint what he wants and not paint what he doesn't want. The photographer doesn't begin with a clean canvas—he confronts a real scene. If there's something in a scene you don't want, you can't ignore it or pre-

several hundred yards, you need a telephoto lens. If you want to create a perspective effect that demands a close viewpoint, you may need a wide-angle lens to get the entire scene into the picture.

If you want a good, dramatic separation between white clouds and blue sky in your color pictures, you'll need a filter. But a color filter won't do because it would upset the total color balance of the image. You'll need a polarizing filter.

If you want to shoot a tall building and keep the vertical sides of the structure parallel, you'll have to move a long way back with your SLR, and probably use a wide-angle lens. That

may enable you to aim your camera horizontally at the building, so the verticals don't converge in the image.

However, that's a clumsy way of doing it, and it won't work in all circumstances. If you want to do architectural photography regularly, you'll need a field camera that offers full camera movements.

For most landscape work, you don't need elaborate equipment. Know what you want to shoot and be aware of the limitations and capabilities of your camera equipment. If the limitations frequently inhibit your creativity, it's time to get more equipment. Get that extra lens, or the polarizing filter—and be sure you learn how to use them most effectively.

ALWAYS BE PREPARED

In landscape photography, you must always be prepared for the unexpected. Many opportunities will suddenly and fleetingly present themselves—only to disappear just as quickly, never to be repeated in quite the same way again. Some of the most dramatic and spectacular cloud, atmospheric, weather, color or lighting conditions appear with little forewarning and stay for only moments.

During their brief existence, such conditions may change dramatically and rapidly. To exploit this opportunity you must be prepared to start shooting quickly and work fast. Every picture you get will be unique. None of the conditions are likely to ever be repeated in precisely the same way. Storms, rainbows and the radiation of sunlight through a gap in clouds must be captured "now" or lost forever.

The only way to capture those unique moments is to always have your camera with you. Always have it loaded with film. Have an approximate idea of how to expose under a wide variety of conditions to achieve the photographic effect you want.

You may find it worthwhile to keep notes of exposure data for photos made under unique conditions, when a meter reading may not yield the most desirable exposure. Keep such notes handy and refer to them when you anticipate similar conditions.

If you have no other choice, shoot first—and think later. If you have a second chance, shoot again, adjusting your viewpoint, changing your lens and modifying your exposure as you see necessary. If necessary, shoot through your car window—but have the window open.

When you're out shooting, have photography on your mind constantly. When I'm wandering through woods, for example, I look behind me almost as frequently as in front and to the sides. Often, I'll see a very special lighting effect that gives me a beautiful picture and that I would have missed if I had marched steadfastly forward!

Don't just *see* the scene in front of you. Try and *visualize* it in a photograph. See things graphically and pictorially. In the next essay, on *Composition*, I'll go into this in more detail.

THE MANY FACETS OF LANDSCAPE PHOTOGRAPHY

What's worth shooting? I have on file some 50,000 landscape photographs. To stimulate your creativity and imagination, I'll list here just a few of the major topics included in my collection. There are mountains and hills, lakes and oceans, rivers, streams and waterfalls. I've photographed in the desert, on the prairie and in forests.

I've documented the arts and crafts of different regions and cultures and have recorded the customs and costumes of people ranging from the Navajo Indians of Arizona and New Mexico to the people of Afghanistan.

My camera has been aimed at wildlife and I've shot close-ups of plants, flowers, rocks and leaves. I've also photographed cities and have produced photobooks on San Francisco and Salt Lake City.

One of the major parts of my landscape photography constitutes what I would call *atmosphere* shots. In these, the subject matter is often secondary to the mood that prevails. I have made such photos in fog and mist, in thunderstorms and after heavy snowfall. I have photographed dramatic rainbows, forest fires, dust storms and flash floods.

EACH SCENE IS A NEW CHALLENGE

Each location and condition calls for a unique pictorial treatment. Have your standard photographic technique by all means—but be prepared to customize it to each specific situation. Here are just a few examples that illustrate how a little extra thought can lead to better pictures.

Water—Select only bodies of water that truly impress you. They need not be large, and you don't have to include the entire water area in your picture.

Incorporate mirror reflections on still water and rippled reflections on water that's in slight motion. The effects of the two are quite different. For example, the moon reflected in still water will look like a second moon. Reflected in rippled water, the moon will give a long streak of light on the water.

You can choose to reflect mountains, trees, people or clouds in water. Generally, it's preferable to include the entire reflected subject in the picture. For example, don't cut the peak off a reflected mountain or the head from a reflected person.

A boat moving through water will create a wake. An oar dipped into a lake will generate circular ripples. Use these effects to your photographic advantage.

Mountains—The grandeur of mountains can be elusive to the photographer. A photograph rarely reveals the awe-inspiring magnificence of the real scene. Make every effort to retain the grandeur in your photos. I'll tell you something about this in the next essay, on *Composition*.

A couple of brief tips: Include foreground matter in the form of trees, cabins, people or animals. Use side light to give graphic relief to the face of the mountain. Strive for dramatic cloud effects.

Waterfalls—Show the water *falling*—not frozen in midair. This means that you should use a relatively slow shutter speed. Set your shutter to 1/15 or 1/30 second and you'll get a picture in which the water truly appears to be falling. Of course, at such shutter speeds you should have your camera on a tripod.

Don't give too long an exposure, however, or the film will record too much water, resulting in a uniform white sheet rather than a textured waterfall. For example, an exposure time of 1 or 2 seconds is likely to be too long.

Prairie—To reveal the expanse of wide, open spaces, include plenty of foreground and place the horizon high in the picture. A wide-angle lens is often helpful.

Cloudscapes—If you're impressed with a particular cloud formation and want to make a photo of it, place the horizon low. Devote most of the picture area to the sky.

All these tips are derived from no more than plain common sense. But, to use them, you have to be very deliberate in your photography. Know exactly what you're after and then figure out the best way to achieve it.

INCLUDE PEOPLE

People can add a lot to your landscape photographs. When human foreground interest is appropriate, I always have someone with me to pose for me—myself. When I travel alone, I take with me a selection of shirts, jackets, caps and hats of different colors and styles. I put on the appropriate outfit, place my camera on a tripod and, with the help of the camera's self-timer, place myself in the picture.

If you are traveling with friends or family members, you can easily ask someone to pose for you. Even strangers will usually be pleased and flattered to be included in your pictures. However, always ask beforehand, explaining what you're trying to achieve.

You need not send photos to everyone you include in your photos. However, some people will beg you to send a copy. I have always had a firm policy in this regard: I don't promise photos unless asked. And I don't promise them unless I fully intend to stand by my promise.

In poorer countries, people who cooperate with you will generally be more interested in money. A dollar or two to these people means a lot—and a fine picture of a native person in some exotic scene is certainly worth that amount to me.

People can serve many different purposes in landscape photography. Following are among the major ones:

Human Interest—People add life to a scene. When a viewer of a photo sees a person in the foreground, admiring a scene, he can easily imagine himself in that person's position.

Scale—When you photograph a scene that's unknown to the viewers of your photo, the size of different components may not be immediately evident. When you add a human being, whose size is more or less familiar to all, the viewer has a reference point. For example, if your "model"

is standing by a rock, the size of that rock becomes immediately evident.

Composition—You may have a tree on the left side of your picture area. The tree has a nice overhanging branch that can frame the top of the image. You want to complete the frame with something of interest on the right side. By placing a person at that location, looking into the scene, you achieve that objective. At the same time, you add a scale reference point and some human interest.

Always be prepared for the unexpected in landscape photography. Many opportunities will suddenly and fleetingly present themselves, only to disappear just as quickly, never to be repeated in quite the same way again.

Memento—Often, you'll want to include someone in a photo who is close to you, to provide a souvenir of your travels together. In such a case, you may want to have the person face toward the camera, so you can clearly see the face, rather than looking out into the scene. When you have the time, take several pictures with different poses.

Documentation—You may want to record local costumes in their native environment. Ask natives of the area, dressed accordingly, to pose for you. In my more recent travels, I have discovered to my dismay that one must increasingly rely on older people for this. With the younger ones, tradition is dying fast. An exception may be such occasions as church time on Sunday morning or the celebration of special festivities.

Credibility—When you include people or animals in your landscape pictures, be sure that you maintain credibility. For example, it's OK to include a lone dog in the foreground of a photo showing an old inn and church. It's believable that the dog lives there because the place is clearly inhabited.

Do not, however, include a lone dog (unless it's a coyote) in the foreground of a vast expanse of desert. The dog will appear lost. The only credible way to include the dog there is together with a human being.

I have become well acquainted with the Navajo Indians of Arizona and

New Mexico. Over the years, I have won their confidence and they readily allow me to photograph them. I use them almost exclusively in my photos of that part of the Southwest. To me, they are the essence of that part of the country. They give credibility to my pictures. The bonus for me has been that I have gained many lifelong friends among the Navajo.

PICTURE SEQUENCE

When one picture is not enough to tell a story, shoot a picture sequence. Such sequences are not likely to be required often in landscape photography. However, some activities, such as rodeos, sheep herding by dogs and the felling of tall trees, fall into the natural domain of the landscape photographer.

Be sure that you are well informed about the event you want to record. Then, select key activities in that event. Shoot them from different angles, at different distances, with different lenses. Introduce as much variety as possible.

If you're unsure of the precise course the activity will take, be prepared to shoot rapidly—and to shoot more film than you normally would. Select the best pictures later, at your leisure.

In a picture sequence, *variety* is good but *inconsistency* is bad. Avoid confusing the viewer by changing your camera angle and distance drastically and too frequently. As far as possible, try to shoot the entire sequence in similar lighting conditions.

If you shoot a series involving human activity over several days, try to have the participants dressed the same way each time you shoot. □

Three
Composition

When you've decided *what* is worth shooting, you must determine *how* to shoot it. In other words, when your *taste* tells you what has the potential for a good picture, your *technique* must translate that potential into fact on film.

As a landscape photographer, you must make several important decisions. The most important esthetic decision involves *composition,* or the way you "put the image together."

DIFFERENCE BETWEEN SCENE AND IMAGE

With experience, you will learn a very important lesson: While the scene your eye sees and the photo your camera records may both be beautiful, there are some important differences between the two. When you view a scene, even before you reach for your camera, you must *visualize* how it will appear on film.

To visualize a scene as a photograph, you must know why the photographed image looks different from the "real thing." To get your visualization on film, you must know some techniques that enable you to record what you see as effectively as possible. Many of these techniques involve photographic composition.

Here are some of the major ways in which a photograph is different from the scene it depicts:

The Image Is Flat—A scene is three-dimensional and a photographic image is flat—or two-dimensional. This is perhaps the most obvious difference between the "real thing" and its record on film. But, as I'll describe in this essay, there are many ways to create the illusion of three dimensions on the flat surface of film.

The Camera Has One Eye—We get a visual sense of distance by the stereoscopic vision of our two eyes. A camera has only one eye—its lens. Therefore, not only does the flatness of the film prevent us from photographing three dimensions, but so does the camera's limitation of its one eye.

The Image Is Framed—A photograph is contained within the edges of the film or photographic paper. This frame limits what the viewer, who is accustomed to an unlimited 360° view of his environment, can see. Even so, there are compositional ways of keeping the viewer's attention within the frame of the picture and, at the same time, giving him some information about what lies beyond the frame.

The Image Has a Definite Format—You can shoot a photograph to get a horizontal or vertical image. It's significant that, in Britain, these used to be called *landscape* and *portrait* formats, respectively, because landscapes inherently lend themselves to horizontally oriented images and por-

traits are mainly vertical. However, many landscapes are more effective in the vertical format. Some are most effective when shot, or printed, to give a square image.

Films and photographic printing papers have a certain *aspect ratio,* the ratio of image width to image height. The aspect ratio of 35mm film is about 2:3 while that of 4x5 film is 2:2.5. By cropping an image, you can achieve any aspect ratio with any film.

Whether you shoot a scene with your camera held vertically or horizontally, and how you choose to crop the final image, are important compositional considerations.

The Camera Freezes Action—The camera freezes on film the events we're used to seeing in full action in real life. There are photographic means of suggesting action, even in a so-called "still" photograph.

The Camera Ignores Nothing—To put it in modern idiom, a photographic image "shows it like it is." The camera unforgivingly records whatever is in front of the lens. Our eyes see much more selectively.

For example, we're constantly admiring beautiful scenes through ubiquitous telephone poles, wires, lamp posts and billboards. We have become accustomed to mentally eliminating such obstructions from our view to the point where we are not aware of them any more. However, in

a photograph such objects are very real intrusions.

Part of good composition involves avoiding or eliminating unwanted clutter in a picture.

There are numerous other ways in which a photographic image differs from the scene it records. The ones I have listed are most closely related to composition.

KEEP IT SIMPLE

I have rarely seen Navajo Indians with a camera, and yet I have learned an important photographic lesson from them—the lesson of understatement. The Navajo have convinced me that less can be more.

Ask a Navajo for directions to a certain place and he won't stretch out his arm and poke his finger in the direction you should follow. If a slight nod of the head will do the job, that's what you will get. And it's surprising how often a slight nod *does* the job!

When a Navajo greets you, he doesn't grip your hand tightly in a macho manner and shake it vigorously. He holds your hand in his lightly for a few seconds and then releases it—and the intended contact has been established.

When you are inspired to make a landscape photograph, there's usually one compelling component or characteristic that attracted your attention to the scene. That one key component will also attract viewers to your photo. Make your point as graphically and effectively as possible, but don't embroider it. Adding more where more isn't needed will only weaken your message.

PERSPECTIVE

Webster's dictionary defines *perspective* as "the appearance of objects or scenes as determined by their relative distance and positions."

When you look for the best viewpoint for a picture, you tend to move left and right and sometimes up and down. It's easy to forget that moving toward or away from the scene can have an equally dramatic effect on the image. For example, by moving closer to a totem pole, I may be able to make it project well above the disturbing facade of the building behind it. Or, by moving farther back from a cabin I can make a distant mountain range appear more massive.

Don't make the common mistake

of trying to affect perspective by lens choice. The *only* way you can control the perspective in your photos is by doing what every landscape photographer should love to do—walk a lot! When you've found the location that gives you the picture you want, *then* is the time to select the lens that will frame that scene appropriately.

THE BEST FOCAL LENGTH

You can easily determine the approximate lens focal length you'll need for framing a specific area of a scene in front of you. You don't need to have all your lenses with you to do this.

First, using thumb and forefinger of one hand and forefinger of the other, form a frame that resembles the format of 35mm film. The frame you make should be about 1-1/2 inches long and 1 inch wide.

Close one eye and look at the scene through the frame with the other eye. Move the frame back and forth in front of your eye until the desired area is framed. Estimate the distance of the frame from your eye. This will give you the lens focal length you'll need.

For example, if the frame is about 4 inches from your eye, the focal length you should use is about 4 inches, or 100mm.

Instead of forming a frame with your hands, you can make one of the right size from cardboard or simply use an empty slide mount. You can do

the same for other film formats. If you're using 4x5 film, make a 4x5-inch frame. If you shoot with a medium-format camera, make a frame that measures the same size as the image. In each case, the distance in millimeters of the frame from your eye, when the scene is framed as desired, indicates the focal length of the lens you need.

FRAME THE SCENE

The edges of a photograph, the frame in which it hangs or the edges of a projection screen are necessary

physical limitations. Obviously, a photo can't truly represent the infinite panorama of nature. We have to live with the limitation of physical framing.

There's another kind of framing —*esthetic* framing—that can make the physical frame much more palatable. By retaining the main subject within a boundary of natural foreground matter, you can keep the viewer's attention on the main subject.

The ways you can frame an image are almost unlimited. You can use trees, walls, doorways, natural or man-made arches, people or even shadows. You can frame an image at top and bottom as well as on both sides. Sometimes, framing on one side alone is adequate.

The photos in the portfolio section of this book provide many examples of natural framing. As you'll see, you can even use a prominent cloud formation to partially frame an image.

FOREGROUND INTEREST

Another thing you'll learn from the portfolio pictures is that I frequently use prominent foreground detail. In some cases, the foreground detail serves to partially frame the image as well.

When you place people in the foreground, they add life and human interest. Usually, it's best to have people looking into the scene. However, avoid direct back views. Po-

Don't make the common mistake of trying to affect perspective by lens choice. The only way to control perspective in your photos is by doing what every landscape photographer should love to do—walk a lot!

sition people so that you see part of their faces.

When you use two or three people in a scene, vary their poses. For example, have one person standing and another leaning on a rail. Or, have one crouching and another sitting on the ground. You'll get a better composition if you have each person at a slightly different height.

Place people close together. Rarely do you want two points of human interest in a landscape. This would distract from the main theme of the picture—the scene.

Foreground interest can also be included in the form of animals, rocks, trees or fallen tree trunks and pathways leading into the scene.

Besides having esthetic value, foreground detail can also provide useful information. For example, because you know roughly the size of human beings, you can infer from them the size of other non-familiar features in the foreground of the scene. Prominent foreground items also increase the sense of space between foreground and distant scene. In other words, they help to make the image appear three-dimensional.

When you use people traveling with you to provide foreground interest, be sure they have clothing of different colors with them. When you ask strangers to pose for you, your choice is limited to making a selection from the people available to you.

In most circumstances, red stands out more clearly than other colors. This is particularly true when foreground detail appears relatively small in the picture because it is relatively far away. For example, if someone is standing 15 feet from the camera and is looking over a vast expanse of the Grand Canyon, a red garment will stand out much more clearly than a blue one.

your photographs. Leave out roads, cars, hotels and houses. If a log cabin looks as if it belongs in the scene, leave it there by all means, but don't include a refreshment stand or a tourist-information booth.

It isn't always easy to eliminate clutter. I once set up my camera to shoot a beautiful, tranquil scene. Everything seemed in order. There was no sign of litter. It took me a few minutes to set up and get everything just right. Then I shot the picture.

You can imagine my dismay when I received my transparencies and found that a highlight from an aluminum beer can had spoiled the image. While I had prepared to shoot, the sun had moved just far enough to suddenly direct this reflection straight at my camera lens!

There are some signs of the work of man that can, and sometimes should, be included in your landscape pictures. Man helps to beautify and enhance his environment in many ways. I don't object to the inclusion in my photos of man-made paths and trails, carefully mowed lawns, clipped hedges or cleaned beaches.

TAKE A TRIPOD

Before I describe a few more compositional tricks, I want to say a few

the camera at a speed slower than 1/250 second. If you don't heed this advice, you may end up with a lot of spoiled images caused by blur from camera shake.

Exposure times may be long in dim lighting conditions, when you need to use a small aperture for maximum depth of field. Or, you may need a relatively long exposure time to deliberately blur the water in a waterfall or stream.

In addition to the above, a tripod can be invaluable for compositional purposes, especially when you have nearby foreground detail that must be located precisely in the image. For easy compositional control, the tripod should be equipped with a ball head or a swing-and-tilt head.

GIVE YOUR IMAGES DEPTH

At the start of this essay, I pointed out one of the main drawbacks experienced by the landscape photographer—being limited to a two-dimensional medium for showing three dimensions.

Fortunately, you can simulate a three-dimensional effect in several ways. When natural conditions cooperate with us, it is possible to achieve a remarkable feeling of depth in a photograph.

Converging Parallel Lines—When we see something that features parallel lines and yet we observe those lines converging, we know that they are receding toward the distance. Fortunately, photographic film and paper can record this phenomenon just as the eye sees it.

When a road, railroad tracks, a row of houses, a fence or a line of telephone poles appear to get smaller or narrower, we know we are looking into the distance. You can make good use of this in your photography to create a feeling of depth or distance.

Angle of View—To make the most of receding parallel lines on the ground, such as those formed by paths or streams, point the camera down at a distinct angle. If you were to point the camera horizontally from near ground level, the ground area would occupy very little of the image space. At the other extreme, pointing the camera straight down, as from an airplane, would totally destroy the illusion of distance.

Sometimes the view from a standing position may be high enough. Some-

When you want to convey the feeling of wilderness in your photographs, leave out roads, cars, hotels and houses. If a log cabin looks appropriate in a scene, include it by all means—but don't include a refreshment stand or a tourist-information booth.

To retain color contrast, avoid people dressed in colors similar to the background. For example, don't have someone pose in a green shirt in a green forest.

When you have two volunteers to pose for you, avoid clashing colors. Don't, for example, have one wear purple and the other red. Red and yellow harmonize better.

AVOID CLUTTER OF CIVILIZATION

Unless you're on a cross-country hike, you are unlikely to get far away from the signs of man's handiwork. If you want to convey the feeling of wilderness, avoid such giveaways in

words about the value of tripods to the landscape photographer.

You needn't use a tripod for every shot you take. Indeed, many good images would be lost if you were to always take the time to set up a tripod. However, I recommend that you take a sturdy tripod with you on all landscape-photography trips.

A tripod is important when exposure times are relatively long. Even with the standard 50mm lens for a 35mm SLR, you should not attempt to take pictures with the camera handheld at slower than 1/60 second. With a 100mm lens, use a tripod at shutter speeds slower than 1/125 second, and with a 200mm lens, don't handhold

times you may need to stand on a rock or some other structure to gain height. To get even higher, you may need to climb a hillside. If there's a building nearby, you may be able to use it to gain height.

If you cannot gain the required height, use a wide-angle lens. This will give you added foreground, so you can exploit the receding lines.

Relative Object Size—When you see objects in a photo that you know to be of about equal size and their images are of different sizes, you know they are at different distances from the camera. The "objects" can be people, animals, houses or trees. When they appear progressively smaller, you know that, in the image, you're looking into the distance. Learn to use this effect to add depth to your photographs.

Object Overlap—When objects appear to overlap, you know that they are at different distances from you. For example, you may see several large rocks in an image, each rock separate from the others. It may be difficult to determine whether the rocks are of different sizes or at different distances.

If you compose your picture so that some of the rocks overlap, you'll immediately know which are in the foreground and which recede to the distance.

Several Planes—A scene is made up of countless planes that are perpendicular to the viewer's line of sight. You can emphasize this sequence of planes by composing a picture to include several distinct planes perpendicular to the axis of your camera lens.

The first plane may be a row of benches. Beyond these may be a narrow strip of open space, followed by a fence. Beyond the fence may be a green field. At the far end of the field are some low hills. Behind the hills is a mountain range. And, in the far distance, there's a row of puffy, white clouds.

You'll find several examples of this kind of image in the portfolio section of this book.

Framing and Foreground Interest—As I've mentioned earlier, framing a distant scene with a prominent foreground always enhances the sense of distance.

Atmospheric Haze—So far, I've discussed geometric considerations that can add the illusion of depth to your images. Another very useful tool to achieve this effect is atmospheric haze.

Haze can consist of moisture, dust and industrial pollutants. It hangs in the atmosphere like a veil. The farther an object or scene is from you, the thicker the veil is between you and what you're looking at. As the veil gets thicker, three things happen—what you see looks lighter, less distinct and of a different color. Generally, haze has a bluish appearance.

When you look at a series of mountain ranges, one behind another, you can easily distinguish the nearer ranges from the more distant ones. The closest range may appear very clear and sharp. A range farther away will appear a little lighter and less well defined and will have a bluish color cast. An even more distant range will appear even lighter, more blue and less clearly distinguishable. The most distant range may be visible as nothing more than a very light, uniform bluish surface.

Don't be discouraged from shooting in hazy conditions, and don't be tempted to filter away haze. It can be one of your most effective tools in putting depth and dimension into your landscape photographs.

Haze is generally most evident when the sun is low, during the early-morning or late-afternoon hours. That's just one more reason why I urge you to shoot at those times.

Back Light—Back lighting is a wonderful tool for creating a feeling of depth in photographs. It causes a rim light on a subject, making it stand out clearly against dark backgrounds.

Back lighting also causes shadows to run toward the camera, emphasizing the distance between the camera and the subject.

Because the sun is at a seemingly infinite distance from us, the shadows from various objects are parallel. However, when you look at the shadows of a row of trees, for example, they tend to converge toward the distance. They do this like all other parallel lines, as discussed earlier.

This apparent converging of shadows toward distant objects enhances the three-dimensional effect.

Depth of Field—Another way to emphasize three-dimensional space in your photographs is to vary the degree of sharpness over different subject parts. For example, you may want to render a plant in the foreground sharply against a recognizable, but blurred, mountain background.

Depth-of-field control with a standard lens works well only if you have foreground interest. For example, it's impossible to focus selectively at distances between about 50 feet and infinity, even with the lens aperture wide open.

If you want depth-of-field control at longer distances, use a telephoto lens. This technique is very effective in wildlife photography. With a 200mm lens, you can get a good head shot of a deer at a relatively long distance and achieve a blurred, unintrusive background at the same time.

In most cases, I like to see everything in a landscape photo sharp, from the nearest foreground interest to the most distant scene. Therefore, you'll rarely see the deliberate use of depth-of-field control in my photos. But that's only my personal technique. I advise you to do what works best for you in getting the images you visualize.

PRESERVING A SCENE'S GRANDEUR

A special problem for the landscape photographer is how to maintain the grandeur of the scene he sees before him. High mountains often don't look as high, huge ocean waves don't appear as enormous, and great depths—such as canyons—don't appear as deep on film as we would like them to.

You can do several things to minimize this problem. Some have already been mentioned—use foreground interest to provide a feeling of distance; exploit the different apparent sizes of familiar objects, like trees, at different distances; use several distinct distance planes in your composition; make use of atmospheric haze.

Other ways can be helpful, too. By having directional side lighting on a mountain range, you bring out the contours and undulations in the mountains. This makes them look truly three-dimensional and gives them a more massive appearance than would be possible with flat, frontal illumination. Of course, as in most landscape photography, you have to anticipate and wait for the right lighting conditions.

Another way to make mountains look taller and mightier is to wait until their peaks are hidden in clouds. Dark storm clouds can add an extra sense of awe to a mountain range.

Your viewpoint can make a lot of difference, too. Don't point your camera horizontally, thereby avoiding most of the foreground. At the other extreme, don't point straight down from an airplane, either. Instead, position yourself at an elevation where you can point the camera down at a slight angle. This way, you can record two distinct planes—the flat foreground scene and the vertical mountain range. This will help you do justice to the grandeur of the mountains in your photos.

Cloudscapes are much more elusive than landscapes. You can see a landscape all the time and need only wait for the right lighting conditions to occur. Cloud formations move and change all the time. You must wait not only for the right light but also for the very shape and substance that will produce a good picture.

You are probably aware of local weather patterns where you live. This enables you to select times that are most likely to offer skyscapes worth photographing. When you're traveling, familiarize yourself as much as possible with local meteorological peculiarities.

For example, some of the best cloudscapes in Arizona occur from

CONCLUSION

There are some basic rules of composition. You've probably read about them in various books and magazines. All in all, they constitute good advice. However, I advise you to regard them as no more than that—advice and guidance.

First and foremost, you must judge for yourself what will make a good picture. You'll surely make some mistakes along the road. But, with experience, you'll be able to see a good picture more and more intuitively, without even thinking of rules.

Keep your compositions simple. Have a central theme to each picture. Use graphic ways to keep bringing a viewer's attention back to that key part of the picture.

Above all, do a lot of walking. While you're walking, don't just look ahead. Look to your sides and behind you. When you see a worthwhile picture, you'll know it. That's when your work begins. It involves a little more walking—making the composition just right! □

An effective way to make mountains look taller and mightier is to photograph them when their peaks are hidden in clouds. Dark storm clouds can add an extra sense of awe to a mountain range.

SKYSCAPES

Without the presence of special cloud formations and sky colors, you would have no reason to shoot certain scenes. There are times when the sky *makes* a picture. In a case like that, the sky should occupy most of the image area.

However, sky *alone* rarely makes a good picture. There should be at least a narrow strip of foreground land to "support" the sky.

early July to early September. During this season, known locally as the *monsoon,* thunderstorms occur almost every evening. The cloud formations and sky colors at those times can be very impressive.

More traditional skyscapes are sunrises and sunsets. I'll tell you more about these in the next essay, on *Light and Weather.*

Four
Light and Weather

In a studio, you have total control of light—its intensity, direction, color and contrast. In landscape photography, the unpredictability of daylight can give you surprises—both pleasant and unpleasant. With experience, you can use even the "unpleasant" surprises to make fine photographs.

SHOOT, COME RAIN OR SHINE

When I want bright, colorful and detailed landscape photographs, I shoot in sunlight. The best times of day are early to midmorning and mid- to late afternoon, when the sun is not high in the sky. Ideal conditions include a clear blue sky with some fluffy, white clouds. These conditions give me the best subject detail and modeling, the greatest color saturation and the most faithful color rendition.

In a studio, you would rarely use direct illumination from overhead. In a portrait, it causes deep shadows in the eye sockets. With objects, it leads to uninteresting images that lack modeling and form. Overhead illumination is usually just as unflattering to an outdoor scene, and for similar reasons.

When I'm not taking the picture-postcard type of photographs many editors look for, I also enjoy shooting in so-called "bad" weather. Don't imitate the sundial, which can do its job only when the sun is shining. If you do, you'll miss some fine pictures that would otherwise be yours for the taking.

SHOOT EARLY AND LATE IN THE DAY

As any experienced landscape photographer will tell you, if you don't want the best ones to get away, be prepared to go out early in the morning and again an hour or two before

sunset. The low light prevalent at those times has several advantages:

Modeling—Low light from the side brings out the contours in a scene. Mountains, buildings and trees take on a realistic form. Back light often produces a beautiful rim of light, making a subject stand out from its background.

Softness—Low sunlight has to penetrate a greater layer of atmosphere than the high sun at midday. This softens the light, yet leaves it sufficiently directional to leave distinct shadows.

Warmth—As sunlight passes through the atmosphere, much of the blue component of the light scatters. The remaining direct sunlight becomes more reddish, or *warmer*. This warm glow is flattering to many landscape subjects. When it's excessive, you can modify it by using a bluish filter such as a filter in the Kodak Wratten series 82.

Sunrise and Sunset—By shooting directly into the low sun, you can make spectacular sunrise or sunset photographs.

Evening sunlight is usually warmer than the light at sunrise. That's because at the end of the day the content of industrial and automobile-exhaust particles in the air is greater, so that more of the blue content of the sunlight is scattered.

The evening sky also generally contains more dramatic cloud formations. That's probably because there is usually more wind in the evening. For these reasons, I find that sunsets yield more dramatic photographs than sunrises.

The colors of a sunset can vary unpredictably from day to day, depending on the amount of moisture, dust and pollutants in the air. If a sunset is impressive graphically but doesn't

have much color, don't be afraid to use an orange filter on the camera lens. This is most effective when all foreground detail is in silhouette so it doesn't reveal the color change caused by the filter.

Incidentally, there's another good reason to shoot early and late in the day. When you're in a popular tourist area, you're most likely to avoid the crowds at those times—especially early in the morning, around sunrise.

FRONT LIGHT
NOT NECESSARY

Traditionally, camera and film manufacturers have advised amateur photographers to "shoot with the sun over your shoulder." In other words, shoot only when the sunlight is frontal to your subject.

There are many reasons for this tradition. It created a simple standard for recommending exposure. As long as the sun was shining and the light was coming from behind the camera, a fairly reliable universal exposure recommendation could be made.

Front illumination creates the least subject contrast. There are few deep shadows. Subjects of low contrast have a wider *exposure latitude* than high-contrast subjects and can stand greater exposure inaccuracy and still give an acceptable image.

Even cameras with automatic exposure control are easily "fooled" by back or side lighting. Therefore, this old advice seems fine for the camera owner who wants only simple snapshots.

There's just one drawback—front lighting tends to lead to dull pictures! As an ambitious landscape photographer, don't allow yourself to be intimidated into following these "front-light-only" directives. If you

do, you'll forfeit some of your best pictures. Later, I'll give you some guidance on exposure assessment in a variety of situations.

WATCH THE ANGLE OF THE LIGHT

Between sunrise and midmorning, and again between midafternoon and sunset, you can choose between front, side and back lighting. The difference is enormous. You can easily prove this for yourself. The next time you're driving your car in the late afternoon, compare the scene in front of you with what you see in your rearview mirror. The two views will have a totally different character.

The direction of the light affects not only the way shadows will fall. It affects the whole *character* of the light—particularly its color and contrast.

By selecting the appropriate time of day, you can illuminate any scene for the best possible effect. Side light will bring out the contours in a scene and provide a dramatic separation of planes. Low sunlight from the front won't provide much modeling, but can give a scene a dreamlike reddish glow. Back lighting produces dramatic silhouettes and shadows that advance toward the camera. It can also yield spectacular light beams through trees, mist and clouds.

sky is overcast? Well, you should fake it as best you can.

Of course, you can't create the shadows and contrast that would prevail in direct sunlight. But you can do *something*.

My technique is to wait until the light is as directional as possible. This involves waiting for a while in the hope that there will be sufficient break in the overcast for the sun, although not visible, to have some direct modeling effect. Next, I use a warming filter, such as a Kodak Wratten 81 or 81A, to add the warmth of sunlight to an inherently bluish scene.

I avoid including the giveaway gray sky in the picture. If I must include some sky, I conceal it as best I can with tree branches, an overhang from a roof or any other suitable device.

To make up for the lack of color in the scene, I'll deliberately introduce bright colors in the foreground area. I may also introduce some elements of black in the foreground, to make up for the lack of contrast and shadows.

It helps to photograph people in the foreground under an overhanging porch, tree or similar shield so that most of the light reaching them is frontal rather than omnidirectional. It adds modeling to the faces and greater apparent contrast to the scene.

For shooting a rainbow, a low sun is favorable. The lower the sun in the sky, the higher and rounder will be the rainbow. The most shallow rainbows, least suitable for a fine photograph, occur around midday.

Lightning—You can't anticipate exactly when and where lightning will strike. Therefore, you can't simply point your camera and expose the film at precisely the correct moment.

Watch the sky carefully during a storm. If lightning strikes repeatedly in one specific area, set up your camera on a tripod and aim it toward that area.

Don't expect to take good lightning pictures in full daylight. You'll have to wait for storms that occur when it's dark, or very nearly dark.

If you're using a film of speed ISO 64/19°, set your lens aperture to about *f*-11 or *f*-16. Open the camera shutter for a time exposure. Wait, and hope several lightning bolts will strike within your picture area.

If it's so dark that you can barely see the outline of distant trees and hills, you can leave the shutter open for as long as four or five minutes without getting the sky too bright in your picture.

If the storm lasts long enough, take several photos. Include several lightning bolts in each picture.

Finally—be careful. Lightning kills numerous people in this country each year. Stay under a safe cover. Don't stand under tall structures such as lone trees. When wet, these form excellent lightning conductors. They—and you—will attract the lightning. Also stay away from wide-open spaces and from bodies of water.

Rain—There's a story of a Hollywood movie director who had ordered the construction of a device to produce artificial rain on a set at a time when it had been very rainy for days. Asked why he didn't take advantage of the real rain, the director said, "It isn't *rainy* enough!"

We can learn from that story. What you see *isn't* always what you get. There are more and less effective ways of photographing in rain—*real* rain!

Don't have the rain coming down right in front of your camera. Stay under a roof, overhang, bridge or any other suitable cover. Try to have the nearest rain several feet from the camera. This advice is intended not

I enjoy shooting in so-called "bad" weather. Don't imitate the sundial, which can do its job only when the sun is shining. If you do, you'll miss some fine pictures that would otherwise be yours for the taking.

If light coming from the southeast doesn't seem quite suitable for a scene, wait until evening. Perhaps illumination from the southwest on the same scene will be better.

Of course, you can't do *everything*. For example, in the northern hemisphere you can never illuminate with sunlight a surface facing directly due north, except in southern latitudes in midsummer.

CREATING A SUNSHINE EFFECT

What do you do when you're in a place you're not likely to visit again for a long time and you want some bright sunny pictures but the entire

TYPICAL BAD-WEATHER OPPORTUNITIES

Following are some typical bad-weather conditions that offer fine picture-taking opportunities:

Rainbow—As the clouds move away after a heavy downpour, it will generally still be raining nearby. If the storm clouds are directly opposite the sun, watch for a brilliant rainbow.

You can record a rainbow most effectively when it is backed by darkness—usually the storm clouds. To enhance the effect, underexpose the film slightly. This will give you more saturated colors in the rainbow and at the same time make the stormy sky look even more ominous.

only for your camera's protection. It enables you to record the "texture" of the falling rain rather than simply a blurred "sheet" of rain.

The shutter speed should be fast enough to limit the amount of rain recorded. If you expose for too long, you will, again, simply get a uniform sheet of rain on the film. Incidentally, this would also obstruct much of the subject behind the rain. I suggest you use a shutter speed of about 1/60 second—and have your camera on a tripod!

Good visibility doesn't extend very far in rain. Concentrate on nearby objects and scenes. A relatively dark background will make bright streaks of rain stand out most clearly.

Heavy rain often rebounds from the ground in a spectacular way. Immediately after rain, there are puddles and shiny road surfaces with reflections. Exploit all these photographically.

Mist—An early morning mist has a special, pure quality. However, mist *alone* doesn't make a good picture. Look for hills and trees extending above the ground fog. Look for openings in a drifting and whirling mist that reveal a partial scene beyond.

A photograph taken in mist tends to have a narrow *tonal range*—most of the picture will be light to medium gray. Include some foreground interest that's unaffected by the mist and therefore darker. A person, dog, horse and mailbox are just a few of the many suitable foregrounds you can use.

SEASONS

The seasons can be distinguishing in many ways. In winter the trees are bare and there may be snow. In spring, the country becomes green again and shrubs and flowers bloom. Summer brings a darkening of the green in the trees and evidence of a harvest. Fall is accompanied by a splendid display of red, orange and yellow foliage.

In the absence of these obvious seasonal signs, I have sometimes been tempted to take a "summer" shot in winter. I've found that it doesn't work. That's because the light itself is totally different during different seasons. I'll give you just one example. You may think of similar ones from your own experience.

I have taken photos at the Grand Canyon about two hours after sunrise in clear sunlight in midsummer. The colors of the canyon rock, and the differentiation between subtle color variations, appeared—and photographed—spectacularly. There was a brilliance in the scene.

I've photographed in the same location in similar light in midwinter. At about midday in January, the sky was clear and the sun was low. However, I could not match the sheer color brilliance and differentiation possible in summer sunlight.

I'm not a scientist and so can't evaluate this scientifically. However, my personal experience over many years has convinced me that you can't take a good "summer" picture in winter.

What this means, of course, is that the seasons of the year, together with the times of day and different weather conditions, offer an infinite variety of lighting conditions. We need never take quite the same landscape photograph twice!

POLARIZING FILTER

In b&w photography, you can darken the blue sky to make white clouds stand out by using a yellow or orange filter. With color film, you can't use a color filter for this purpose because the filter would give the entire scene a color imbalance. You can, however, use a polarizing filter.

In my early days as landscape photographer, I never used a polarizing filter. When I started using one, however, I quickly realized its value. Today, I use this filter for about one-third of my landscape shots.

Darken a Blue Sky—A polarizing filter can darken certain parts of a blue sky to make it look more dramatic and to make cloud formations stand out more clearly. The filter does not affect the colors in the picture.

The effect of the filter is greatest when the angle between sun, camera and sky is about 90°. As you deviate

from this angle, the effect of the filter becomes progressively weaker.

You can modify the darkening effect of the filter by rotating it. As you rotate it in front of the camera lens, observe the image in the viewfinder. Leave the filter at the setting that gives you the effect you want.

Saturates Colors—I use a polarizing filter for another important reason: In many circumstances it enhances color saturation. The colors in painted surfaces, foliage, rocks and clothing are desaturated by random surface re-

> *A photograph taken in mist tends to have a narrow tonal range—most of the picture will be light to medium gray. Include some foreground interest that's unaffected by the mist and therefore darker. A person, dog, horse and mailbox are just a few of the many suitable foregrounds you can use.*

flections of sky and other surrounding areas. In many instances, these surface reflections can be removed or lessened with a polarizing filter to leave you with a purer color of the object itself.

Again, I recommend that you look through the viewfinder of your camera while slowly rotating the polarizing filter on your camera lens. When you have the best effect, shoot.

This use of the polarizing filter is also most effective when the reflecting surface is at a certain angle to the camera. Therefore, don't expect all the leaves on a tree, for example, to be affected identically. In some instances—for example, when you shoot a painted wall head-on—the polarizing filter won't have any effect.

When a scene has strong side lighting, the sky on one side of your picture will tend to be lighter than on the other. This unevenness will be made worse by the use of the polarizer, especially when it is set for maximum darkening effect.

MOONLIGHT AND SUNLIGHT

At the time of a full moon, you can often make spectacular photos using the light of both the sun and the moon. You have to capture that rare occasion when the moon is just above the horizon and the sun has just set, or is about to set.

Because the moon, unlike the sun,

will be in considerably different locations at the same time on successive days, it's not easy to predetermine exactly where the moon will be on a specific day—unless you happen to be an astronomer!

Here, as in so many other situations, I can only advise you to be observant and be prepared. Shoot when the conditions are right.

Using a film of speed ISO 64/19°, I get a detailed image of the moon—not a washed out disc—with an exposure of about 1/2 second at *f*-8 or equivalent. The amount of detail in the scene depends on the amount of daylight that's left.

If it's nearly dark, you'll get a skyline of mountains or trees silhouetted against a slightly brighter sky. Sometimes you can brighten nearby foreground detail with flash, as I'll explain next.

For photos of the moon, I don't recommend exposure times longer than about five seconds. Longer times can produce a visible elongation of the moon due to its movement during the exposure. This is particularly true when you're using a telephoto lens to get a larger image of the moon.

FLASH WITH DAYLIGHT

You can use flash effectively in several situations in landscape photography. Of course, the flash can only be used to illuminate the foreground area.

Sunset—Sometimes I want to shoot a close-up of a blossoming plant against a dramatic sunset. While the illumination in the sky at that time may be very dramatic, it rarely makes for good foreground illumination. I solve this problem by using flash.

I begin by making an exposure-meter reading for the sunset. It may indicate 1/60 second at *f*-8. To get sufficient depth of field, I'll need to use a small lens aperture—probably about *f*-22. I can adjust the shutter speed accordingly, giving an exposure of 1/8 second. Of course, my camera will be on a sturdy tripod.

It then only remains for me to balance the flash part of the exposure. If the flash guide number for ISO 64/19° film is 55 (feet), I have to bring the flash within 2-1/2 feet of the subject.

If you were to do this using your flash on-camera, you would have to shoot from that distance. If you were using the flash off-camera, you would

have to take care not to get the flash unit into the picture area.

Moon—To make a moon exposure, as discussed in the previous section, together with a close-up flash exposure, I recommend a shutter setting of about 1 second at *f*-11 with ISO 64/19° film. With a 200mm telephoto lens, your closest focusing distance may be six or eight feet. Therefore, you must use the flash off-camera on a long extension to get it close enough to the subject.

This is an awkward procedure. First, you won't get everything from six or eight feet to infinity sharp, so your focus setting must be a compromise. Also, sometimes you may not be able to light the subject adequately and at the same time keep the flash unit out of the picture. In a situation like this, I prefer to use the remaining daylight for foreground illumination.

Of course, I have to wait until conditions are such that moon exposure and foreground exposure are the same. Then I have to work fast because the conditions change almost by the second.

Fill Flash—When a distant scene is in bright sunlight, foreground detail is likely to have deep shadows. These can be lightened by adding fill flash.

It's very simple. Calculate the exposure for the scene. It may be 1/60 second at *f*-16. If you have a person, or some object in which you want to record detail, seven feet from the camera and flash, correct flash exposure, at a guide number of 55 (feet), would be about *f*-8.

This means that, at the *f*-16 setting of the lens aperture, the flash exposure would be about one-fourth of "full" exposure. That's all you need! Remember, your aim is to fill the shadows—not to remove them!

Painting with Light—Occasionally, a legitimate "landscape" scene can be indoors and require artificial light. Caves and mines are typical examples. You can illuminate a relatively large area with just one flash unit by firing the flash several times, from different locations, during one exposure. This is called *painting with light*. Of course, the location you're shooting in must be in almost total darkness at the time.

I have photographed in the Carlsbad Caverns in New Mexico. I had arranged to shoot at a time when tourists

were not in the caves.

I set up my camera on a tripod and composed and focused the image. After I had explored the cave to determine the most effective light placement, a ranger extinguished most of the dim lights illuminating the cave. He left on only one to help me move about.

Using ISO 64/19° film, I set the lens aperture between *f*-11 and *f*-16 and opened the shutter for a time exposure. I rapidly went to each of five predetermined locations and fired a flash from each. The flash and I were always hidden from direct view of the camera. After the final flash, I closed the camera shutter, which had been open for about a minute.

Using the flash guide number, I could easily control the effect each flash was to have by directing it at the cave walls from a specific distance.

SILHOUETTES

Silhouettes can enhance many of your landscape photographs. For example, a person or object in the foreground can be silhouetted. In a sunset photo, most objects and features on the near side of the horizon are frequently in silhouette. Sometimes, the skyline itself will be no more than a dark outline.

Whenever you use silhouettes in your pictures, you must remember one important thing: Because a silhouette contains no detail, the only information it gives the viewer is through its outline. Therefore, you should only use subjects for silhouettes when the outline clearly indicates what the subject is. This involves not only selecting the subject itself carefully, but also choosing the viewpoint with care.

CONCLUSION

Lighting, weather and atmospheric conditions change constantly. Often, you'll have to work fast to get your picture. At other times, however, you may have to wait a long time for the best conditions. If you see something developing in the sky that may lead to a spectacular storm, for example, don't go home just because it's dinner time! Hang around a while.

In anticipation of such occasions, I always carry some food and drink in my car. Somehow, it helps to stretch my patience much further! □

Exposure Control

To get a correctly exposed photograph, with full detail from the lightest to the darkest parts, you need to determine exposure carefully.

SUBJECT-BRIGHTNESS RANGE

In determining exposure, finding the general brightness of the scene isn't necessarily enough. Especially with contrasty subjects, you must establish the *subject-brightness range.* This is the ratio between the brightest and darkest parts of the scene that you want to record with some detail.

Color Film—Typically, color-slide or color-negative films can reproduce detail within a subject-brightness range of about 1:32. This means that there should not be more than a five-exposure-step difference between the brightest and darkest subject parts you want to record with detail.

For example, you may want to record detail in fluffy white clouds in the sky and not simply record them as a uniform white surface. At the same time, you may want some detail in a shaded area under trees and not record that area as pure black.

If an exposure meter indicates an exposure of 1/250 second at *f*-16 for the clouds and 1/250 second at *f*-2.8 for the shadow area, the subject-brightness range is five exposure steps or 1:32. You can take a satisfactorily exposed photo and record all of the detail. The actual camera exposure should be an average of the above—about 1/250 second at *f*-5.6 to *f*-8.

If the reading of the shadow area were *f*-1.4, the subject-brightness range would be seven exposure steps or 1:128. By exposing for detail in the clouds, you would force the shadow area to go black in the image.

If you exposed color-slide film for the shadows in a case like this, the highlight end of the scale would burn out, causing a washed-out, colorless image. It's almost always best, with color-slide film, to favor highlight areas, even if shadow areas go black.

Why compromise between highlight and shadow readings and not give the actual exposure indicated for the white clouds? Because the meter thinks that they, too, are gray and would suggest an exposure to record them accordingly.

B&W Film—A b&w negative film can accept a greater subject-brightness range than can a color film. The range varies from film to film and with the processing technique used, but is approximately 1:128 or seven exposure steps. Unlike color-slide film, negative films should be exposed to give detail in the darkest important shadow areas.

Controlling the Subject-Brightness Range—If the ratio of subject brightness from lightest to darkest part is greater than the film can satisfactorily record and you want detail in all parts of the image, you must find a way to reduce the brightness range.

In landscape photography, this generally involves waiting for softer lighting conditions. Sometimes, changing your viewpoint or altering foreground subjects can help, too.

Keeping within the acceptable subject-brightness range of a film is only the first exposure problem you have to solve. If you don't calculate *camera exposure* accurately, and over- or underexpose the film, even a scene that lies within the acceptable subject-brightness range of the film is likely to have either washed-out highlight areas or shadows without detail.

EXPOSURE METERS

"Correct" exposure is not an absolute value. It is dependent on the speed—or sensitivity—of the film, the brightness of the illumination and, to some extent, the characteristics of the subject, such as its contrast. It also depends on how you want the picture to look.

With experience, you can estimate "correct" exposure reasonably accurately without the help of an exposure meter. If you *bracket* liberally—taking the same picture at different exposure settings, giving greater or lesser exposure than your best estimate—at least one good picture is likely to result. What you can't do so easily without a meter is evaluate the brightness range of a scene, as just discussed.

I don't like guesswork in exposure assessment. I like to make as accurate an evaluation as I can and keep bracketing to a minimum. I can do this with the use of a reliable meter.

There are several kinds of meters, each with its own advantages and disadvantages.

Built-In Camera Meter—In an SLR, it measures the light that actually reaches the film. It's useful for rapid shooting and for pictures taken of subjects of average tonal values.

A disadvantage of these meters is

that they do not measure the entire image field uniformly. Typically, their sensitivity is greatest in the center and falls off toward the edges. There's an additional sensitivity falloff toward the top when the camera is held for a horizontal image. The problem is compounded by the fact that different manufacturers use different sensitivity patterns in their cameras.

Most metering patterns are center-weighted because it's assumed that the major part of interest in a photo—such as a person's head—is usually centrally located. It is also assumed that a horizontal photograph will generally include some sky. Because a reading from the sky would upset the accuracy of the metering of the main subject, meter sensitivity in that area is kept low.

These assumptions may be fine for people taking average snapshots. However, a non-uniform metering area such as this makes it very difficult to make accurate exposure assessments in a wide variety of conditions. For this reason, I always use a separate meter that reads the entire field within its view uniformly.

Incident-Light Meter—This meter measures the light reaching the subject, not the light reflected from it. Ideally, you hold it at subject position and point it toward the light source. While very popular and effective for studio use, I don't consider it ideal for landscape photography.

First, it is rarely possible to stand at the main subject position, which is usually at a distance in landscape photography. Second, this meter tells you only how much light is reaching the subject. It does not enable you to evaluate the brightness range of a subject or to make readings from specific subject areas.

Spot Meter—This is a narrow-angle meter that measures reflected light from a very small area. It is very useful to the landscape photographer because it enables you to make accurate exposure assessments from small parts all over the scene.

Reflected-Light Meter—My trusted helper in finding correct exposure is a compact, reflected-light meter. I carry it in a little pouch attached to my belt. That way, I have easy access to it and it doesn't interfere with my activities as does a meter hung around my neck on a strap.

Unlike the meter built into most SLR cameras, a separate handheld meter measures uniformly over its entire field. You don't have to allow for the center-weighted feature.

Not all reflected-light meters cover the same angle of view. Even if you know the angle covered by your meter, this is not easily translated for practical usage. Here's a guide: From camera position, most reflected-light meters take in about half the image area, or two-thirds the linear dimensions, of a scene covered by a standard 50mm lens on a 35mm camera.

In other words, the covering angle of the meter is generally about two-thirds that of the standard camera lens.

WHAT A METER DOES

An exposure meter would really be more appropriately named a *light* meter. It measures the light coming from the scene. *You* must translate that light reading into an exposure setting.

Basic Principle—An exposure meter is designed to give you accurate exposure of an *average* scene. An average scene is one that is not excessively contrasty and does not contain strong highlights or catchlights. It is also a scene of *average tonality*—if all the tonal values in the scene could be converted to a uniform gray surface, that surface would reflect about 18% of the light striking it.

Here's a graphic way of explaining what an average subject is. Imagine all the tonal components of a scene being mixed together in a pot. If the resultant "paint" had an 18% gray value, the scene would be average.

This means that if you were to point your meter at a uniform gray card of 18% reflectance, you would get an exposure indication that would lead to an equally gray image. However, because the meter can't think, it can do only what it is programmed to do. It assumes that *everything* it is pointed at is a uniform 18% gray.

Point your meter at a *white* card—or at snow—and give the exposure indicated, and you'll again end up with an *18% gray* image. Take a meter reading from a card that's almost *black*—or from a black cat—and expose accordingly, and you'll again get an *18% gray* image.

Practical Application—You can use a reflected-light meter in several ways. First, you should be familiar with what 18% gray looks like. Kodak makes 18% gray cards for exposure purposes. They can be purchased from photographic dealers.

In nature, some approximate examples of that tone include a healthy green lawn and an average granite rock face. I have also found from experience that a shadow in snow on a bright sunny day represents approximately an average gray.

Remember that reference to *gray*, in this context, does not imply a lack of color. For example, a lawn is green, but its *tonal* value represents a gray that reflects about 18% of the light reaching it.

HOW TO USE A METER

I use my reflected-light meter in several ways, depending on the situation and the information I am looking for.

Average Scene—If your scene includes some foreground grass, a few trees, a mountain in the distance and a deep-blue sky, your meter is dealing with a typical, average scene. This kind of scene is easiest to assess for accurate exposure.

Point your meter at the part of the scene that most closely resembles 18% gray and give that exposure. Avoid very dark and very bright areas and be careful not to include in the metering any bright catchlights, such as bright reflections of the sun in windows or from cars.

Subject-Brightness Range—If a scene appears to have higher-than-average contrast, I use my meter to evaluate the subject-brightness range. I can make a selective reading from the brightest and darkest important parts of the scene. From these I can determine whether the scene lies within the five-exposure-step subject brightness range that most color-slide films can record well. I can average my exposure between these two readings to get an acceptable image.

If I can't get close enough to a subject part to take a reading, I can read from a substitute surface. For example, if the mountain rock face I want to read is too small to read selectively from where I am, I can take a close-up reading of a smaller rock of similar tone. It's important, of course, that the close-up rock be in the same lighting as the mountain.

If I want to read the shadow area

beneath some distant trees but it's too small to read selectively, I can read a similar shadow area close to where I am. Of course, a spot meter would do the same job even better. However, I have become so accustomed to making all my exposure assessments with my one, compact meter that I don't carry a spot meter. That doesn't mean I want to discourage you from using a spot meter—a very useful tool.

Exposure Placement—You may have read about the Zone System developed by the famous landscape photographer Ansel Adams. It involves the *placement* of exposure. What this means, in simple terms, is that you need not expose an 18% gray surface to record as 18% gray. You can expose *creatively,* to achieve a specific esthetic result. With b&w film, additional creativity would often be exercised in the darkroom at the enlargement stage.

Essentially, I'm reading an average gray and then deliberately *placing* exposure to give the darker tone of my choice.

With color-slide film, creative underexposure often works, giving you a dramatic image. However, overexposure of color-slide film is rarely recommended because it merely leads to weak, washed-out colors.

Sometimes I must "place" exposure, not for a creative effect but for an accurate tonal rendition. For example, as I've indicated earlier, if I were to take a meter reading from sunlit snow and give the exposure indicated, I would end up with dull, gray snow in my image. To get white snow, I must give more exposure —perhaps two or three exposure steps more. The same situation could occur on a sunlit beach—or in the case of the white clouds mentioned earlier.

- Polarizing Filter—Increase exposure by 1-1/2 to 2 exposure steps.
- Orange Filter—When I use an orange filter to enhance the color of a sunset, I generally don't increase the exposure because I want the darker sky and deeper colors for dramatic effect.

CONCLUSION

In exposure technique, more than perhaps any other area of my photography, I'm a pragmatist. If you were to watch me at work, you would see me "painting" the landscape in front of me with my meter. I evaluate all the readings I take and make a final exposure assessment that's dependent on years of experience. I can't explain to you in words every intuitive step I take.

What I can do—and have attempted to do in this essay—is to tell you something about exposure theory and how I apply that theory in my work. I hope I have given you some useful information and ideas. In the portfolio section of this book, you'll find additional useful exposure tips.

The most valuable tool you can have, however, is the background of practical experience. Go out, take lots of pictures, have a lot of fun, make a few mistakes—and bring home a few masterpieces. In other words, don't just expose your film—expose yourself to lots of experience! □

An exposure meter would really be more appropriately named a light meter. It measures the light coming from the scene. You must translate that light reading into an exposure setting.

With color-slide film, you must do it in the camera.

For example, I may see a scene with clouds in front of the sun, causing the sunlight to radiate from a small opening in the cloud layer. An average reading of the scene would give me a picture representing the scene as I see it. The clouds and foreground scene would read and record as an average gray.

I may consider that this scene and its special illumination lend themselves better to a darker reproduction, representing a threatening storm situation. By simply giving the film half the exposure indicated by the meter, I can produce the image I had visualized.

FILTER FACTORS

When using filters, you generally have to increase the exposure by a factor recommended by the manufacturer to allow for light lost through the filter. Using the exposure meter built into your camera, this compensation is made automatically. When you use a separate meter, you must make this compensation.

I have found the following factors to work best for me with the filters I commonly use:
- Wratten 81 Warming Filter—No extra exposure.
- Wratten 81A Warming Filter— Increase exposure by 1/3 exposure step.
- Wratten 81B Warming Filter— Increase exposure by 1/2 exposure step.

Six
Creative Color Control

When you shoot in b&w, tonality and graphic design are of extreme importance. When you photograph on color film, the colors in the scene tend to be the dominant factor. To create fine color images, you must try and control color effectively.

As landscape photographer, you can't change the colors you see before you, but you can manipulate them to some extent. For example, you can choose a time of day or weather conditions that give illumination having a color quality best-suited for your intentions. With color filters, you have further control.

You can select a viewpoint that gives prominence to some colors rather than others. If a color seems obtrusive, hide it behind something in the scene. If a color seems to be missing, introduce it by including people or other appropriate foreground interest.

COLOR HARMONY AND CONTRAST

I've rarely seen a good definition of color *harmony* and color *contrast*. To me, harmonious color combinations consist of colors that are subtly but clearly different and pleasing to the eye. Contrasting colors are harshly different, tending to compete with each other for attention.

Color harmony is more important to me in my landscape photography than color contrast because it seems more typical of nature. That's probably why I prefer pastel colors, which harmonize much more easily than saturated colors.

When I use color contrast, I tend to limit it to small image areas. For example, I may include a bright-red piece of farm machinery in the middle distance in a green field. The contrast is just enough to make the object stand out clearly.

The only time I deliberately use color contrast in large areas of an image is when the contrast is a genuine part of the natural scene. For example, if a spring scene is filled with many brilliant blossoms of contrasting colors, I'll record the scene as I see it. Or, if a native costume happens to be colorful, or even gaudy, I'll feature it prominently. In such a case, I will often shoot another image without the costume or with the person who is wearing it at a greater distance.

AVOID BLACK

Most of the black you see in my photographs is in the form of shadows. You'll also see some black in the form of tree trunks or other graphic outlines. Generally, I avoid including large black objects or areas in my landscape photographs. To me, black doesn't harmonize with the colors and tones of nature.

MONOCHROMATIC COLOR

Many scenes in nature consist of variations of one basic color. The dominant color in nature is green, and it's easy to think of typical scenes that contain only varying shades of green, blue-green and yellow. Other monochromatic scenes include the reddish rock formations of some of the canyons, buttes and bluffs of the southwestern states of the U.S.

A monochromatic color photo is something halfway between a full-color and a b&w photo. In the absence of distinct color differentiations, tonal values are important. Shoot in conditions that give distinct light and shade effects to the scene. Exploit the subtle color differences that do exist, to add shape and detail to the image.

RED ADVANCES; BLUE RECEDES

We tend to associate blue with distance and red with closeness. These associations are partly psychological. For example, blue signifies distance because the distant sky is blue. For primitive people, red signified the warm glow of a nearby fire. Today, we associate it with the comforting glow of home at night.

However, the associations are also physiological. I'm sure we've all had the experience of seeing red image areas pop right out at us from a two-dimensional slide.

You can use advancing red and receding blue to advantage in your landscape photography. A typical example is the use of haze, where each more distant mountain range looks a little more blue. At the other end of the scale, a nearby person in a picture will emphasize the space between him and the distant scene most dramatically if he is wearing red.

FRAMING PHOTOGRAPHS

Color is an important consideration when framing photos for exhibition.

To maintain color harmony, for a predominantly brown scene I favor a frame of a similar, but not identical, brown. A scene that is made up mainly of shades of yellow goes well in a golden frame.

CONCLUSION

Creative color control is one of the most difficult topics in landscape photography to discuss. Color evaluations are so subjective that even the firmest rules can be nothing more than guidelines. The ultimate guidline is this: Do what pleases you and learn from what pleases others. □

Seven
Tips for the Traveling Photographer

If your freedom to travel is unlimited, you should arrange your photographic trips so you're always in the right place at the right time. For example, if you head for the desert in the spring, when the cacti bloom, you're likely to come home with lots of spectacular pictures. Go to New England in the fall, when the leaves turn to a bright red and gold, or visit Washington, D.C. at cherry-blossom time. You'll surely get pictures to be proud of.

If you're not a professional whose prime consideration is landscape photography, your freedom to travel as you want is likely to be limited. You have only a certain amount of vacation time. You may not be able to take that time precisely when you would like. If you travel on business, your destination is dictated by others.

However, even if you can't go exactly where and when you want, almost all travel offers some opportunity for landscape photography. If you can't travel for extended periods, take as many long weekends as possible. If your company sends you to Arizona in April or May, you're fortunate. If you must travel to a large city in January or February, you'll have fine picture-taking opportunities, too, if you keep your eyes open.

In this essay, I'll give you some advice that should make all your travels more relaxing, enjoyable and photographically productive.

KNOW YOUR SHOOTING LOCATION

If you're planning to visit a place that's unfamiliar to you, gather as much information about the location as you can. This includes typical weather conditions and temperatures at the time you'll be visiting. Learn as much as you can about the nature of the landscape, the architecture of the cities and the customs of the people.

Look around your local library or a good book store. You can get a lot of useful information from travel books. Familiarity with local conditions will make you more confident and efficient when you're shooting.

TOURS AND WORKSHOPS

Guided tours are available to many places in the United States and throughout the world. They offer a fine way to get to know a place and become familiar with its customs, even if you don't speak the language. Some tours are specially designed for photographers and have guides that are photographically knowledgeable. See a travel agent for details.

In many places you can hire local tour guides privately by the day or week. For information, see the local tourist information office.

A wide selection of photographic workshops is also available each year. Many are intended for the landscape and nature photographer. You can find details in the major photographic magazines.

EQUIPMENT

Take equipment that's suitable for the kind of photography you're planning to do. For example, if you intend to do a lot of hiking and climbing, take a 35mm camera and perhaps three or four lenses of different focal lengths.

Take with you an adequate amount of film and an exposure meter. A tripod is always useful, so consider whether you're prepared to carry one.

If you're going to a city and your main aim is architectural photography, take a 4x5 camera, if you have one. I recommend that you use a tripod for this kind of photography, no matter what camera you use.

Take everything you are likely to need to take the pictures you want—but don't take a single item more.

Lenses—Whichever format I happen to be shooting with, I normally carry four lenses—a standard lens, a wide-angle, a short telephoto and a medium telephoto. In the 35mm format, this typically means 50mm, 35mm, 85mm and 135mm lenses. In the 4x5 format, the lenses I normally carry are a standard 150mm, together with a 90mm, a 210mm and a 360mm. If I'm going on a trip that is likely to call for wide-angle or telephoto lenses beyond the above limits, such lenses will be among my equipment, too.

Be Familiar with Your Equipment—Don't make an important trip with equipment or film you haven't used before. This is not the time for testing. You want to be sure everything works the way you intend it to.

Be sure your camera and accessories are in good working order. This includes checking that all batteries are OK.

Protect Equipment—Sand, dust, dirt, water—especially salt water—and extreme heat and humidity can damage your camera and film. In conditions such as these, place cameras, lenses and film in plastic bags.

Don't leave camera equipment or films in the glove compartment or trunk of a car in hot weather. Protect unused film from humidity by keeping it in its sealed container until you need it.

If you're shooting in mist, rain, snow or on a windy beach, protect your camera while you're shooting by putting it in an appropriate cover or housing. When shooting in rain, try to find some overhead protection. It may be a barn, an overhanging tree, a bridge—or a helpful person with an umbrella.

If equipment should get damp, dry it immediately. Avoid sand and salt spray at all costs. If these should get into your camera, consult a camera repair shop or dealer as soon as possible.

I've been on many rafting trips on the Colorado River. I take many photos from the raft, but never while we're going through rapids. At those times, my cameras and all other equipment are safely sealed in sturdy rubber bags. To photograph the rafting action in the rapids, I ask to be dropped off at a suitable point, walk ahead to a good overlook, and shoot from there. I'm always confident of being picked up again—because I know that all participants are eager to eventually see the pictures of their adventure!

To keep equipment cool in my parked car, I place it in an insulated cooler. Even without ice, this environment is many degrees cooler than a sun-baked car. When I work within sight of my parked car, I'll leave the windows open. Of course, when the opportunity presents itself, I park my car in the shade.

In addition to insurance, take every reasonable step to protect equipment from theft. Don't use easily recognizable camera bags. Avoid bags imprinted with a camera manufacturer's name. They tend to attract thieves. Use other suitable, plain bags or containers. Don't leave equipment lying visibly in your car.

If possible, don't leave equipment in hotel rooms. If you must leave it there, disperse camera and lenses in suitcases and lock the cases.

Avoid stickers and decals on your car indicating that you're a member of a photographic organization.

Airport X-Rays—It's difficult to say categorically to what extent airport X-ray machines damage film. Different countries and airport authorities use different types of machines. The dosage with some machines is higher than with others. Fast films are affected more than slow films.

One thing is certain: The more frequently a film goes through X-ray inspection, the more likely it will deteriorate in quality. This is an important consideration if you travel by air a lot. Ask for hand inspection of your film. However, some countries insist on X-ray inspection.

I protect my film in special bags lined with lead foil. The bags I use are called *Film Shield* and are available from Sima Products Corporation, Lincolnwood, Illinois. Each bag holds up to 22 rolls of 35mm film. The bags hold back a large percentage of the X-ray radiation.

DRESS APPROPRIATELY

When you pack clothing for a trip, bear in mind the climate of your destination at the time you'll be there. Be

TRAVEL LIGHT

It would be nice to have all the comforts of home while you're on the road. However, such comforts are not essential and can be a considerable burden to the traveling photographer.

Traveling light makes traveling easy. However, *preparing* to travel light isn't that easy. You have to make choices.

Your basic guideline should be: Take *everything* you'll need. Take *nothing* you don't need. This applies to photo equipment, clothing and personal "creature comforts."

As I've said earlier, one thing I never go without is some food and plenty of drinking water. These are necessities for the photographer out in the field.

BE ORGANIZED

When you're on a photographic trip, the less you have to think of day-to-day worries, the more time you'll have to devote to your picture-taking. I advise you to organize in advance as much as you can. This doesn't just mean that you should have all camera equipment and film in order. It means that everything else relating to the trip should be in order, too.

Be sure airline and hotel reservations are confirmed. Carry a clear itinerary of your travels. Check that you have all necessary documents. These include passport, driver's license, credit cards, rental-car reservation and airline tickets. If you're traveling in your own car, be sure it is in good running order.

Make it a true photographic trip—not a troubleshooting trip!

THE BEST ROUTE

If you must get to your destination fast, by all means fly. If you have plenty of time, drive. The *trip* is often more exciting than the *arrival* and can offer many varied photographic opportunities.

Avoid major highways on which you have little opportunity to stop. Take secondary highways and minor roads, where you can travel slowly, stop at will, and easily make detours. Minor roads usually offer the most attractive and spectacular scenery.

If you're not in a hurry and the environment is suitable, other exciting methods of transportation include hiking, cycling or going by boat.

Don't make an important trip with equipment or film you haven't used before. This is not the time for testing. You want to be sure everything works the way you intend it to.

Insurance—Good camera equipment is valuable. With even the greatest care, it is subject to possible damage and theft while you're traveling. I have all equipment fully insured. You can do the same through your homeowner's policy. A good insurance agent can advise you.

sure you'll always be dry enough, warm enough, cool enough—in other words, comfortable!

If you plan to sleep outdoors, take an adequate sleeping bag and other appropriate equipment. If you expect to be in deep snow, consider taking snow shoes or skis.

BE ADAPTABLE

Be prepared to change your plans. If you get new information along the way, indicating that you should head elsewhere for best picture-taking opportunities, do so if at all possible.

Weather conditions can change your plans. So can new information about local events. Perhaps a community 20 miles from your planned route is due to have its annual parade the next day. Talk with local people along the way and keep informed about conditions and events in near and not-so-near neighborhoods.

BE CONSIDERATE

Always be considerate of other people. If people are aware that you're about to photograph them, ask for permission. If you want them to pose, explain what you want. Or, if you want people to move out of a scene while you shoot, ask them if they would oblige you. In my experience, people are nearly always helpful if you explain what you're doing. However, don't delay people for more than a minute or two.

If people in your scene are not aware of your presence and are naturally posed as you want them, photograph them without asking. However, never depict anyone in a compromising or undignified situation.

Generally, you don't need a signed model-release form from people you photograph in public places, as long as the photos are not used for advertising purposes.

People of some cultures and reli-gions are sensitive about being photographed at all. Respect that sensitivity.

In some places you may need permission to set up a tripod. In some locations overseas, you may need a permit to photograph at all, or may be banned from photographing. Observing these rules is not simply a matter of consideration—it's one of expediency. Failing to comply could seriously curtail your photographic adventure!

Don't promise people copies of photos you've taken of them unless you firmly intend to keep that promise. Treat all people as if you

If you have the time, take secondary highways or minor roads where you can travel slowly, stop at will, and easily make detours. Minor roads usually offer the most attractive and spectacular scenery.

expect to meet them again next month or next year. You just may!

KEEP NOTES

The more information you have about your photographs, the more valuable they will be. Always carry a notebook and write down all important details about each photo you take. This includes location, date and special details of importance. Also, write down details of the photographic technique used, including exposure data.

Number each note in a way that will enable you to bring it together with the appropriate film roll and frame after processing.

Don't rely on memory. After a lapse of a couple of weeks, it's not easy to accurately recall all important data about several hundred pictures.

BE PREPARED

I've said it so often, you probably think by now that I'm the original boy scout! However, I can't overstress it, especially to the traveling photographer: Be prepared.

You don't know what picture-taking opportunities may present themselves from moment to moment. Always have your loaded camera ready.

It would be unreasonable to expect someone on a business trip to carry a briefcase full of cameras and lenses. It would be equally inappropriate to expect a parent on a family vacation to haul around an arsenal of cameras and lenses. However, it's not difficult to carry one camera with one lens—perhaps a zoom.

If necessary, shoot first and think later. If you get a second chance, plan your picture carefully, using the advice I've given you in these essays and in the portfolio that follows. □

Portfolio

1

Location: Glen Canyon National Recreation Area, Arizona and Utah
Time of Year: June
Time of Day: Early afternoon
Light Conditions: Shaft of direct sunlight through canyon
Lens: Standard
Film: Ektachrome 64
Exposure Metering: Close-up reflected-light reading from red rock in center

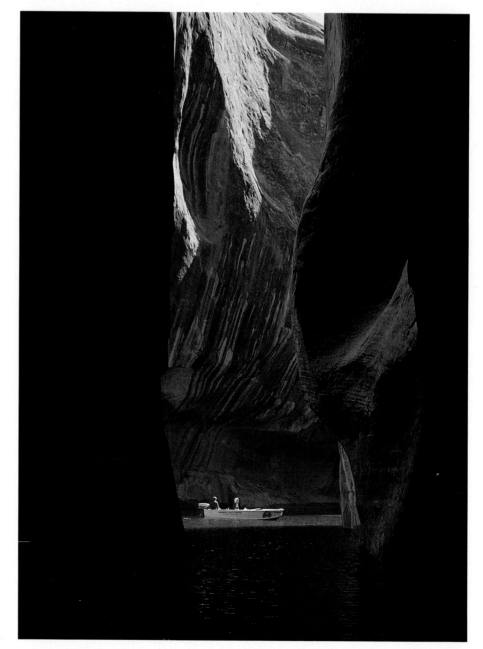

The light angle must be exactly right for a photograph in this kind of location. The sunlight had to come from a specific position to enter the canyon, highlight the water and rock face, and reflect some light into the darker areas.

When this lighting condition exists, it lasts for no more than a few minutes. In a deep and narrow canyon, you may get appropriate lighting on no more than a few days each year. You either have to plan ahead carefully or be lucky!

I maneuvered my boat to get the best composition. At the same time, I directed the other boat into the most favorable position.

I needed a small lens aperture for adequate depth of field. However, the shutter speed couldn't be too slow because two moving boats were involved. Therefore, my exposure setting had to be a compromise that satisfied both requirements.

Since Glen Canyon Dam harnessed the Colorado River, the canyon's terrain has changed considerably. Because of the great change in the water level, many areas previously accessible are now inaccessible and many exciting new areas have opened up. □

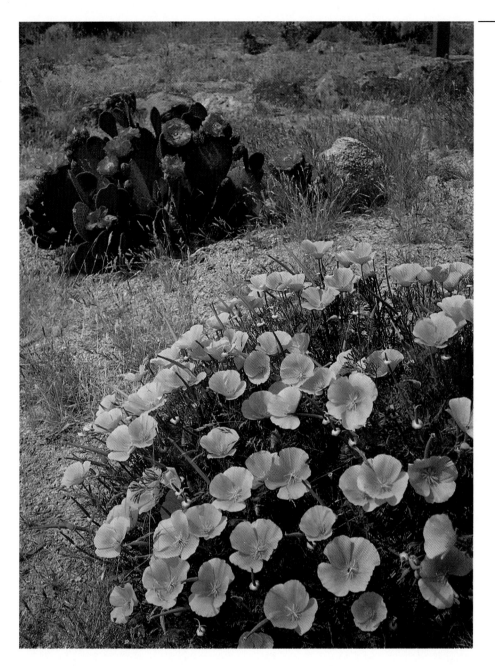

Location: Arizona desert
Time of Year: April
Time of Day: 11 a.m.
Light Conditions: Sunlight through light haze
Lens: Standard
Film: Ektachrome 64
Exposure Metering: Reflected-light reading from central area

In composing a close-up image of this kind, it's useful to have the camera on a tripod. A change in camera position of just a few inches can make the difference between a fine photo and a mediocre one.

Contrast in both color and tone play an important part in the success of this image. Although the distant cluster is small and has relatively few blooms, it attracts attention because of its bright-red color. It stands out even more because of its contrast with the foreground yellow.

The tonal contrast between the dark green of the clusters and the lighter surrounding desert area graphically separates the two plants.

I did not want to include the entire foreground plant in the picture. My aim was to include an area that would provide a pleasing visual counterbalance to the "weight" of the distant plant. □

Location: Near Kitzbuehl, Austria
Time of Year: June
Time of Day: Midday
Light Conditions: Direct sun, blue sky and white clouds
Lens: Standard
Film: Ektachrome 64
Exposure Metering: Reflected-light reading from grass, cabin, trees and part of mountain but not sky

High, frontal sunlight was ideal for this scene. It gave the cabin a three-dimensional effect. Notice how shadows help to separate the receding downstairs area from the upper floor and how the roof overhang stands out.

Compositionally, the outline of the trees approximately repeats the shape of the cabin roof. With experience, a sixth sense tells you when a composition looks "right."

A blue haze helped to make the mountains look distant. The towering white clouds touching the peaks gave an added sense of grandeur to the scene. □

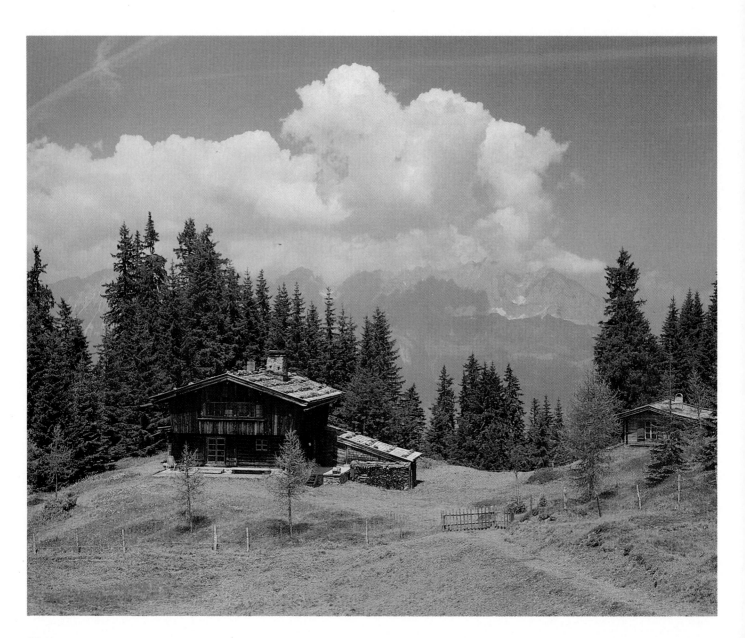

The clouds were in an ideal position. They added interest to an otherwise uniform sky and also made the distant rock formations stand out clearly. To enhance the tonal separation between blue sky and clouds, I darkened the sky by using a polarizing filter.

Red is a good color for foreground detail. Notice how dominant the two Navajo Indians are, even though they are not very large in the image.

I deliberately placed the light-colored pony in front of the dark one because it attracts more attention. This placement tends to lead the viewer's eye into the scene rather than out of it. □

Location: Monument Valley, Arizona
Time of Year: July
Time of Day: Midafternoon
Light Conditions: Direct sun
Lens: Wide-angle
Film: Ektachrome 64
Filtration: Polarizing filter
Exposure Metering: Reflected-light reading of the desert floor and the rock face at right

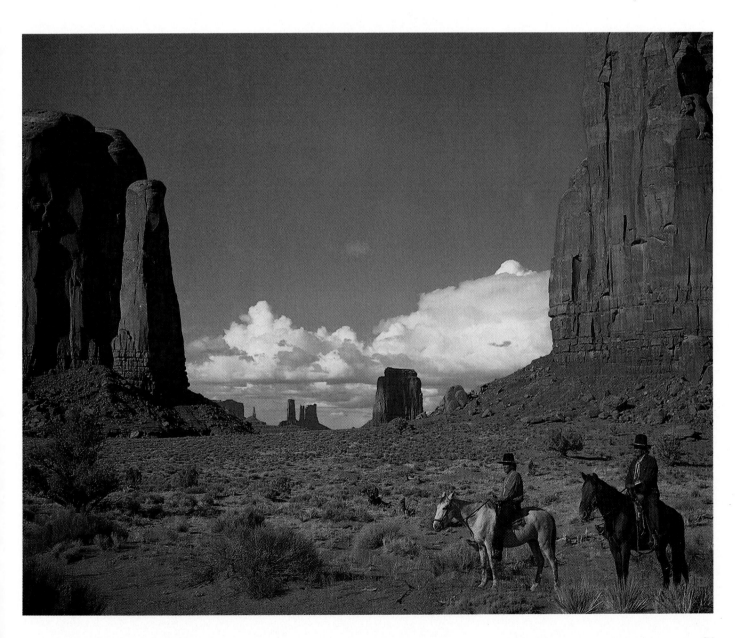

5

Location: Monterey Peninsula, California
Time of Year: April
Time of Day: Sunset
Light Conditions: Direct sun from clear sky
Lens: Standard
Film: Ektachrome 64
Exposure Metering: Reflected-light reading of lower area, excluding sun

This is a good example of breaking the "rules" to achieve a specific effect. The theme of the picture is the setting sun and its reflection. I have placed that theme in the center of the image—something that's normally discouraged. However, I did it quite deliberately. The symmetrical composition tends to give a feeling of peace and tranquility to the scene.

The rocks help to give the image a feeling of distance. Notice that I chose my position carefully so that no rock interrupts the reflection streak.

When shooting a picture like this, don't wait until the sun is nearly touching the horizon. At that point, even the smallest waves or ripples will obstruct the rays of the sun and break up the band of reflection on the water.

Shoot as soon as you've made your exposure reading. At this time of day, light conditions change almost by the second. □

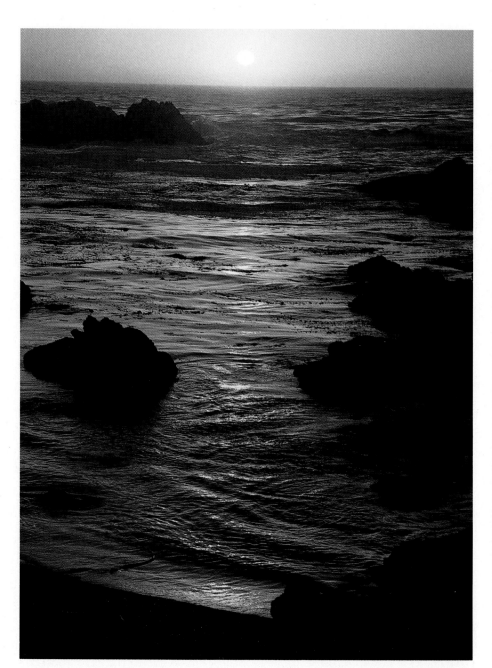

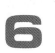

The scene was almost monochromatic. Everything consisted of various shades of green. Although pleasing to the eye, the scene needed added interest to make an effective photograph. I achieved the desired effect by including the tractor. It provides a focal point and its bright-red color contrasts well with the green.

I waited until the tractor was about one-third of the way into the picture and then made the exposure. It's generally advisable to have more space in front of a moving object in an image than behind it. Movement should appear to be into a picture rather than out of it.

The pattern of diagonal lines on the meadow helps to give the image a three-dimensional effect. □

Location: Inn Valley, Austria
Time of Year: Midsummer
Time of Day: 11 a.m.
Light Conditions: Hazy sun
Lens: Standard
Film: Kodachrome 25
Exposure Metering: Exposure determined by in-camera meter

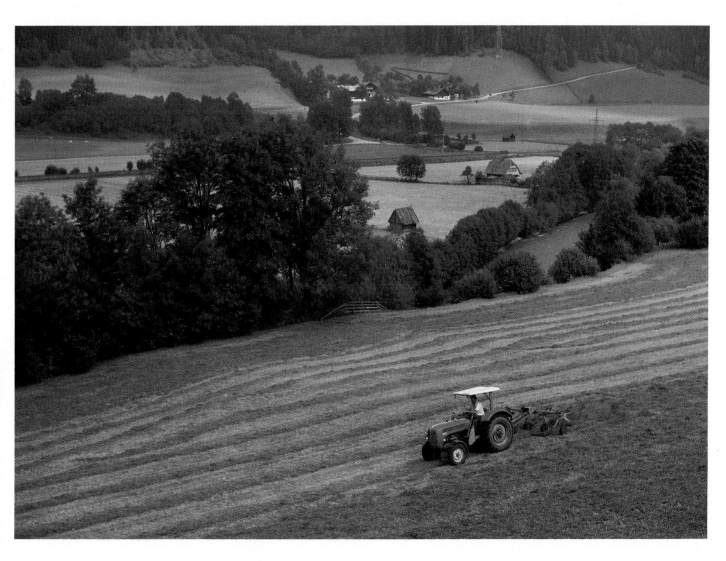

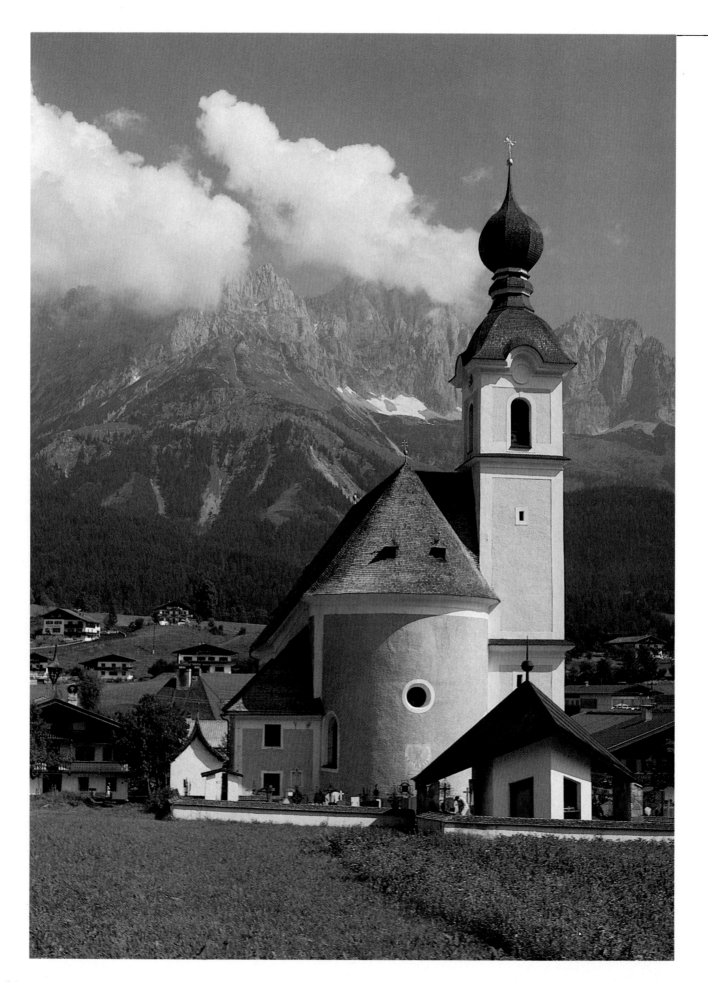

Location: Village church in Going, Austria
Time of Year: Summer
Time of Day: Midday
Light Conditions: Direct sun, blue sky, some clouds
Lens: Standard
Film: Kodachrome 25
Exposure Metering: In-camera meter; gave indicated exposure

I waited until the lighting on the church was almost ideal. The sunlight struck the church from the right side, giving beautiful modeling to the rounded, yellow wall. In frontal sunlight, or under an overcast sky, the wall would have appeared flat. This is a good example of using lighting to provide the viewer with information about a subject.

The sun was high enough in the sky to cause shadows under the various roof overhangs. This adds a three-dimensional look to the structures.

The feeling of distance between the church and the forest under the mountains is enhanced by the seemingly diminishing size of the houses in between. The three-dimensional effect is further enhanced by the contrast between the green grass in the foreground and the bluish veil of haze in front of the mountains.

The clouds form an attractive break in an otherwise uniform blue sky. When clouds cover the tips of mountains, they have another useful effect: They make the mountains look even more imposing.

In western cultures, the fact that we read from left to right has a strong influence on the way we look at pictures. The eye tends to move more naturally from left to right than in the opposite direction.

In this picture, our attention moves from the left side of the scene toward the church. The prominent, bright church steeple arrests our attention and directs it back into the picture. Had the steeple been on the left side of the picture, our attention would have wandered out of the right side of the picture much more easily. □

8

Location: Coast at Monterey, California
Time of Year: April
Time of Day: 10 a.m.
Light Conditions: Sunny, clear sky, no haze
Lens: Standard
Film: Ektachrome 64
Exposure Metering: Reflected-light reading from flowers and green area

The scene is divided into several nearly horizontal planes. This can help strengthen the feeling of distance. However, you should generally avoid planes that are almost exactly parallel to each other.

The color combination in this scene further helped to suggest distance. As I explained in the essay on *Creative Color Control,* page 24, blue tends to recede from you while the reddish colors advance toward you. In this image, the blue ocean and sky suggest distance while the yellow-orange flowers provide a sense of nearness.

To add more contrast and life to the image, I waited for the surf to break and exposed when I saw the nice, white foam recorded here. □

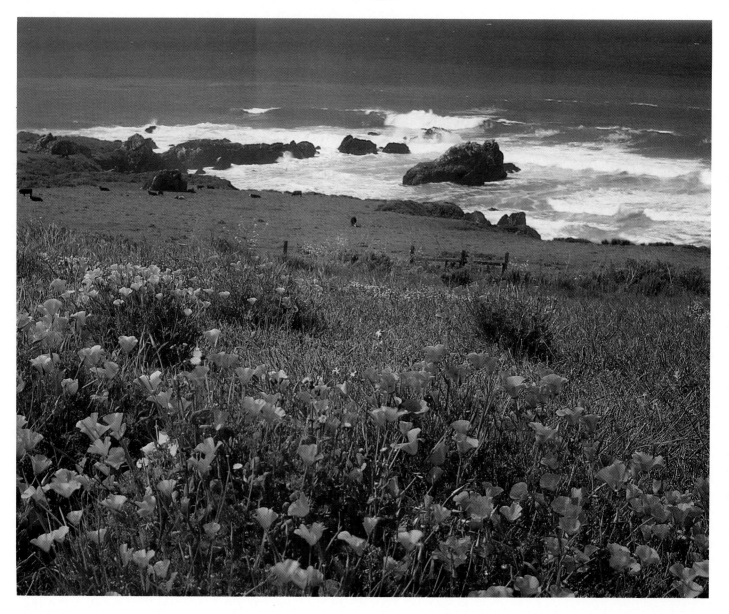

9

Location: Sequoia National Park,
California
Time of Year: May
Time of Day: 11 a.m.
Light Conditions: Weak, direct
sunlight through lightly overcast
sky
Lens: Wide-angle
Film: Ektachrome 64
Exposure Metering: Reflected-
light reading of flowers in
foreground

Direct, undiffused sunlight would have been too harsh for this location. It would have caused contrasty shadow and highlight patches because of the surrounding trees.

General subject contrast between the bright flowers and the dark tree trunks would also have been too great in direct sunlight, even without the patches mentioned. Consequently, I waited for a lightly overcast day to shoot in this location.

I purposely avoided having a person in this scene. I thought it would have made the image too busy and detracted from the tranquility of the scene.

In this instance, I didn't need the human element for scale, to indicate the size of the trees, because the flowers served the same purpose. Because they are very close to the trunks and most viewers are aware of their size, it is easy to deduce the size of the giant sequoias.

I chose a position that placed the trees at different distances from the camera. This allowed for a more interesting composition than simply placing the trees across the picture at an equal distance. □

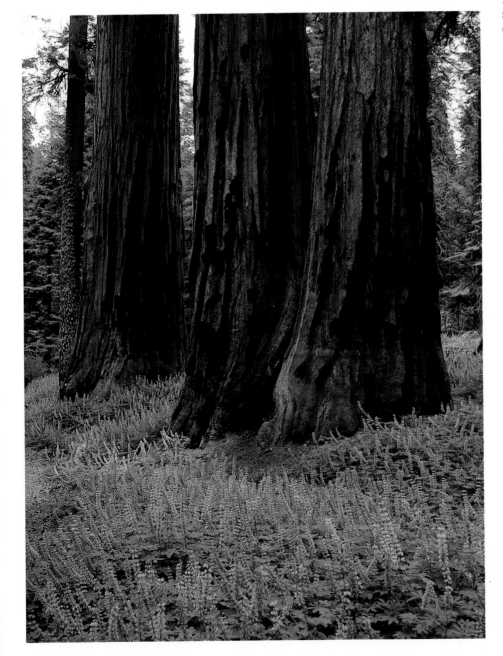

10

Location: Arizona desert
Time of Year: June
Time of Day: Late afternoon
Light Conditions: Direct sun on foreground; storm clouds in background
Lens: Standard
Film: Ektachrome 64
Exposure Metering: Reflected-light readings (details in text)

11

Location: Arizona desert
Time of Year: June
Time of Day: At sunset
Light Conditions: Setting sun and glowing background sky
Lens: Standard
Film: Ektachrome 64
Exposure Metering: Reflected-light reading (details in text)

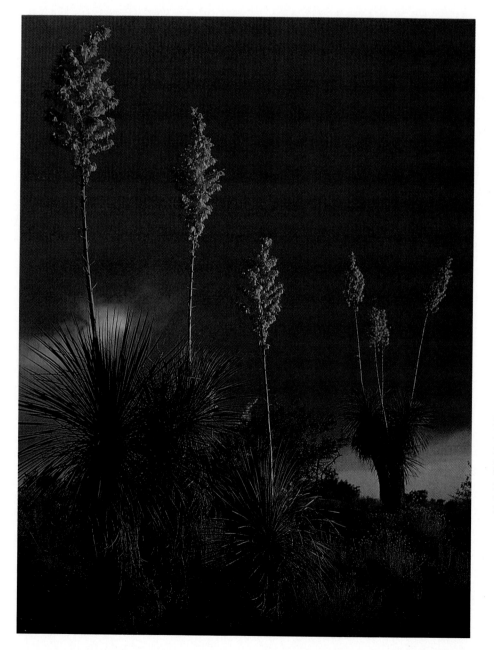

These two strikingly different images of similar subjects show how the sky's appearance can affect an image dramatically. If you're observant, you can use these sky variations in a creative way.

The two images are almost exact reversals of each other. On this page, the foreground detail is bright against a blue-gray sky. In the image on the next page, the foreground is relatively dark against a bright, orange-red sky. The sunlight in each case came from the right side. For the image on the next page, the sun was barely beyond the picture area on the right side.

For the image on this page, I took a reflected-light meter reading from the sunlit foreground area, not all included in the final image. The reflected-light reading for the image on the next page was made from the three stalks and the sky behind them. I carefully shielded the meter from the sun, which was almost in front of me.

When a storm is approaching or receding, and at sunrise and sunset, lighting conditions change very rapidly. You must work fast. Take your meter readings and shoot. If you have time, shoot again. If you really have time, take another meter reading before taking another shot! □

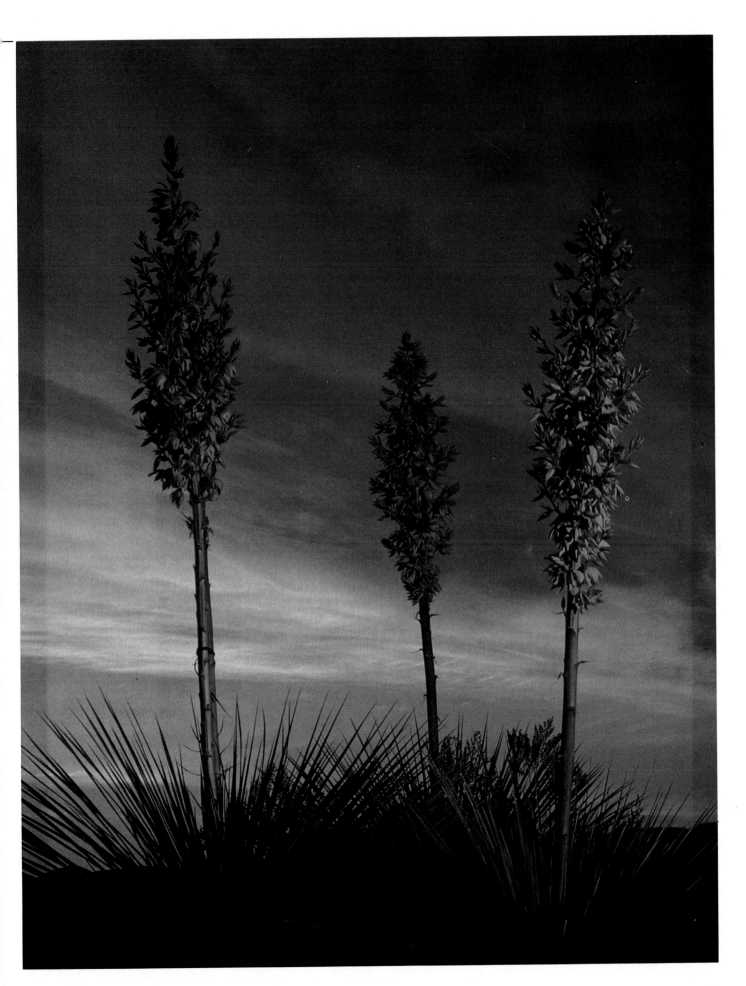

12

Location: Mount McKinley, Alaska
Time of Year: June
Time of Day: 10 a.m.
Light Conditions: Direct, slightly veiled sunlight
Lens: Short telephoto
Film: Ektachrome 64
Exposure Metering: Reflected-light reading from central area including lake, foreground, mountains and a bit of sky

While preparing to shoot this scene, I wished I could add some human interest to the image. A woman appeared, apparently from nowhere, and watched me. I told her how nice it would be to have someone on that lake for my picture. She answered that she had a canoe tied up around the next bank and would be happy to go out in it.

I asked the woman to paddle out very slowly and gently, so as not to disturb the tranquil surface of the water. She did just that. Then she carefully followed my directions for getting into precisely the right position. Notice that she is about one-third of the way into the picture and looking into the scene. I also made sure that she would appear within the highlighted part of the lake.

The presence of the canoe on that lake "makes" this picture. Such is the serendipity of landscape photography—things often tend to turn up at the right time. However, you must be able to recognize an opportunity when you see it.

I framed the image so the bank of the lake crossed the foreground and then slowly wound toward the distant mountains. This provides a feeling of distance and also draws viewer attention toward the mountain range.

The clouds that envelop the mountains suggest great height. This effect is further enhanced by the contrast between the totally snow-covered mountains and the snowless foreground.

The sun was to the left and a little ahead of the camera. This side light provided fine modeling to the landscape as well as the canoeist. □

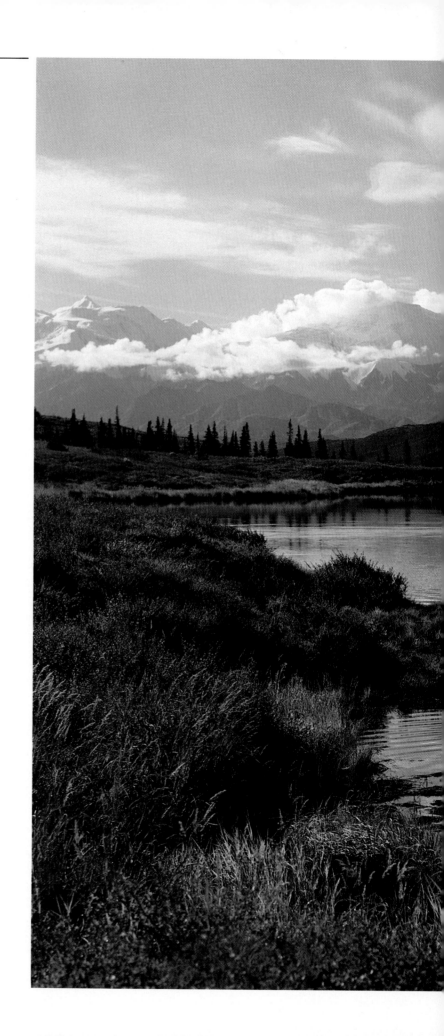

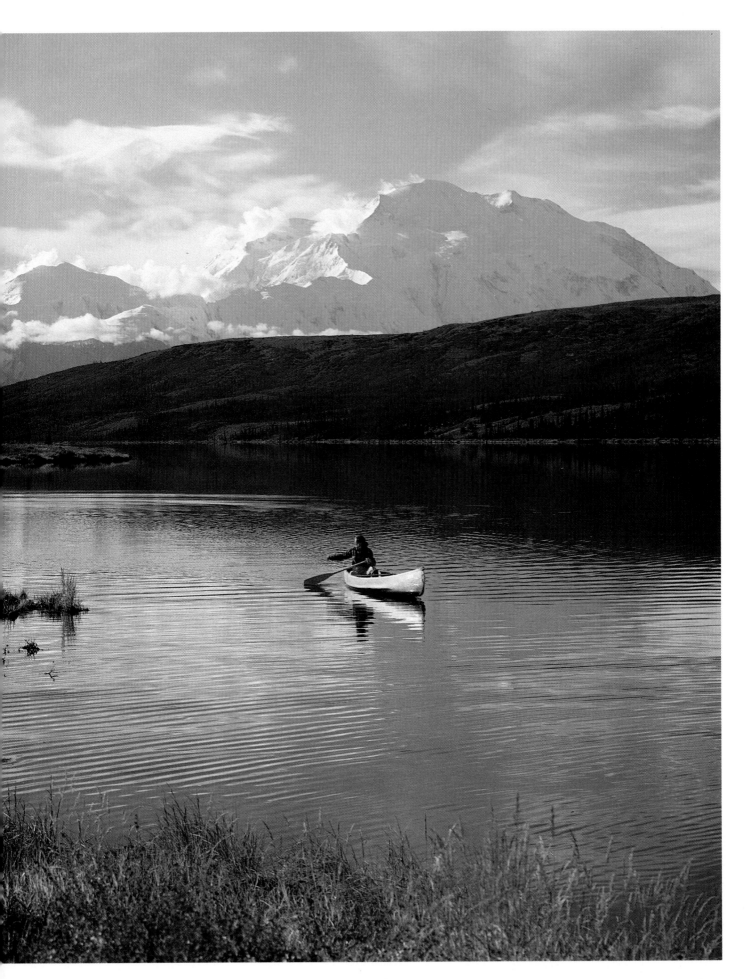

13

Location: Moccasin Arch, Monument Valley, Arizona
Time of Year: April
Time of Day: Early afternoon
Light Conditions: Weak, direct sunlight through lightly overcast sky
Lens: Standard
Film: Ektachrome 64
Exposure Metering: Reflected-light reading, half of ponies and background rock and half of foreground, extending beyond area photographed

Even a spectacular scene like this can be enhanced by human interest. These Navajo Indians are an authentic part of Monument Valley. Their presence in the picture helps provide a sense of scale, enabling the viewer to appreciate the grandeur of the terrain.

There is enough white in the ponies to make them stand out clearly from the darker rock face behind them.

The ponies were originally facing in the opposite direction. I didn't want them to face out of the picture, so I asked the women if they would kindly turn around. They were happy to oblige me.

Notice how I have used a bright foreground area to counterbalance the bright areas through the rock window and from the sky. □

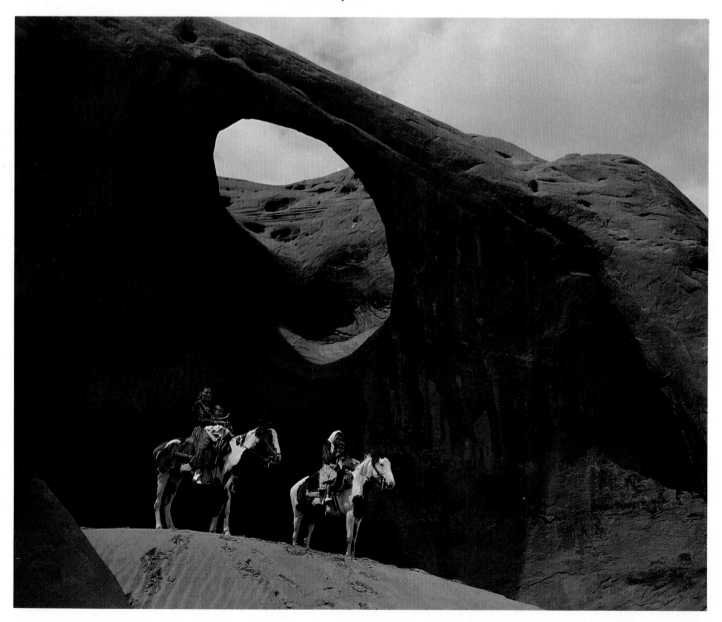

One bright, sunny day much resembles another. However, conditions such as are shown in this photo are unique. They are never repeated in quite the same way.

The sun was about to set to my left. While the foreground was still sunlit, there was a fierce storm in the background. I exposed for the foreground area. I didn't want the background to be exposed "correctly"—I wanted it to be dark.

Notice the relatively bright, narrow area between the clouds and the horizon. It enhances the feeling of heavy rain and also emphasizes the skyline. Conditions like this are not uncommon in a desert storm.

To show as much detail as possible from foreground to background, I chose a fairly high viewpoint. I also selected a position from which the interplay of light and shade was most pleasing.

When an evening storm clears, a beautiful sunset often follows. On this occasion, there was already a spectacular sunset to my left as I shot. However, I didn't have time to photograph it. Only moments after I made this photo, it began to pour where I was, too, and I had to run to my car for cover. □

Location: Monument Valley, Arizona
Time of Year: Autumn
Time of Day: Late afternoon
Light Conditions: Setting sun; storm in background
Lens: Standard
Film: Ektachrome 64
Exposure Metering: Reflected-light reading of right foreground, including highlighted rock

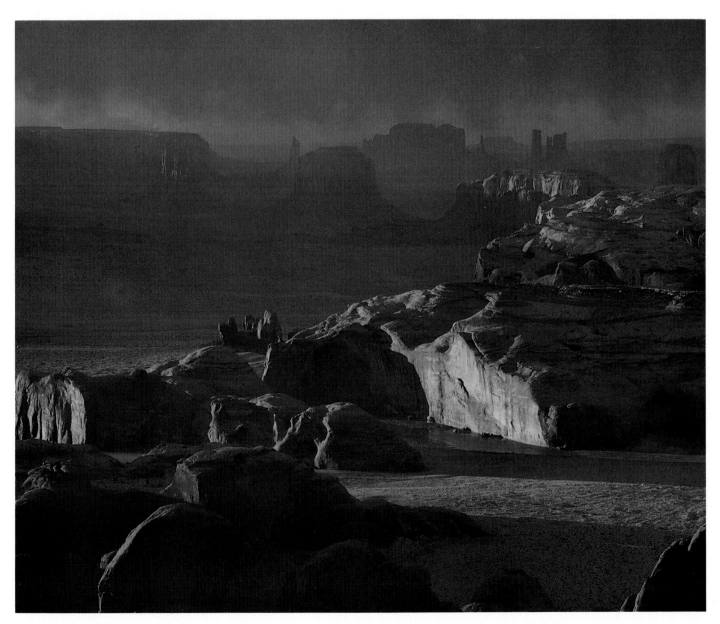

15

Location: Matterhorn, Switzerland
Time of Year: Early June
Time of Day: 10 a.m.
Light Conditions: Clear sunlight
Lens: Standard
Film: Ektachrome 64
Exposure Metering: Reflected-light reading of green area, lower part of mountain and reflection

It's difficult to make a mountain appear as majestic on film as it does in real life. In this book, I've explained some methods of making mountains look awe-inspiring in your photographs. However, there are a few peaks that always look majestic, no matter when, or from what angle, you photograph them. The Matterhorn is one of these. Its steep incline and pointed summit make it not only a mountaineer's constant challenge, but also a photographer's delight.

I took this photograph in spring, when the snow had melted on the lower ground but the mountain was still in deep snow. This apparent climatic contrast always helps to further enhance the grandeur of a mountain scene.

To emphasize the famous pyramid-like structure of the Matterhorn, I composed the picture nearly symmetrically. Notice, however, that I placed the peak just a bit off center. Exact central placement of a main subject is rarely appropriate or advisable.

The snow cover acted as an efficient reflector, brightening the shadows caused by direct sunlight from the left. Without snow, the scene would have appeared much more contrasty.

I took a reflected-light meter reading from the lower two-thirds of the picture area, including the green area, the reflection in the lake and part of the mountain. I exposed according to the meter's indication.

A polarizing filter was not necessary. The sky was a deep enough blue without the filter, and I certainly didn't want to remove the reflection from the water! □

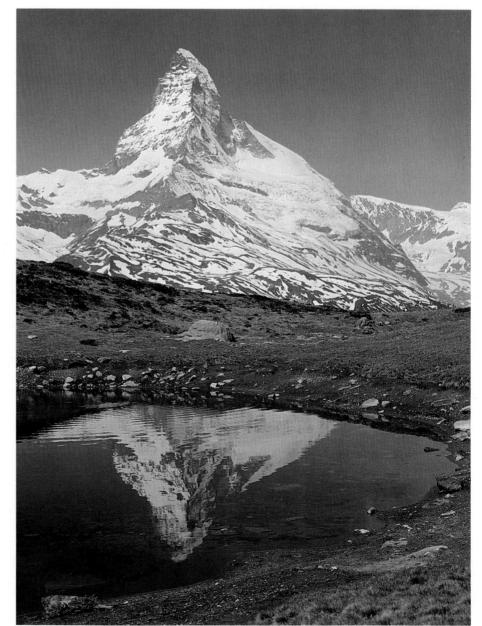

It's well-known that b&w infrared films penetrate haze to let you record distant scenes in less-than-clear atmospheric conditions. However, as this photo shows, when there's a blue sky and plenty of foliage, you can also create special and unusual images with such film. By printing an infrared image very dark, you can produce a very realistic moonlight effect.

Because you don't know what objects reflect infrared radiation, and to what extent, you can't predict precisely the effect you're going to get. However, blue sky will always record very dark and most foliage very light.

Estimating exposure is unreliable because you can't see the infrared reflected from the scene and because different types of scenes reflect it in very different amounts.

Making exposure-meter readings for infrared photography tends to be unreliable, too, because a meter's photocell is sensitive to visible light and not infrared. However, I have always used my meter in the normal way to get very acceptable results, as this photo shows.

Infrared film is sensitive to both visible light and infrared radiation. To get the desired effect, you must use a deep-red filter, such as a No.25, to absorb all but the red and infrared. When assessing exposure, remember to allow for the filter factor.

If you want to get similarly dramatic images without specially buying infrared film, try using normal panchromatic film and a deep-red filter such as the No.25. Your photos won't be as dramatic as pictures made with infrared film and foliage won't be lightened as much, but the effect will be somewhat similar. □

16

Location: Fremont River Valley, southern Utah
Time of Year: Autumn
Time of Day: Midday
Light Conditions: Direct sun from clear sky
Lens: Standard
Film: Kodak High-Speed Infrared
Filtration: No.25 (red) filter
Exposure Metering: See text

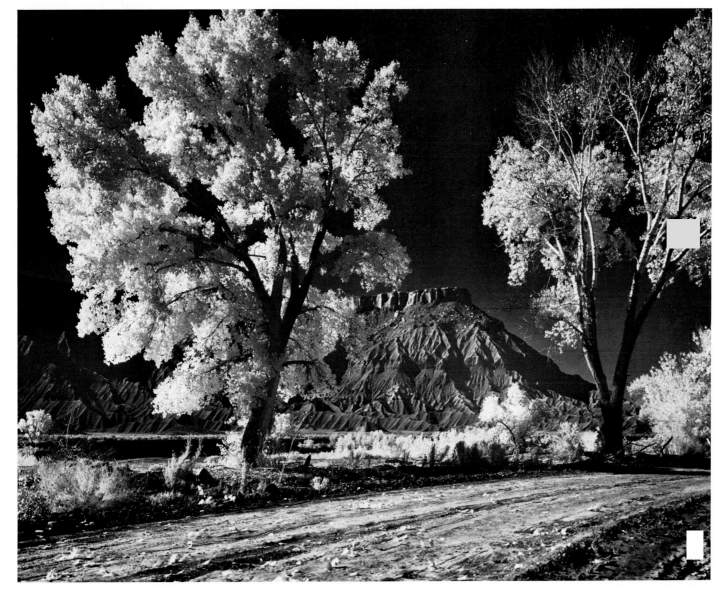

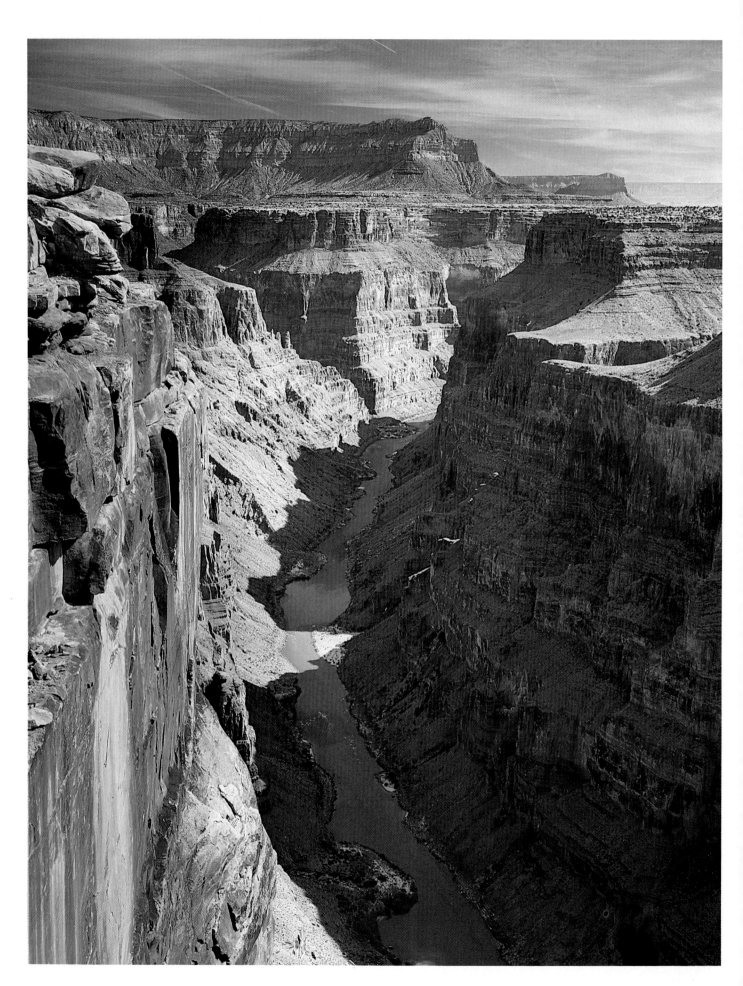

Location: North Rim, Grand Canyon, Arizona
Time of Year: Midsummer
Time of Day: Midday
Light Conditions: Clear sun
Lens: Standard
Film: Ektachrome 64
Filtration: Polarizing filter
Exposure Metering: Reflected-light reading from reddish rockface at left

At this, the narrowest section of the Grand Canyon, the width is about half a mile and the depth 3,000 feet.

The photo is a fine example of how it pays to wait for the right light. Notice the triangle of light on the river. It, together with a slight highlight on the canyon wall, is the only indication that a side canyon enters from the right side.

This lighting effect, which exists for only a few minutes each day, adds drama and dimension to the image. It also emphasizes the presence of the Colorado River, most of which is in deep shade. You can verify this by covering the triangle of light with a finger.

The scene had considerable contrast because one side of the canyon was in direct sunlight and the other in shade. The sunny cliff helped to reduce the contrast somewhat by acting as a natural reflector, directing some light toward the shaded side.

I reduced the contrast further by using a polarizing filter on the camera lens. This removed much of the surface reflection from the sunlit cliff. The result was a darker wall face with better color saturation and a total subject-brightness range that the film could record with detail.

The polarizing filter also darkened the sky, making the white clouds stand out more clearly.

My exposure-meter reading was made from the nearest thing I could find to an 18%-gray tonal value—the reddish rockface at left. □

Location: Place de la Concorde, Paris, France
Time of Year: Summer
Time of Day: After dark
Light Conditions: Floodlighting
Lens: Wide-angle
Film: Ektachrome 64
Filtration: Orange filter
Exposure Metering: Reflected-light reading of fountain area, including some sky

I took this photo from a low viewpoint for several reasons. First, I wanted to show the detail in the lower part of the fountain bowl. I also wanted to accentuate the fountain by making it appear as large as possible and outlining it against the dark sky. Because I knew the exposure would be several seconds, I needed a low viewpoint that concealed the light streaks of moving traffic as much as possible.

Notice, however, that I placed the camera high enough to record some of the water surface in the fountain.

Using a wide-angle lens not only enabled me to get this dramatic angle of the fountain but also gave me a close viewpoint that prevented traffic from passing between the fountain and me.

To retain the warm, yellow glow of the floodlights, I used daylight-balanced film rather than film balanced for tungsten light. I also used an orange filter as an added safeguard against a possible blue color shift caused by reciprocity failure at a 10-second exposure.

The exposure time had to be long enough to allow me to stop the lens down for adequate depth of field. I also needed an exposure of several seconds to produce some streaking in the moving water.

In making my exposure assessment, I allowed for the filter factor and reciprocity failure.

One final word of advice: When you want to photograph floodlit buildings and monuments in busy cities, avoid the rush hours! □

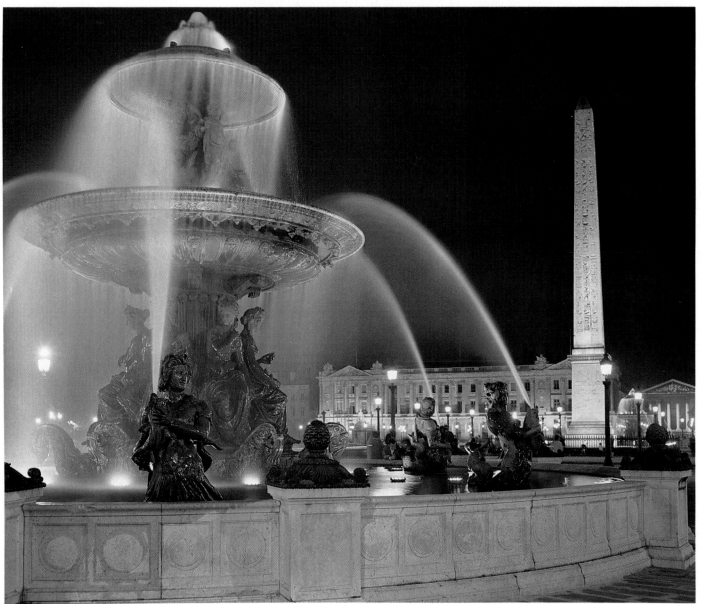

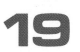

Location: Sonoran Desert, Arizona
Time of Year: May
Time of Day: 20 minutes after sunset
Light Conditions: Full moon; remaining glow of daylight in sky; flash on cactus blooms
Lens: Standard
Film: Ektachrome 64
Exposure Metering: Estimated moon exposure; metered ambient-light condition; used flash guide number

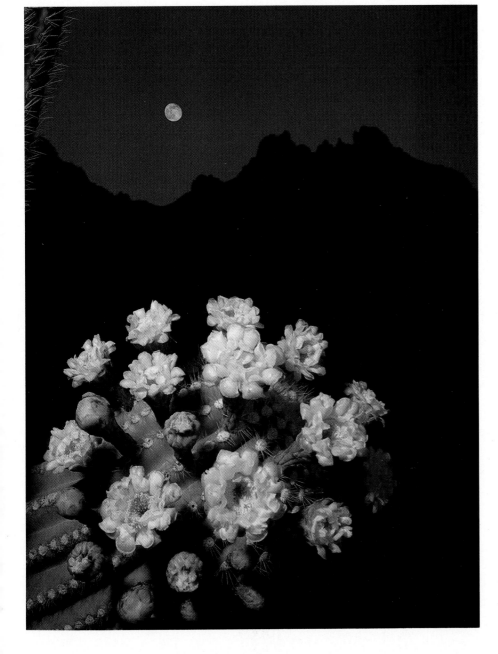

Although much of this photo is in silhouette, it contains three distinct planes—the nearby cactus, the mountain skyline and the rising moon. This gives the image a feeling of spatial depth.

I waited until it was dark enough to render the mountains in silhouette while the sky retained a glow of daylight. I needed a lens aperture of about *f*-11 to get enough depth of field. From past experience, I estimated that the moon would require an exposure of about 4 seconds at that aperture. My camera was on a tripod.

A meter reading of the mountain range confirmed that 4 seconds at *f*-11 would record that part of the scene in silhouette—the way I wanted it. In estimating the flash distance from the cactus, I used about two-thirds of the recommended guide number to compensate for the lack of surrounding reflecting surfaces outdoors.

Notice that the four-second exposure caused the moon to elongate slightly because of its movement during that time. For that reason, I don't recommend moon exposures longer than about five seconds.

Because the brightness of the remaining daylight was changing almost by the second, I had to make my exposure assessments and take the picture very quickly. □

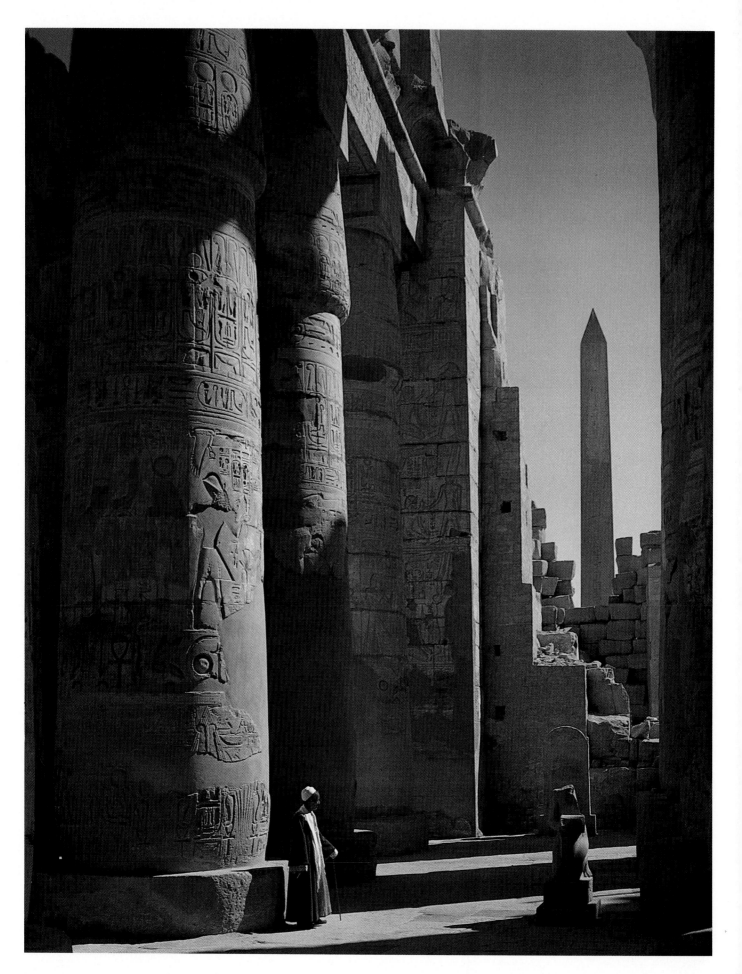

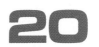

Location: Temple of Karnak at Luxor, Egypt
Time of Year: Spring
Time of Day: Midafternoon
Light Conditions: Direct sunlight from clear sky
Lens: Standard
Film: Ektachrome 64
Exposure Metering: Close-up reflected-light reading from nearest column, half highlighted area and half shadow area

This photo illustrates well that waiting for the right lighting can make the difference between a striking photo and a mediocre one.

The sun was shining from the right side at a vertical angle of about 45°. For just a few minutes, the sun was in the right place to create several favorable effects. The side light gave the nearest two pillars a rounded, three-dimensional look. At the same time, the lighting angle ensured good detail in the pillar engravings.

The alternating highlights and shadows on the ground provided foreground interest and indicated that there were similar pillars on the right side.

When you have a contrasty scene like this, people must be placed with care. I positioned the man in one of the shafts of sunlight, to "spotlight" him. I also asked him to stand in front of the shaded pillar so that the white he was wearing would make him stand out boldly from his background.

In addition to providing a pleasing composition, the man's presence served a second purpose: It helped to give the scene scale, providing the viewer who is not familiar with the location a sense of the structure's actual size.

I could have used a polarizing filter to darken the blue sky and make it appear more dramatic. However, I deliberately kept the sky light so that the obelisk would stand out more clearly.

In foreign countries, where you don't speak the language and are unfamiliar with local customs, traveling with a guided tour can be helpful. Local tour guides can help you to get people to pose for you. Sometimes the guide himself, in local costume, will pose for you. It may cost you a small fee, but it's well worth it for a picture you'll be proud of. □

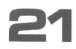

21

Location: Sequoia National Park, California
Time of Year: May
Time of Day: 11 a.m.
Light Conditions: Diffused sunlight through overcast sky
Lens: Standard
Film: Ektachrome 64
Exposure Metering: Separate reflected-light readings from bloom and near hillside; gave compromise exposure

There's a "rule" of composition stating that the main object of interest should not be in the center of the picture. I deliberately broke that rule to emphasize the nearby plant's isolation and the tranquility of the scene. You, the viewer, can determine whether my composition works or not.

I had to shoot this scene in soft, diffused light. Direct sunlight would have given a subject-brightness range too great for the film. The soft light enabled me to retain detail in the bright blooms as well as the dark trees in the distance.

The light haze gives the image a feeling of distance. The clouds that envelop the mountain impart a feeling of grandeur to the scene and emphasize its isolation. □

Snow is common in the high country that forms the rim of the Grand Canyon. It rarely reaches down to the low-lying areas, as it did when I took this photograph. When conditions like this exist, you must work fast with your camera. The snow usually doesn't stay long once the sun warms the canyon bed.

Mindful of the rarity of these conditions, I took more photos that morning than I normally would of one scene.

Without the snow, the relatively soft winter sunlight would not have given me a spectacular image, full of contrast and color. The snow helped to put sparkle into the picture. Contrast was enhanced by the alternation of snow on the ground with bare, vertical rockfaces.

I like to photograph snow scenes in which the trees are also covered with snow. This means I have to shoot soon after a snowfall. Wind and the warmth of the sun quickly remove the glistening, white adornment from the branches. □

Location: Grand Canyon, Arizona
Time of Year: Midwinter
Time of Day: 11 a.m.
Light Conditions: Direct sunlight from clear sky
Lens: Standard
Film: Ektachrome 64
Exposure Metering: Reflected-light reading of central area, not including sky

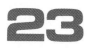

Location: Hohe Tauern
Mountains, Austria
Time of Year: Late June
Time of Day: Early morning
Light Conditions: Direct sunlight
from clear sky
Lens: Standard
Film: Kodachrome 25
Filtration: Ultraviolet (UV) filter
Exposure Metering: In-camera
meter measured scene as shot

This photograph shows the beginning of a bright, clear day in the Austrian Alps. The Grossglockner, Austria's highest mountain, is on the left.

In addition to the light haze in the air, the morning mist covering the valley on the left enhances the sense of distance.

When mountain tops reach out above a sea of mist, their grandeur is accentuated just as much as when their peaks are hidden in clouds. Use both of these conditions to get spectacular mountain pictures.

Valley haze is not caused by moisture alone. People in this alpine area burn wood fires that often cause a smoky haze.

A lot of ultraviolet radiation is present at high altitudes. I used an ultraviolet (UV) filter to hold back the UV and prevent the photo from becoming too blue. A UV filter has little other effect on photos, and many photographers leave one on the camera lens at all times as protection from physical damage to the lens. □

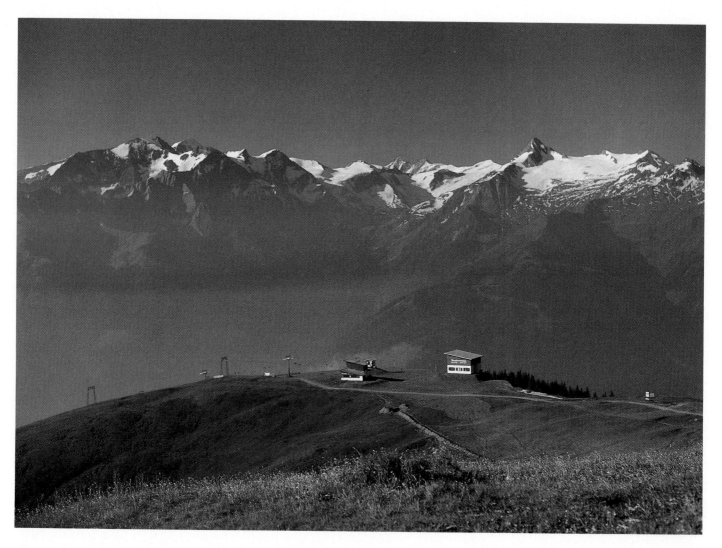

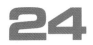

Location: Ruins of Betatakin,
Navajo National Monument,
northern Arizona
Time of Year: Summer
Time of Day: Midday
Light Conditions: Direct sunlight
from clear sky
Lens: Standard
Film: Kodak High-Speed Infrared
Filtration: No.25 (red) filter
Exposure Metering: See text

I wanted to depict this scene by moonlight. However, exposure by moonlight would be so long that all shadows would be blurred and fuzzy. I wanted to record sharp shadows. So I cheated a little—I used b&w infrared film, together with a deep-red No.25 filter.

This enabled me to record only the red and infrared part of the spectrum. The blue sky at the left recorded as black. So did the shadows because such light as they contained was blue, reflected from the deep-blue sky.

I made a reflected-light exposure-meter reading from the lower half of the scene and exposed accordingly, allowing for the filter factor. I made a contrasty print of the negative. I think you'll agree that the moonlight effect is pretty convincing—at least until you notice the sharp shadows. They betray the fact that the exposure was only a fraction of a second—an impossibility with moonlight!

For more information on exposure with infrared film, see the text with portfolio image number 16. □

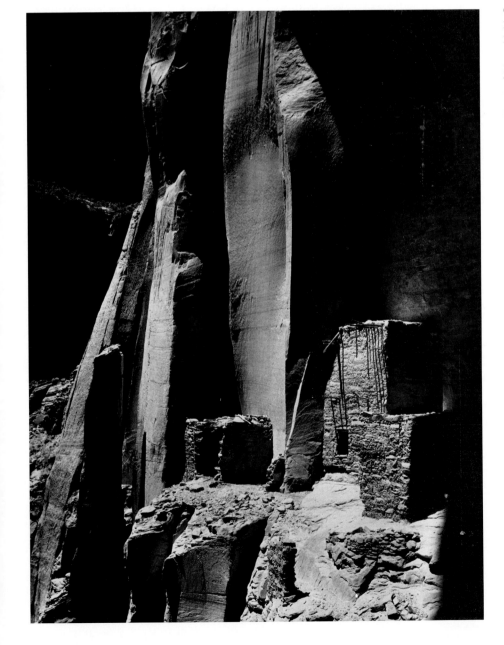

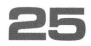

Location: San Francisco Peaks, near Flagstaff, Arizona
Time of Year: June
Time of Day: Midday
Light Conditions: Direct sunlight
Lens: Standard
Film: Ektachrome 64
Exposure Metering: Reflected-light reading of entire scene, including field, mountains and clouds

Your eyes naturally follow the pattern of yellow flowers as they become apparently smaller, receding into the distance. This leads your attention to the mountains.

The sun was high in the sky and just behind me. It provided uniform, shadowless lighting on the field.

The clouds served two purposes. First, they added apparent height to the mountain peaks they enveloped. Second, the shadows they caused reveal some of the contours of the mountains, giving them a three-dimensional appearance.

Notice that I did not contain the image within a natural frame on either side. I wanted the viewer to get the impression that the same scene continues a long way beyond the picture's edges.

I had to use a shutter speed fast enough to prevent the flowers from blurring as they waved in a light breeze. However, the light was bright enough to also enable me to use a small lens aperture. This ensured that the entire image, with the exception of the closest flowers on the left, was in sharp focus.

With the sun overhead and behind me, and air that was clean and unpolluted, the sky in front was dark enough not to need further darkening with a polarizing filter. The clouds stood out nicely from the blue sky. □

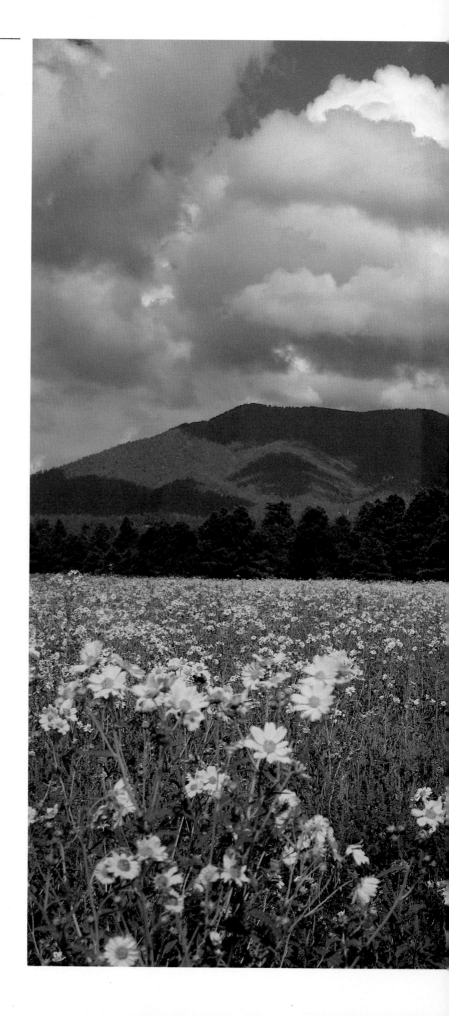

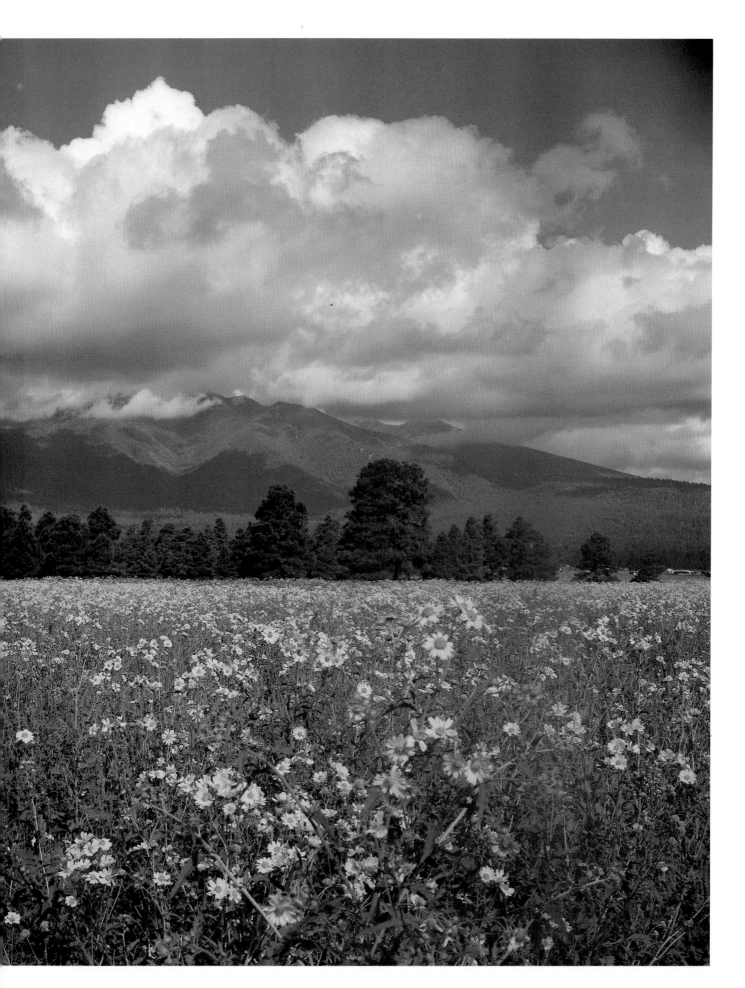

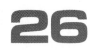

26

Location: Havasu Falls, Havasupai Canyon, Arizona
Time of Year: April
Time of Day: Noon
Light Conditions: Direct sunlight
Lens: Standard
Film: Ektachrome 64
Exposure Metering: Reflected-light reading of lower two-thirds of scene

I wanted to add human interest to this scene. Fortunately, my companion and I were on horseback. I think the horse adds something extra to the image. Perhaps it's because a standing person would have added just one more vertical element to a picture that's already dominated by vertical components—the falling water and the tree.

I selected the lighter of our two horses for the photograph. The dark one would have contrasted too strongly with the white water. The light one harmonizes with it.

The highlighted tree on the left frames the waterfall nicely and directs your attention toward the waterfall.

I wanted to give an exposure time long enough to streak the falling water. A shutter speed of 1/250 second, or even 1/60 second, would have been too fast and would have "frozen" the water in midair. I placed my camera on a tripod and exposed for 1/8 second.

A word of warning: You can expose falling water for too long, too. For example, an exposure time of one or two seconds would have recorded too much water on the film. The result would have been two solid-white sheets of water without any detail or texture. □

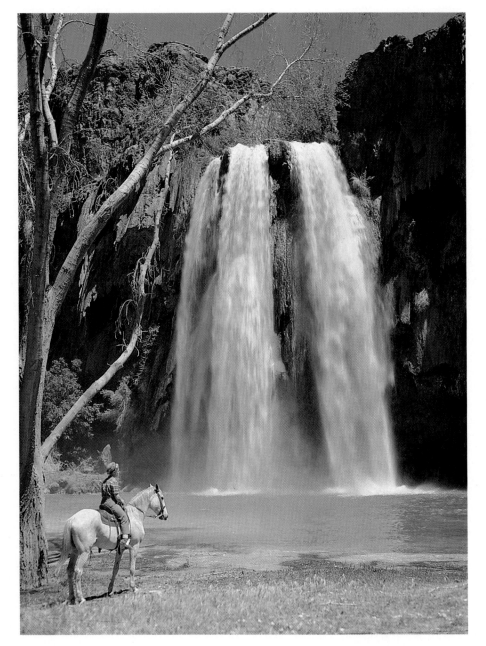

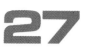

This is a fine example of natural framing. The foreground trees form an arch over the distant group of poplars and the mountain peak. Placing the arch—and the main point of interest—off center provides a more attractive, dynamic composition than central placement would.

The foreground trees and overhanging foliage served a second purpose: I used them to conceal most of the sky, which on that day did not contain spectacular cloud formations. The same technique is useful when the sky is totally overcast and gray.

There was enough haze to provide a sense of distance between the foreground and the mountains. This was enhanced by the color contrast between the blue haze and the yellow foliage.

I waited for side light. It helped to make this image a success in several ways: It highlighted the foreground foliage, made the distant poplars stand out against the shaded mountainside, and provided highlights and texture in the large tree trunks on the left side of the image. □

Location: Owens Valley, California
Time of Year: Autumn
Time of Day: Early afternoon
Light Conditions: Direct sun; blue sky overhead; light clouds over mountains
Lens: Standard
Film: Ektachrome 64
Exposure Metering: Reflected-light reading of lower-right area, including bright foreground foliage, a bit of sky

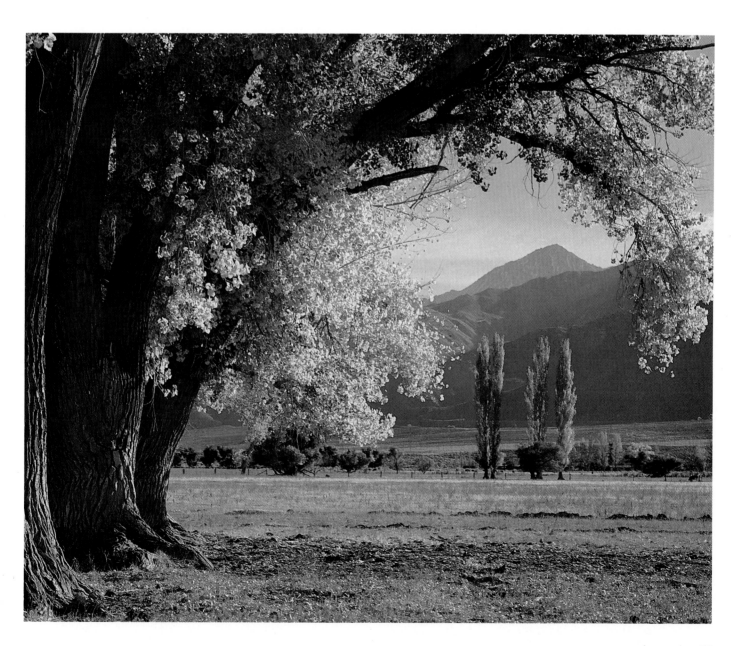

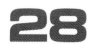

Location: Mount San Jacinto, near Palm Springs, California
Time of Year: Spring
Time of Day: Morning
Light Conditions: Direct sunlight from clear sky
Lens: Standard
Film: Ektachrome 64
Exposure Metering: Reflected-light reading of scene as photographed

These three photos illustrate how a slight change in viewpoint can make a great difference in a picture. The mountain range looks similar in each photo because it is seen from approximately the same angle. However, the foregrounds are very different.

By choosing different viewpoints, using different lenses, framing some images horizontally and others vertically, and selecting different kinds of foreground, you can produce a wide variety of photographs of the same basic subject.

These photos were taken in different years and at different times during spring. That's why the coloration of the terrain is not identical.

For the photo at the top of the next page, I used a polarizing filter. In this case, its main purpose was not to darken the blue sky, which was already dark enough. The filter eliminated surface reflections from the rocks in the foreground, giving them more detail and color. □

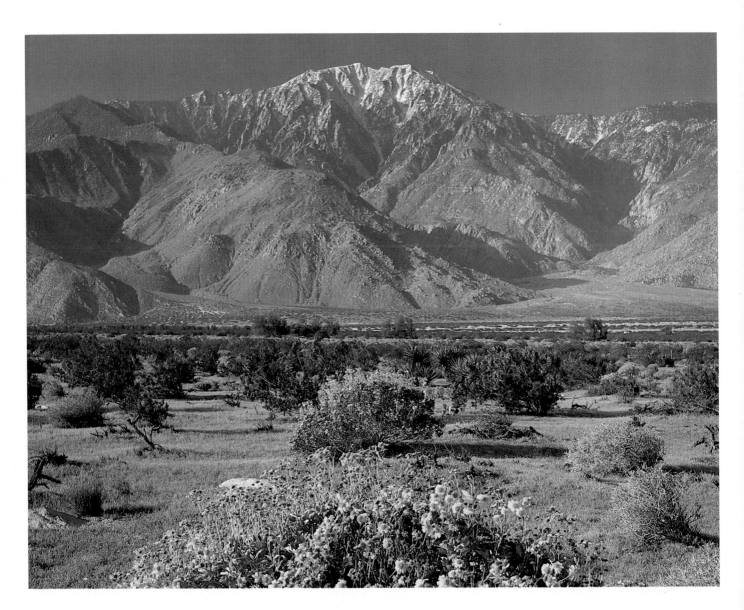

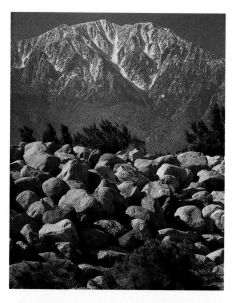

Location: Mount San Jacinto, near Palm Springs, California
Time of Year: Spring
Time of Day: Morning
Light Conditions: Direct sunlight from clear sky
Lens: Short telephoto
Film: Ektachrome 64
Filtration: Polarizing filter
Exposure Metering: Reflected-light reading of scene as photographed

Location: Mount San Jacinto, near Palm Springs, California
Time of Year: Spring
Time of Day: Morning
Light Conditions: Direct sunlight from clear sky
Lens: Standard
Film: Ektachrome 64
Exposure Metering: Reflected-light reading of scene as photographed

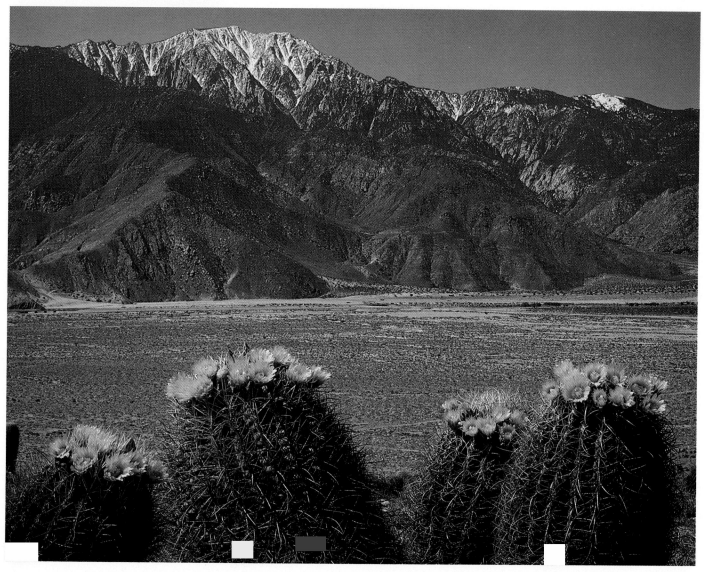

Location: Bamiyan Valley, Afghanistan
Time of Year: April
Time of Day: Late afternoon
Light Conditions: Direct sun at low angle
Lens: Standard
Film: Ektachrome 64
Exposure Metering: Reflected-light reading of scene as photographed

The long arch of trees forms a large frame that directs viewer attention to the two men. To emphasize the symmetry of the scene, I used a central, balanced composition. Notice, however, that I placed the men a little off-center, to make the image more dynamic.

A feeling of distance is conveyed effectively by the apparently converging road and the receding trees, which are highlighted by low sunlight from the left side. The horizontal shadows of the trees appear thinner toward the distance, echoing the decrease in apparent size of the trees themselves.

At the time of my visit, tourists were not uncommon in this area of Afghanistan. In such places, local people expect to be photographed and usually cooperate. □

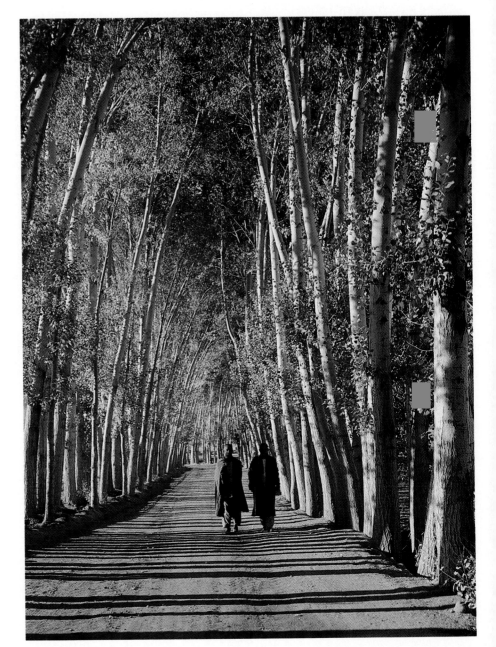

Location: Kaibab Suspension Bridge over the Colorado River, Arizona
Time of Year: May
Time of Day: Afternoon
Light Conditions: Direct sunlight
Lens: Standard
Film: Ektachrome 64
Exposure Metering: Reflected-light reading included bridge, river and distant cliff

This picture reflects the central composition of the one on the previous page. However, this one was much more hazardous to take! To reach my vantage point, I first had to climb up the rockface and then descend onto the structure of the bridge.

Mule teams use this bridge daily to cross the Colorado River. I thought it essential to have some human interest in the picture. Consequently, I waited for a pair of travelers to arrive and reach the part of the bridge most favorable from a compositional standpoint.

I could have shot the bridge much more easily from the side and at a lower angle. However, the viewpoint I went for, aiming down at the muddy river, was much more dramatic.

In a scene like this, it's easy to be tempted to use a wide-angle lens to make the bridge appear as long as possible. However, this can be overdone. I used my standard lens. Had I used a wide-angle, the near end of the bridge would have appeared from almost a vertically downward angle. This would have given the image a disturbingly distorted look. □

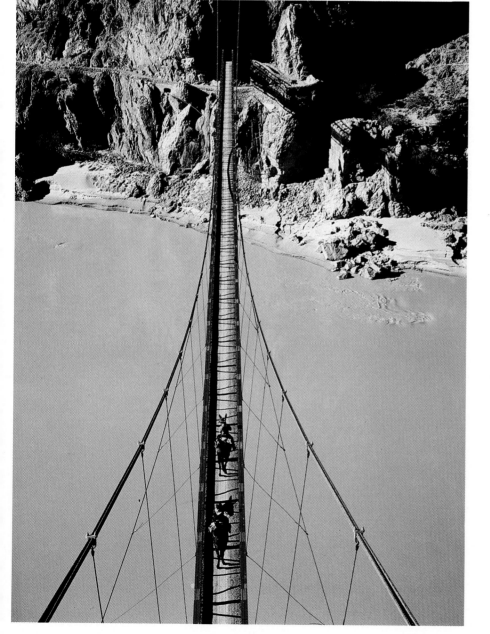

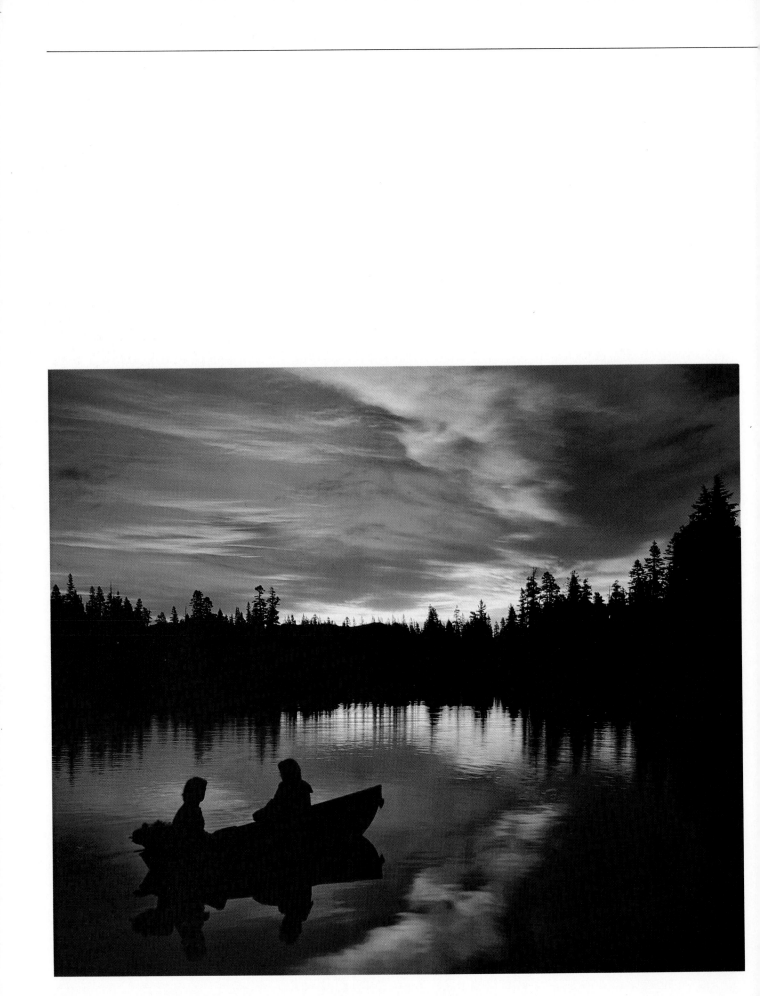

Location: Kirkwood Lake, Sierra Nevada, California
Time of Year: Late June
Time of Day: After sunset
Light Conditions: Light from glowing sky after sunset
Lens: Standard
Film: Ektachrome 64
Exposure Metering: Reflected-light reading from brightest part of sky, trees and water reflection

A silhouette is recognizable only by its outline. Therefore, it is important to position subjects like the boat and its occupants in a way that clearly shows what they are. If I had shot the boat from behind, the outline would probably have been meaningless.

I composed the image so the heads of the two people were not lost in the silhouetted trees and their reflections were not cut off at the bottom of the picture. I also made sure the entire silhouette was outlined sufficiently by light so as not to be partially obscured.

Although I wanted people in the scene, I didn't want action that would disturb the tranquility. Therefore, I chose two people doing nothing rather than, for example, a fisherman at work.

The sun had set and the only illumination that remained came from the glow in the sky near the horizon. This gave a very contrasty image that the film could not possibly record in full detail. In this case, that was exactly what I wanted. It enabled me to produce the silhouetted outlines.

"Correct" exposure of the scene as I metered it would have resulted in too bright an image. I closed the lens down by an additional *f*-stop to get the dark, dramatic effect and the color saturation shown here.

Notice how I used the dark trees and their shadows to frame the image on the right side.

Lighting conditions after sunset change very fleetingly. It helps to have some idea of what you want before the most suitable lighting occurs. Prepare everything you can. Then, when everything looks right and the light is ideal, work fast. □

Location: Bryce Canyon National Park, Utah
Time of Year: Summer
Time of Day: Midmorning
Light Conditions: Direct sunlight
Lens: Standard
Film: Kodak Plus-X Pan
Filtration: No.8 (yellow) filter
Exposure Metering: Reflected-light reading of central part of scene

This is a fine example of natural image framing. Without the tunnel view through the rock arch in the foreground, the image would lose much of its three-dimensional effect.

To make the two men stand out clearly, I placed them in front of a background of uniform tone. Notice also that, although both are standing, I made sure they were at unequal heights. This nearly always makes a composition more pleasing. The men are looking into the picture area, which helps direct the viewer's attention there also.

The sunlight was harsh and would normally have caused deep shadows. However, the bright surrounding terrain acted as an efficient series of reflectors that lightened the shadows and reduced overall contrast. The result is an image with detail through the entire tonal range.

I used a No.8 yellow filter to darken the sky and make the white clouds stand out more clearly. □

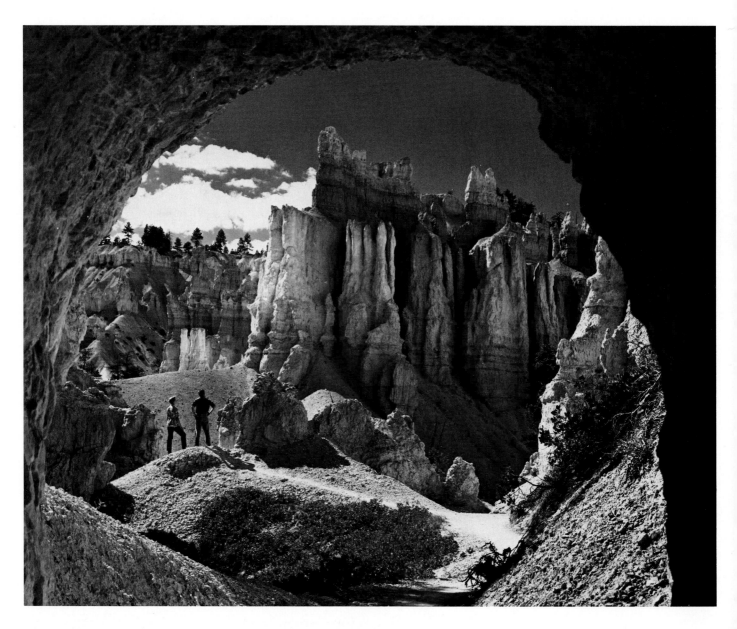

Not all landscape photography need be of grand scenes. Flowers are as much a part of landscapes as are mountains and waterfalls. Close-ups can produce very attractive, detailed images, as this photo shows.

The image has a brilliance derived from good color contrast between the blue-purple and the green and tonal contrast between highlight and shadow areas.

I used a moderately large lens aperture that placed the somewhat "busy" background slightly out of focus. This helps to keep your atten-tion on the flowers.

Flowers outdoors are nearly always moved by a slight breeze. To prevent blurred images, I recommend a shut-ter speed no slower than 1/60 second when the air seems calm. When flow-ers are waving lightly, shoot at no slower a speed than 1/250 second. When in doubt, use a 1/500-second or even a 1/1000-second shutter speed. Fortunately, you often want to use a medium-to-wide lens aperture to limit depth of field, so that fast shutter speeds are easy to attain. □

Location: Point Reyes National Seashore, California
Time of Year: Spring
Time of Day: Midday
Light Conditions: Direct sunlight
Lens: Standard
Film: Ektachrome 64
Exposure Metering: Close-up reflected-light readings of the blooms

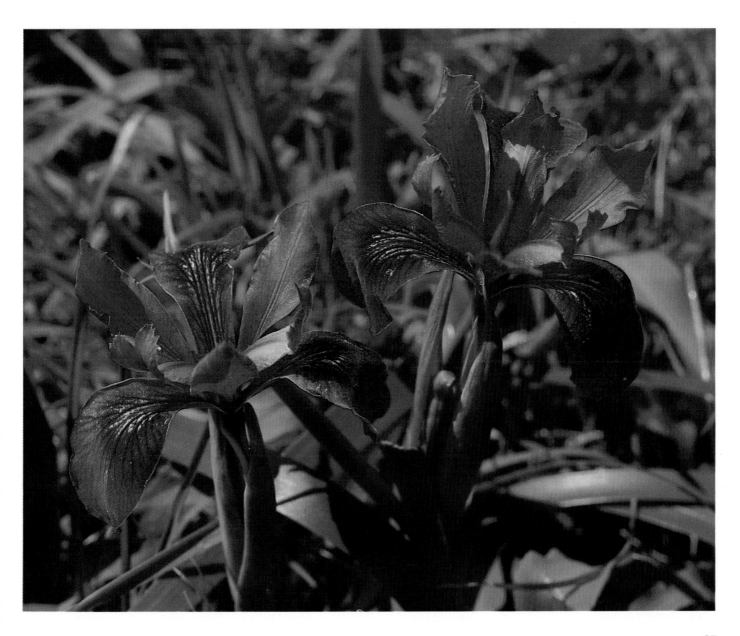

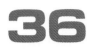

36

Location: Lauterbrunnen,
Switzerland
Time of Year: Spring
Time of Day: 9:30 a.m.
Light Conditions: Heavy overcast;
low clouds
Lens: Standard
Film: Ektachrome 64
Exposure Metering: Reflected-
light reading of mountains and
sky, little of foreground

The village of Lauterbrunnen lies in a deep valley surrounded by massive mountain peaks. This kind of terrain features many varied weather and atmospheric conditions. Often, the most spectacular displays of snow, clouds, mist, rain—and, yes, sunshine, too—occur unexpectedly and fleetingly. If you're prepared, you can take advantage of them and take fine photographs.

I don't normally like black and white areas in my color photographs of landscapes. In this picture, however, the graphic black-and-white of the church contrasts effectively with the subtle gray tones of the distant scene.

By widening the tonal range of an otherwise flat scene in this manner, you can often give an image added "snap" or impact without affecting the basic prevailing atmosphere. However, I recommend that you generally keep the high-contrast areas fairly small.

To emphasize the height and grandeur of this scene, I framed the image vertically. The pointing spire of the church adds to the effect.

When clouds swirl, it's often worth staying around—with your camera ready—until the most spectacular effects occur. The totally cloud-enveloped mountain peaks would have made a dramatic photo. However, it was worth waiting for this moment, when the clouds broke to reveal the mountain both below and above them.

Don't just wait for the one ideal picture, however. You can't predict what is going to happen. Keep shooting—but don't miss the very best opportunities. To ensure this, you must stay alert.

In this scene, the foreground was of secondary importance. Exposure had to be based on the distant scene, even if foreground detail went a little dark. I metered the upper two-thirds of the scene and exposed accordingly. Exposure for the foreground would have resulted in an excessively bright, and disappointing, mountain scene.

When I look at this picture, I can almost feel again the cool mountain wind and the moisture in the air. If the viewer feels a little of this, too, the picture is a success. □

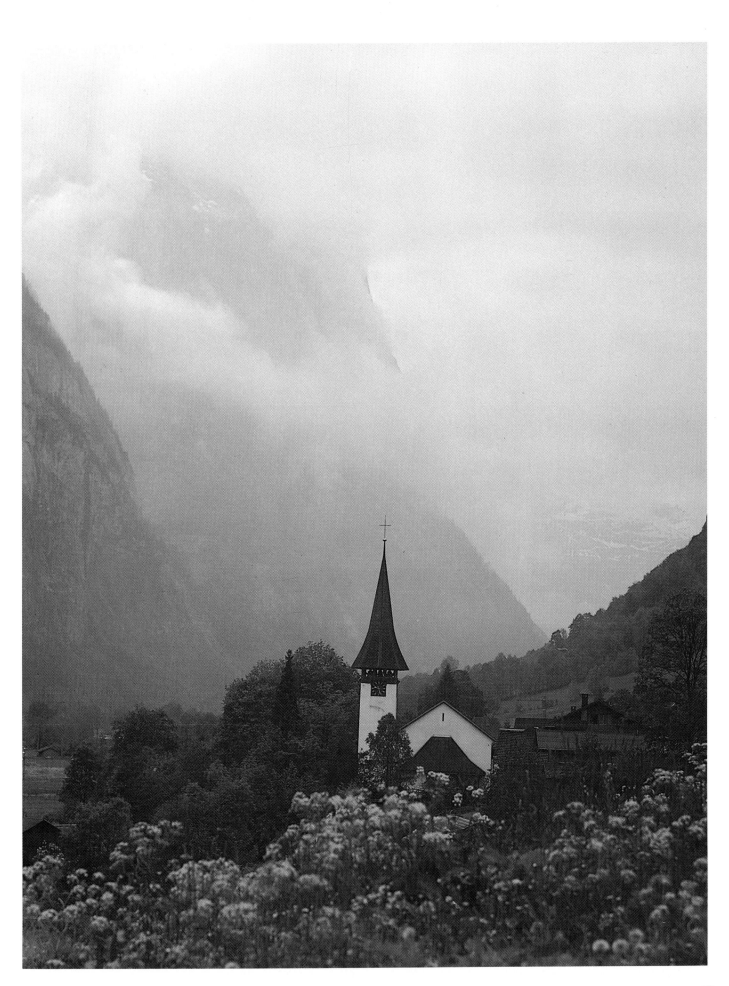

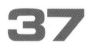

37

Location: Sonoran Desert, southern Arizona
Time of Year: Late April
Time of Day: Midday
Light Conditions: Direct sunlight
Lens: Standard
Film: Ektachrome 64
Exposure Metering: Reflected-light reading of area photographed

Successful photography of desert blooms is largely a matter of wise selection. Most blooms look pretty. However, the way they are located and clustered on the plant makes some more photogenic than others.

Be selective. When you see a cluster of blooms that looks suitable, move around it critically. Evaluate every angle to see which viewpoint—if any—lends itself to making a fine image.

If you find a bloom that's ideal for photography, don't delay in shooting it. Each flower lasts for only a few days and may look its best for an even shorter time. However, new blossoms keep appearing for an extended period of time. For example, prickly pear cacti such as the one shown here bloom for about four weeks.

The flowers I selected to photograph are all healthy-looking and grouped in an attractive manner. Notice also how unopened buds at the top crown the image. Because I wanted the immediate background area rendered with reasonable sharpness, I used a small lens aperture for extended depth of field. Remember that when you shoot close-ups, depth of field is always limited.

Close-up photography of flowers represents one of the few cases of outdoor photography for which direct overhead sunlight is ideal. Midday sunlight enabled me to produce this bright, evenly lit image. □

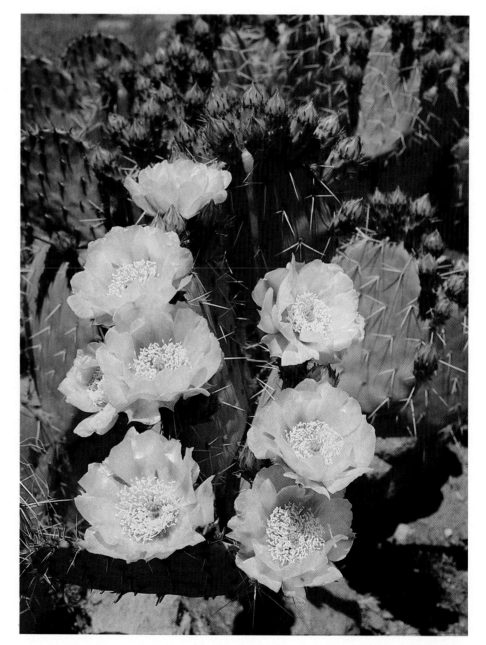

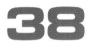

Relatively short caravans of camels, like the one shown here, still follow the same ancient trade routes used by mile-long camel trains long ago.

The receding line of camels and the road winding into the distance give this image a convincing three-dimensional look. The effect is further enhanced by the advancing shadows, caused by back lighting on the man and his camels.

Notice how much detail is visible on the front of the man and the animals in spite of the back lighting. That's because the bright ground acted as a very efficient reflector, throwing a lot of light into the shadows.

In different circumstances, I might have darkened the sky with a polarizing filter. However, in this case the sun was just out of view beyond the right edge of the picture area, causing the sky to appear brighter on the right side than on the left. This unevenness would have been even more marked had I used a polarizing filter. Therefore, I decided to shoot without it. □

Location: Hindu Kush, Afghanistan
Time of Year: April
Time of Day: Midday
Light Conditions: Direct sunlight
Lens: Standard
Film: Ektachrome 64
Exposure Metering: Reflected-light reading of area around camel train, with no sky

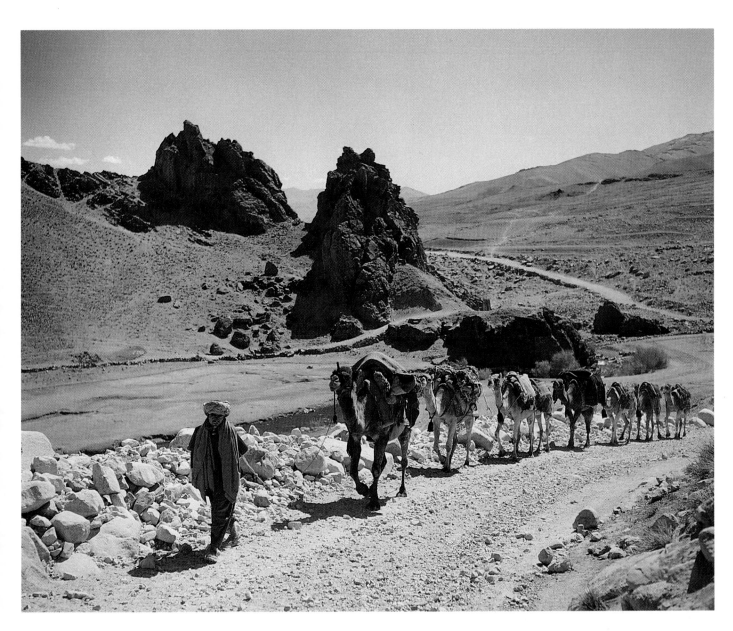

39

Location: Near Darjeeling, West Bengal, India
Time of Year: Summer
Time of Day: Midday
Light Conditions: Direct sunlight through light haze
Lens: Standard
Film: Ektachrome 64
Exposure Metering: Reflected-light reading of area photographed

This is a good example of a monochromatic color picture. Almost everything in the scene is green. However, because there is a variety of shades, textures and patterns, the image keeps your attention and interest.

The brightest green is in the foreground. The slope in the mid-distance is darker, while the farthest area is only partially green. This gradual reduction in the impact of the green helps to create the illusion of spatial depth in the photo.

The tea pickers on this plantation in Darjeeling not only bring life to the picture, but also show an authentic activity.

Having the women at different distances from the camera helped to enhance the feeling of distance. Their diagonal placement complements several other diagonal lines in the composition.

The direct sunlight was veiled by a slight haze. This gave me distinct shadows and good contrast and yet some detail in the shaded areas of the tea pickers.

The women and I didn't speak a word of each other's languages. Nonetheless, I asked them whether they minded being photographed, directed them to take up the positions shown and asked them to continue at their work—all with simple sign language. I have communicated with people in many parts of the world in this manner. Simple gestures of hands and head seem to comprise a universally understood language. □

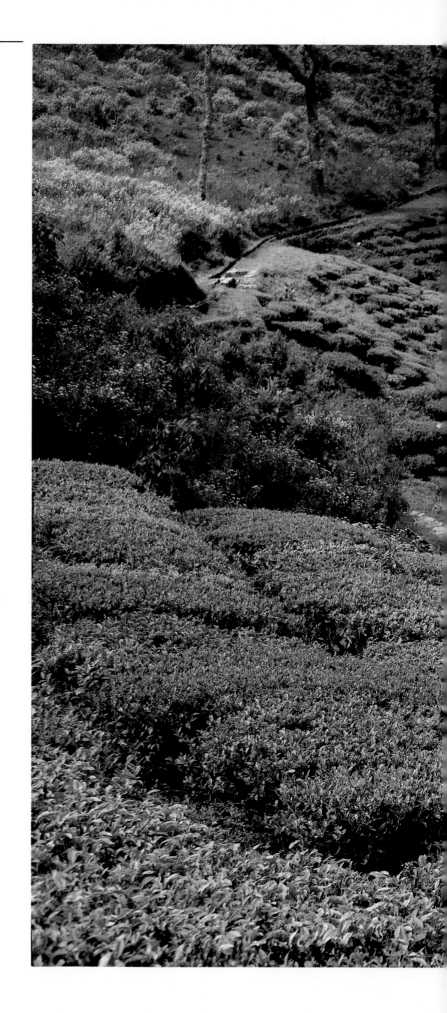

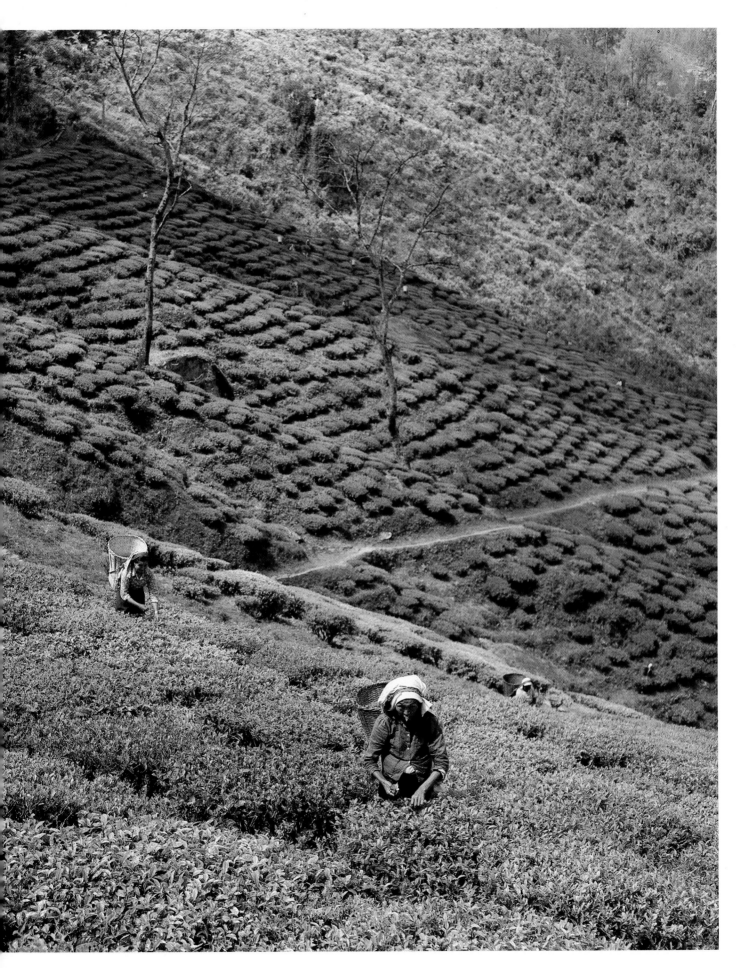

40

Location: Sonoran Desert, southern Arizona
Time of Year: August
Time of Day: Midday
Light Conditions: Direct sunlight
Lens: Standard
Film: Ektachrome 64
Exposure Metering: Reflected-light readings of flowers close up and of distant cactus and sky

I wanted to shoot a close-up view of this blooming barrel cactus and at the same time show some of its typical environment. By keeping the barrel cactus low in the picture, I was able to show the desert scene behind it. A cholla cactus, against a background of blue sky with some fluffy clouds, completed the composition.

I took a close-up reflected-light meter reading of the blooms on the barrel cactus. A second reading, of the cholla and the sky behind it, indicated the same exposure, which I used to take the picture.

The red blooms and blue sky give the image a pleasing color contrast. Because red tends to advance toward the viewer and blue to recede, as described in the essay on *Creative Color Control,* page 24, this arrangement also enhances the feeling of distance in the photograph.

As is so often the case with flower photography, overhead, midday sunlight gave me the illumination I wanted. □

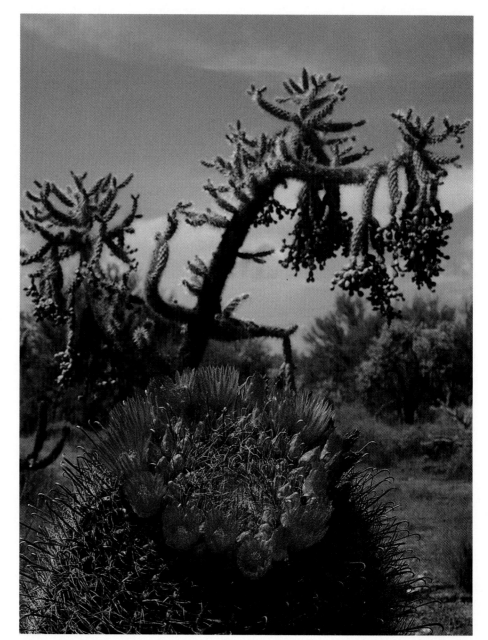

Location: Santa Barbara, California
Time of Year: Autumn
Time of Day: Early afternoon
Light Conditions: Hazy sunlight
Lens: Standard
Film: Ektachrome 64
Exposure Metering: Reflected-light reading of scene as photographed

This photo does not show any recognizable scene, and yet anyone who has ever experienced the rich colors of autumn foliage will readily associate with it.

Depending on where you live, or where you like to visit at that time of year, this may represent Vermont, Minnesota, Arkansas, Virginia or one of hundreds of other places. Actually, I took this photo right in my own back yard in Santa Barbara, California.

You can shoot pictures like this in one of two ways. You can either look around until you find a composition that pleases you or you can move the leaves about until you have an arrangement you like. If you move leaves around, beware of *overarranging* them. You still want them to look as if they have fallen naturally.

To get a pattern in which the leaves are of uniform size, shoot straight down. This also helps you get the entire subject area in sharp focus.

Be sure the area you are photographing is lit uniformly. Sunlight gives the best color saturation. However, to avoid harsh shadows, sunlight through a light haze or thin cloud layer is ideal. Also, be sure your own shadow doesn't appear in the picture area. □

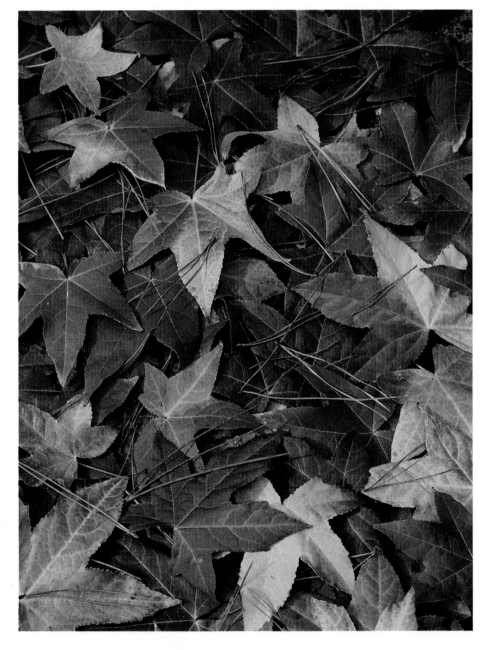

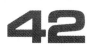

42

Location: Dal Lake, Vale of Kashmir, India
Time of Year: Spring
Time of Day: Midmorning
Light Conditions: Direct sunlight
Lens: Standard
Film: Ektachrome 64
Exposure Metering: Reflected-light reading of foreground only, not mountains

Houseboats provide accommodation for the many visitors to this popular lake resort in the foothills of the Himalayas. I took this photo from such a houseboat. Others are visible on the left side of the image. The gondolas are the only means of transportation for visitors and natives alike.

I waited for two gondolas to come into a position that would complement and strengthen the diagonal line of the narrow, green island nearby.

A distinct haze is visible in front of the distant mountains. To be convincing, such haze should be as light in the picture as it looked in the scene. Beware of taking exposure readings from distant hazy scenes and giving the exposure your meter indicates. If you do, the haze will record too dark and the atmosphere and feeling of distance may be destroyed. □

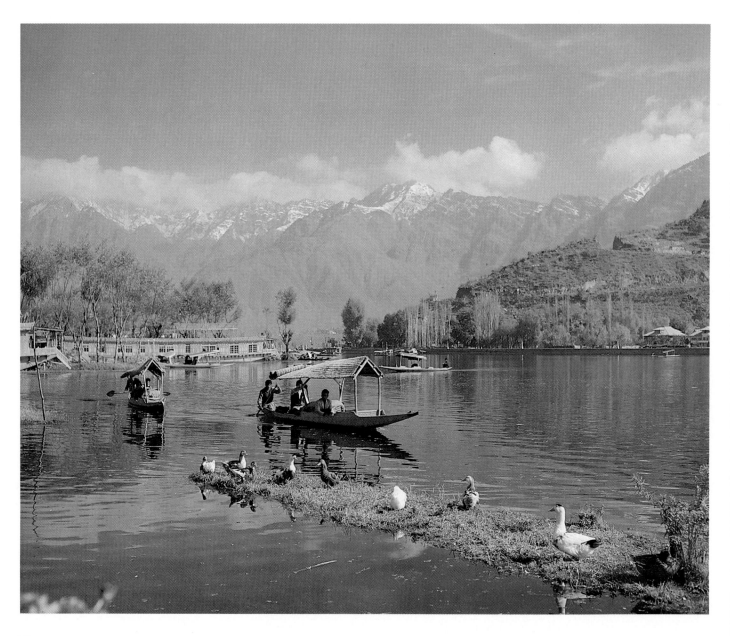

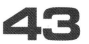

This is another effective monochromatic color photograph. To emphasize the uniform reddish color of the scene and give the impression that it surrounds you, I avoided all other colors, including even the blue sky.

Direct sunlight from the left was ideal. It emphasized the texture of the rugged scene. Notice also how the horizontal shadows of the men help to unite them visually. This is a good example of how shadows can play an important part in image composition.

I posed the three men carefully and yet their attitudes seem perfectly natural. Notice that there is eye contact between them. This can also often be used as an effective compositional technique.

Incidentally, the central figure was our tour guide. He asked the other two to pose with him for me. Without his help, I probably would not have been able to make such an effective picture at this location. □

Location: Ancient Thebes, Egypt
Time of Year: Autumn
Time of Day: Midmorning
Light Conditions: Direct sunlight
Lens: Standard
Film: Ektachrome 64
Exposure Metering: Reflected-light reading of scene as photographed

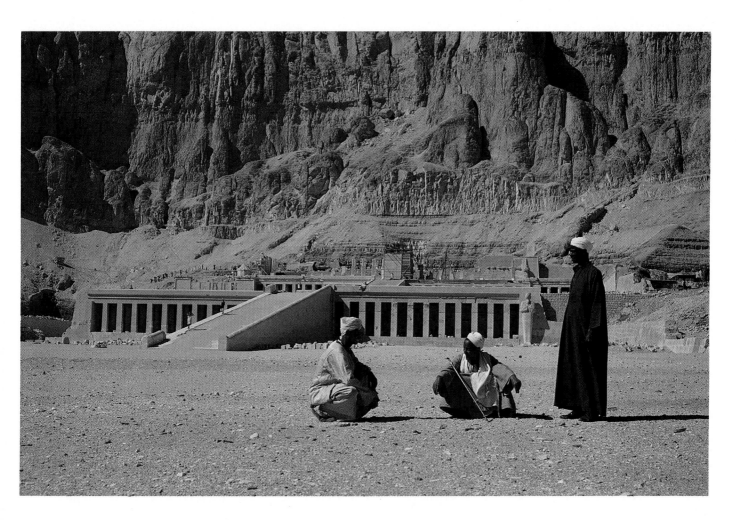

44

Location: Mission Rancho de Taos, New Mexico
Time of Year: May
Time of Day: 11 a.m.
Light Conditions: Direct sunlight
Lens: Standard
Film: Ektachrome 64
Filtration: Polarizing filter
Exposure Metering: Reflected-light reading from sunlit ground

This photo is a good example to show you how I use my exposure meter. I took a reading from the sunlit ground. I didn't do this because that was the most important part of the scene, because it obviously wasn't. I did it because the ground had an approximate 18% gray tonal value. By giving the exposure the meter indicated, I got a well-exposed image.

I also took a meter reading from the sunlit building. It indicated half the exposure given by the reading from the ground. That's because the building's wall was about twice as bright as the ground. If I had exposed the building as the meter indicated, it would have been as dark as the ground—an equivalent of 18% gray. For correct exposure, I had to give twice the exposure the meter indicated for the building.

I used a polarizing filter to darken the blue sky. The filter also increased the color saturation in the building and arch. This filter has a factor of about 4X, so I increased the indicated "correct" exposure by another two *f*-stops.

I wouldn't normally darken the sky to the extent I did in this picture. The purpose here was to make the bright arch, mission and crosses stand out dramatically.

This picture is also a fine example of image framing. Here, I was able to use one major component of the subject to frame another. □

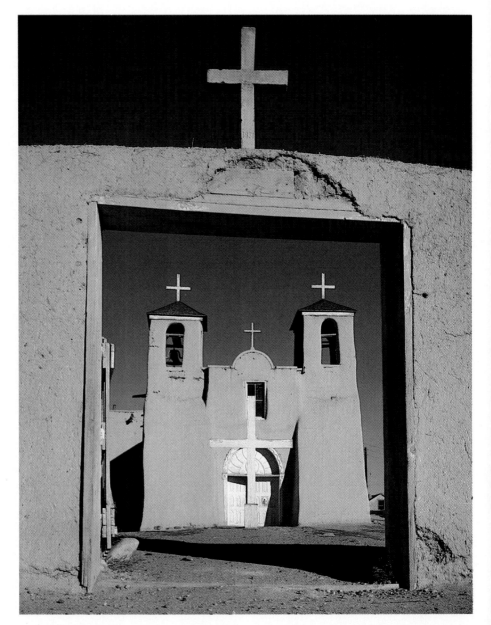

This is essentially a skyscape. If it hadn't been for the sunlight filtering through the clouds to give the sky this dramatic appearance, I certainly wouldn't have photographed the scene.

Fortunately, saguaro cacti are easily recognizable in silhouette. Even so, I positioned my camera carefully to show their outlines at their best.

The sky consisted of sunlit clouds, dark clouds and some patches of blue sky. To darken the blue sky and make the bright clouds stand out more clearly, I used a No.8 yellow filter.

I took a reflected-light meter reading from the sky. The area I read appeared to average to an approximate equivalent of 18% gray. There were a few small but bright patches in the sky that I knew would lead to slight underexposure if I followed the meter reading. However, because I wanted the scene a little dark for added dramatic effect, I exposed exactly as the meter indicated. □

Location: Valley of the Sun, near Phoenix, Arizona
Time of Year: Spring
Time of Day: Soon after sunrise
Light Conditions: Sun behind dark clouds near horizon
Lens: Standard
Film: Kodak Plus-X Pan
Filtration: No.8 (yellow) filter
Exposure Metering: Reflected-light reading from sky in right half of scene

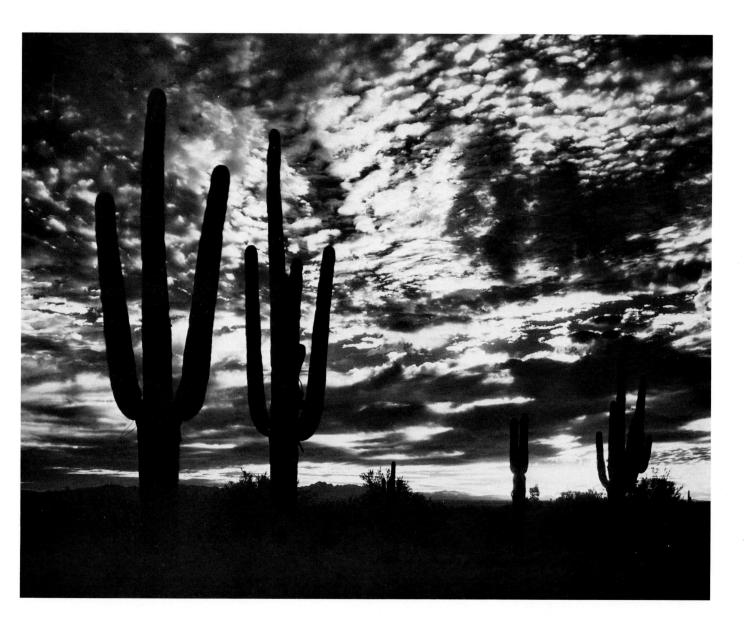

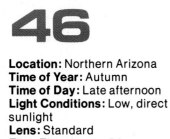

46

Location: Northern Arizona
Time of Year: Autumn
Time of Day: Late afternoon
Light Conditions: Low, direct sunlight
Lens: Standard
Film: Ektachrome 64
Exposure Metering: Reflected-light reading of sunlit scene without deer

When I spotted this Rocky Mountain mule deer emerging from the woods near me, I had the standard lens on my camera. I didn't want to retreat to change to a telephoto lens because I felt sure the deer wouldn't stay around long enough. So I chose the alternative—to get as close to the animal as I could as quickly as possible.

I had to move slowly and very quietly. As I approached the deer, I made a quick meter reading from the golden grassy area in front of me. I set the exposure accordingly, at 1/250 second at ƒ-5.6.

I focused at about seven feet and then made an effort to get that close. I made it—and shot this exciting image as the deer stood in the direct evening sunlight. As soon as my shutter clicked, the deer ran away.

Look for deer in the late afternoon, just before sunset. That's when they are likely to graze. And don't rely on the kind of luck I had—use a telephoto lens!

Limited depth of field caused the somewhat distracting background to blur enough to make the deer stand out prominently.

Photographs of wildlife are as much a part of landscape photography as are close-ups of flowers and foliage, even when the background isn't recognizable as a specific scene. □

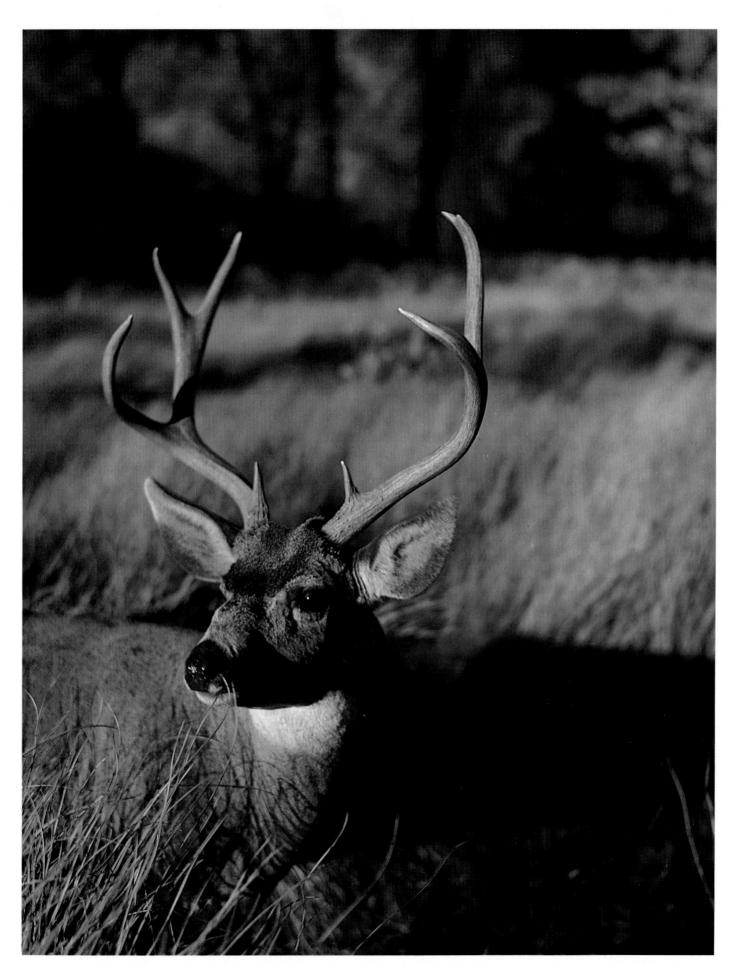

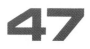

47

Location: Navajo Indian Reservation, northern Arizona
Time of Year: June
Time of Day: Midafternoon
Light Conditions: Direct sunlight
Lens: Standard
Film: Ektachrome 64
Exposure Metering: Reflected-light reading of area from girl's face to bottom of dress

In addition to being an attractive portrait of a young Navajo girl, this photograph tells a story about the tribe. The background shows the kind of terrain they inhabit. The girl is wearing the traditional garb, jewelry and hairstyle of her people. She is holding her pet goat—an animal common among the Navajo. The rug on the ground came from the loom of the girl's mother.

High, noon sunlight is not suitable for portraiture because it causes deep shadows in the eye sockets and a long shadow under the nose. I took this photo in the afternoon, when the sun was shining down at an angle of about 45°. Notice that there is detail in the eyes and that the shadow under the nose does not reach the mouth. A shadow that crosses the mouth tends to be particularly unflattering in photographs of women and girls.

I used a lens aperture that gave just enough depth of field to keep the background recognizable but not render it so sharp that it would distract from the main subject.

I wanted the girl to look directly at the camera. For compositional balance, I waited until the goat appeared in profile. □

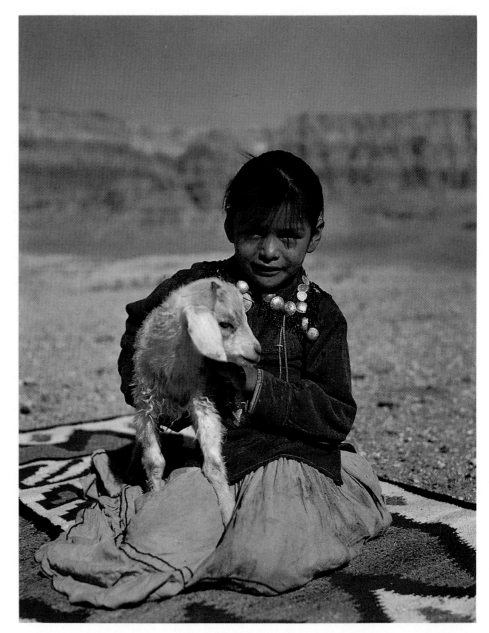

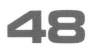

If I had faced to my left, I could have photographed the sunset. In this case, however, I wanted to record the scene as illuminated by the sun just before it set.

I waited for the moment when the blossoms were still highlighted by the sun and the hills beyond were in deep shade. Once this condition existed, I had to work fast. I had no more than a couple of minutes to take a meter reading, set the exposure and shoot.

I needed extensive depth of field, so had to use a small lens aperture.

However, because everything in the scene was static—there was no wind—I could use a slow shutter speed.

I exposed for the nearby blooms. At that exposure, I estimated that most of the detail in the nearby hills would be lost in shade and that the skyline beyond the lake would record with adequate detail. As the image shows, my estimate was correct and the result was a photo with a genuine evening atmosphere. □

Location: Lake Mead, Arizona and Nevada
Time of Year: Spring
Time of Day: Just before sunset
Light Conditions: Low sunlight, causing distinct bright and shaded areas
Lens: Standard
Film: Ektachrome 64
Exposure Metering: Close-up reflected-light readings from the yellow-green blossoms

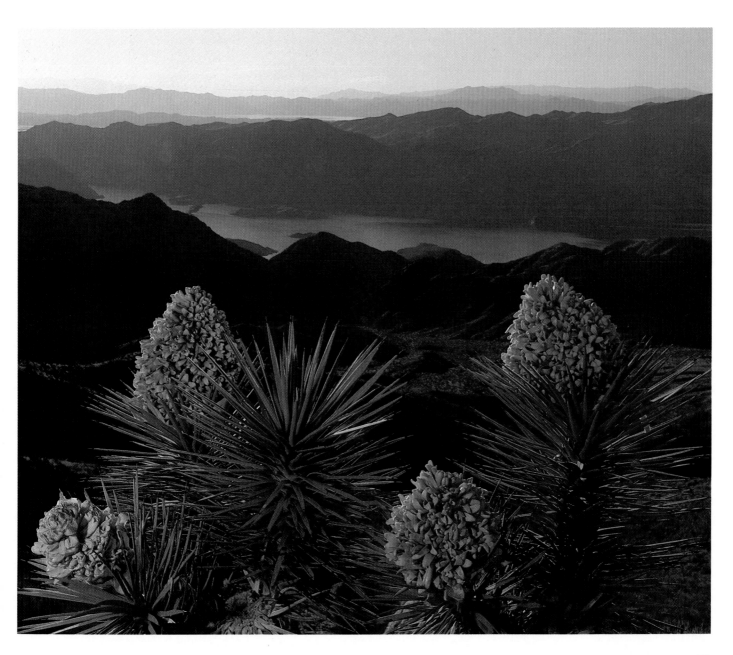

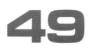

49

Location: Mount McKinley, Alaska
Time of Year: June
Time of Day:
This page— midmorning
Next page—midnight
Light Conditions:
This page— direct light from moderately low sun
Next page—midnight sun
Lens: Medium telephoto
Film: Ektachrome 64
Exposure Metering:
This page—reflected-light reading of nearby hills
Next page—reflected-light readings from distant mountains and reflection in lake

These two photos of mighty Mount McKinley are fine examples of the effect that light direction and height, and atmospheric conditions can have on photographic images.

I made the photos from very similar viewpoints. One scene was lit from the left side, the other from the right. One image looks almost like a negative of the other. Light becomes shade and blue becomes pink.

For the photo on this page, I made a reflected-light meter reading of the green hills in the foreground. The contrast of the scene was such that, had I exposed for the foreground, the snow-capped mountains would have been overexposed and washed out. So I reduced the indicated exposure by about two-thirds of an *f*-stop.

As I've indicated in the essays earlier in this book, color pictures with good highlight detail and color and relatively dark shadow areas are preferable to those with good shadow detail but burned-out brighter areas.

I made two exposure-meter readings for the photo on the next page.

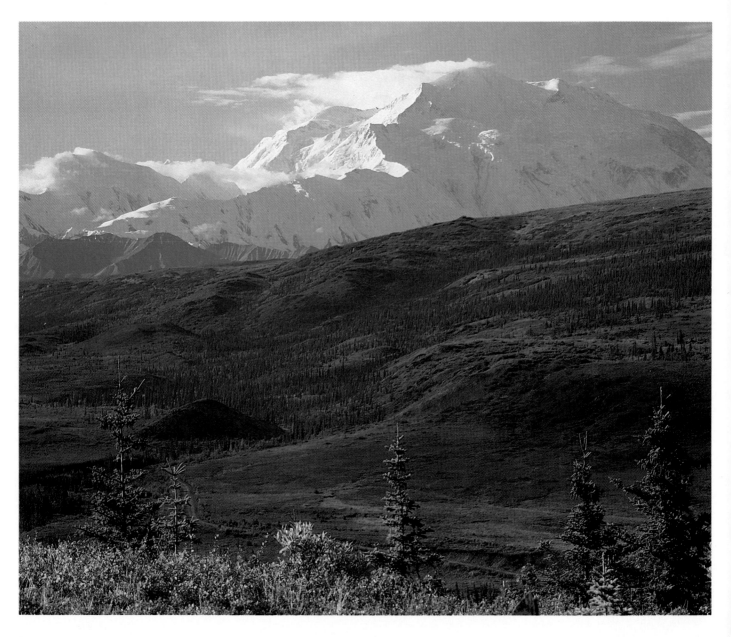

One was of the bright reflection in the water and the other of the distant mountain scene. To get satisfactory detail in both, I set the camera for an exposure halfway between the two readings.

For someone who has spent most of his life in the southern part of the United States, seeing—and photographing—by the midnight sun was a memorable experience. In its own way, it's as unforgettable as seeing the Grand Canyon for the first time. □

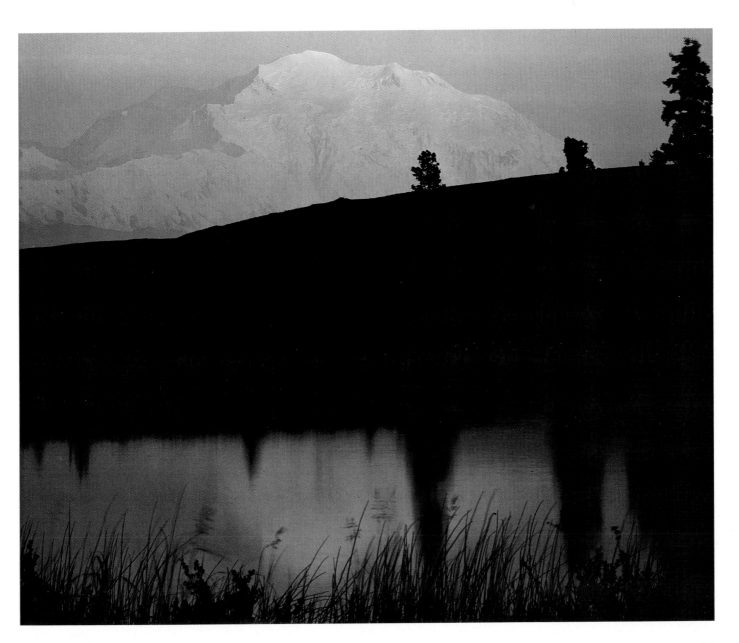

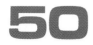

Location: Upper Inn Valley, Austria
Time of Year: Summer
Time of Day: Midday
Light Conditions: Direct sunlight through light haze
Lens: Standard
Film: Ektachrome 64
Exposure Metering: Reflected-light reading of scene as photographed

Drying hay was neatly stacked in this field in the Austrian Tyrol, awaiting transportation to the barn. I was fascinated by the many curves in this scene. My viewpoint for this photo was a nearby road bridge. From there, I was able to get just the right perspective and elevation to show the undulating lines well.

The dark-green curved area on the left and the bushes on the right "contain" the hay and lead your attention to it. As the little haystacks recede into the distance, they become apparently smaller and closer together.

As I discussed in the essay on *Composition*, page 12, receding lines enhance depth in a two-dimensional picture. Wavy lines, rather than straight ones, can give an added pleasing quality to an image.

Notice that there's hardly a straight line in this scene. The trees, hills and distant mountains all have wavy outlines. That's typical of nature, which only rarely features straight lines. I generally don't use rectilinear compositions in landscape photography. This means avoiding manmade structures, such as buildings, unless there's a purpose for having them in a picture.

Unless there's a good reason for it—such as I've shown in several places in this book—don't place major subject items centrally in a picture. Don't have bold subject outlines running parallel to the picture edges. Avoid compositions that are graphically angular. □

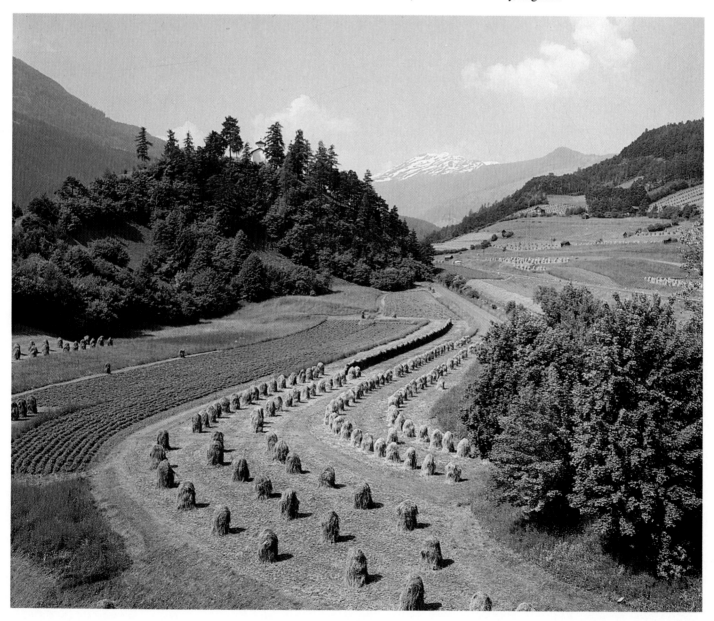

As you can see in some of the other pictures in this book, I sometimes photograph a scene solely to record the special beauty of cloud formations and lighting effects in the sky. The ocean also offers special conditions that attract my attention and make me get out my camera.

I wouldn't have photographed this bay from the same location if the water had been absolutely still. Too much of the picture area would have been occupied by an uninteresting, uniform water surface. However, with the white waves, following the curved outline of the bay, I visualized a striking photograph.

The yellow and green foreground gives graphic "support" to the image and indicates the curvature of the bay. There's a gentle transition of color from the green and yellow hill to the blue-green water in the bay, and finally to the deep-blue ocean beyond.

I waited to see if I could capture a totally uniform series of breakers but it never happened. Motion in nature is rarely symmetrical. Examining this image convinced me that this randomness is precisely what makes natural phenomena so fascinating.

In other parts of this book, I've talked about blurring water in streams and waterfalls to create a realistic image of movement. This involves relatively long exposure times. In this case, however, I had to record the water with reasonable sharpness or the wave formations would have been lost. Consequently, I used a shutter speed of 1/125 second. □

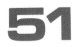

Location: Pacific coast near Big Sur, California
Time of Year: Spring
Time of Day: Midmorning
Light Conditions: Direct sunlight
Lens: Standard
Film: Ektachrome 64
Exposure Metering: Reflected-light reading of foreground hillside and bay

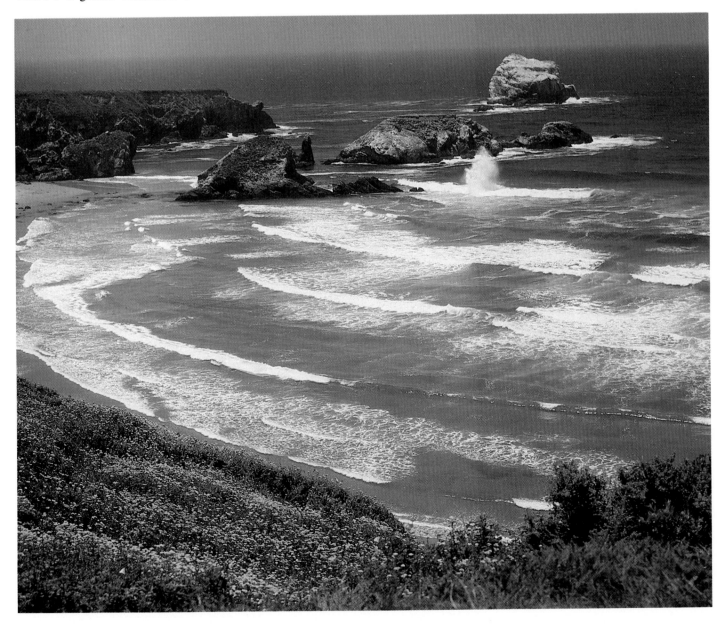

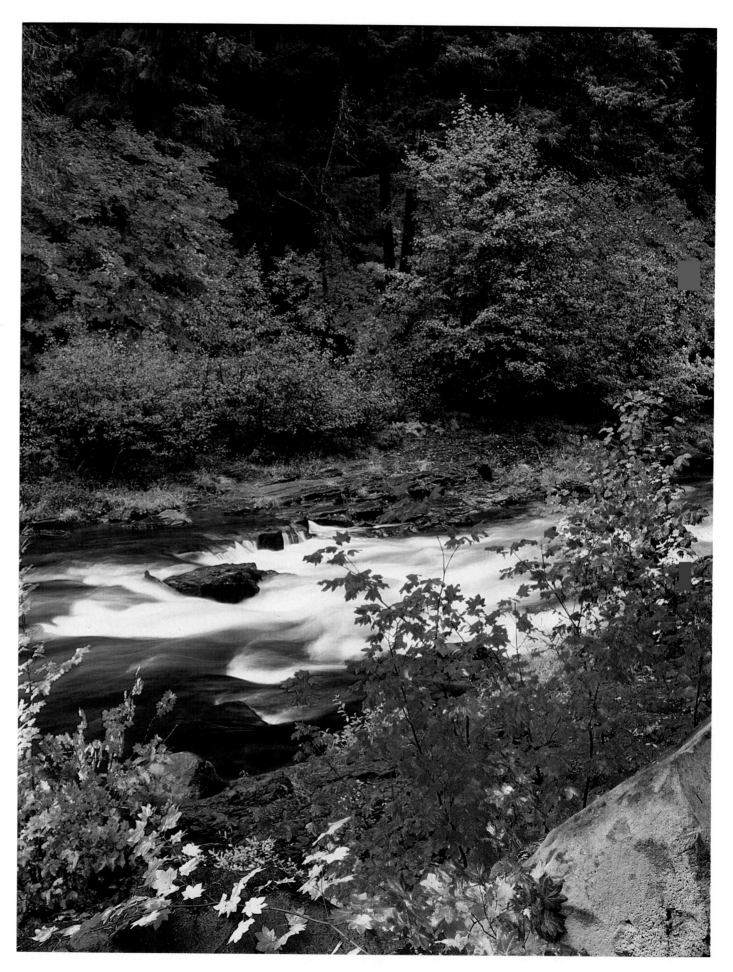

Location: Rogue River, southern Oregon
Time of Year: Autumn
Time of Day: Late morning
Light Conditions: Direct, hazy sunlight
Lens: Standard
Film: Ektachrome 64
Exposure Metering: Reflected-light reading of lower two-thirds of scene

I came across this scene at midafternoon. I knew it had the potential for an attractive photograph. However, the lighting just wasn't right. The trees across the stream were in deep shade, the water wasn't highlighted, and the colors in the nearby foliage were not bright and saturated.

To finally get my picture, I had to employ two of a photographer's most useful qualities—patience and perseverance. I returned to the scene the next morning. I arrived early, set up my camera and waited for the right lighting conditions.

The sun was shining through a thin veil of haze. This was ideal. It gave the scene sufficient brilliance without excessive contrast.

It was just a matter of waiting for the best lighting angle. Not long before noon, the trees across the stream were in a light I considered as good as it was going to get. The water was highlighted nicely and, most important, the foliage in the fore-

ground displayed its colors with brilliance.

My exposure-meter reading included the river. It may appear from the photo that the white water would have caused a misleading reading. However, you must remember that the water didn't appear quite that white to the eye. I deliberately used a shutter speed of 1/5 second to blur the water and give the impression of movement. The relatively long exposure time made the water appear whiter than the meter saw it.

If I had given too long an exposure—say, about one second—the water would have become a uniform white patch without any detail at all.

This photograph is first and foremost a study in color. Just as some pictures are "made" by clouds or ocean waves, the sole purpose for recording some scenes is their color. If I were using b&w film, I wouldn't have shot this scene. □

53

Location: A golden wheatfield, Kansas
Time of Year: August
Time of Day: Midday
Light Conditions: Bright overhead sunlight
Lens: Standard
Film: Ektachrome 64
Filtration: Polarizing filter
Exposure Metering: Reflected-light reading of field

This image has no natural frame, no foreground interest, no receding lines and no exciting cloud formations. And yet, I took it precisely the way I wanted it—and I think it succeeds.

How you should take a picture depends very much on what you want to show. My aim here was to give the viewer an impression of the vastness and sameness of a huge Midwestern wheatfield. I wanted to show the wheatfield and nothing else and didn't want to contain it in any way with framing or foreground. I wanted the viewer to believe that it goes on forever!

To achieve a uniform "carpet" of wheat, I had to wait for high, midday sunlight. Side lighting would have produced too many distracting shadows.

I used a standard lens. I didn't select a wide-angle lens because I wanted to place the horizon high in the image. With a wide-angle, the foreground would have been recorded from almost a vertical angle. That kind of distortion can be distracting. The standard lens also enabled me to record with some prominence the distant line of trees and bushes marking the horizon.

I used a polarizing filter to enhance the color saturation in the golden wheat. Unfortunately, the polarizer also emphasized slightly the unevenness in the sky tone. □

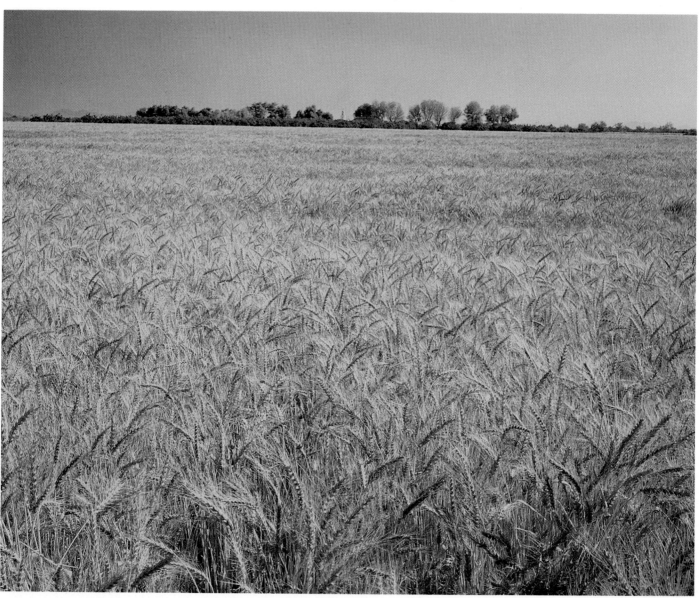

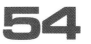

This field of sparkling "ice flowers" was created inadvertently by a thoughtless farmer who had left his overhead sprinkler system on during a frosty night. The result made for an attractive and unusual image.

I carefully selected the wheel with the most interesting ice pattern to appear largest. There were several more wheels to my right. By adopting a low viewpoint, I was able to make the icy wheels stand out clearly against the darker background.

When you photograph a scene like this, be careful not to step into and spoil the part you're going to photograph. This is equally true of snow scenes. If you want to record a scene in virgin snow, don't mar it with your footprints.

I took a reflected-light meter reading of the foreground area. Although it contained bright ice, there were enough bare areas and shadows to average the surface to an approximate 18% gray equivalent. □

Location: A field in California
Time of Year: Midwinter
Time of Day: Early morning
Light Conditions: Low sunlight
Lens: Standard
Film: Ektachrome 64
Exposure Metering: Reflected-light reading of foreground area

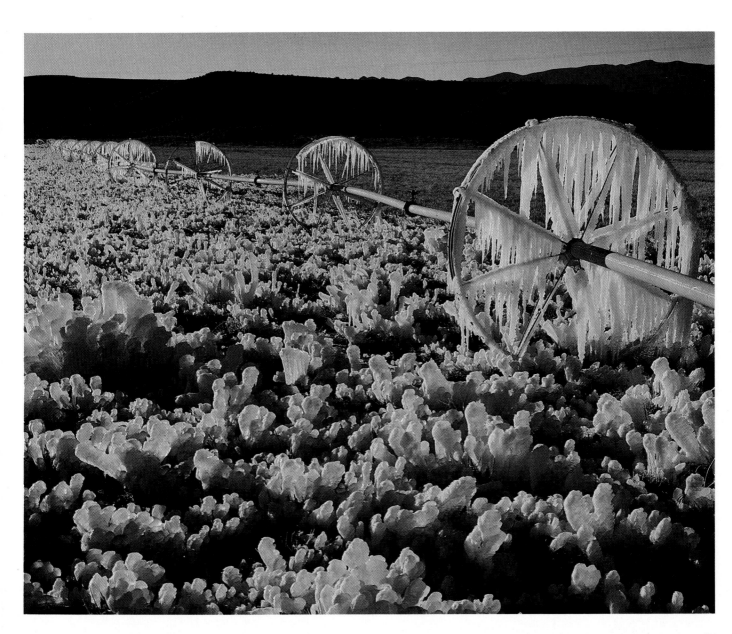

Location: Palmyra, Syria
Time of Year: Spring
Time of Day: Midmorning
Light Conditions: Diffused sunlight through thin cloud layer
Lens: Standard
Film: Ektachrome 64
Filtration: Polarizing filter
Exposure Metering: Reflected-light reading from foreground area, excluding sky

The entire scene is a monochromatic brown. I chose a low viewpoint and shot the main structure of the ruins of this ancient Syrian caravan city against the sky. The blue contrasted well against the brown, and the sky provided an uncluttered background. The low camera position also emphasized the size and magnificence of these remains from nearly 2,000 years ago.

The day was sunny and there were light, fluffy clouds in the sky. To avoid the harsh shadows of direct sunlight, I waited until the sun was behind a thin cloud before making the exposure. The soft shadows were lightened further by the highly reflective surroundings. The side light provided plenty of texture and modeling.

I composed the picture so that the foreground rocks would naturally lead your attention toward the main arch. This arch made a fine frame for the old Arab fortress on the hill beyond. □

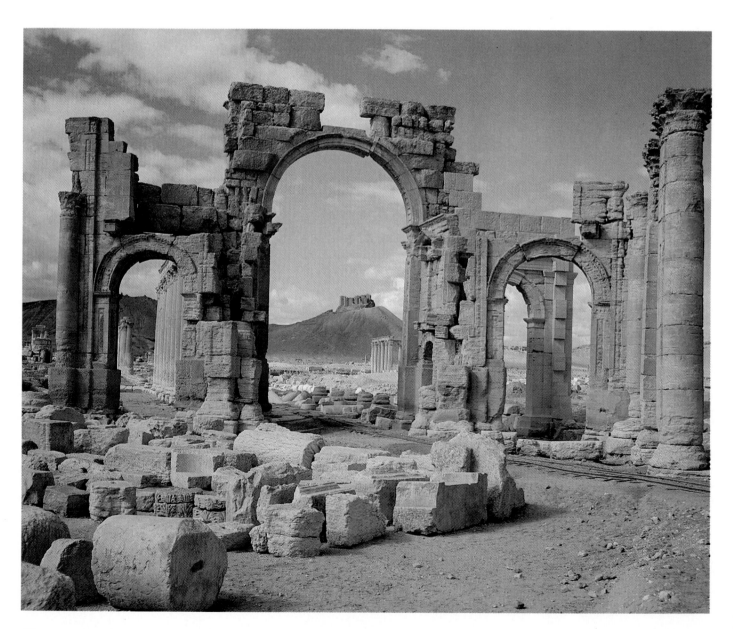

Location: Typical courtyard in Vorarlberg, Austria
Time of Year: Early summer
Time of Day: Midday
Light Conditions: Sunlight through light haze
Lens: Standard
Film: Kodachrome 25
Exposure Metering: Exposure determined by in-camera meter

The best time of day to photograph this old courtyard was about noon, when the sun was high in the sky. Early or late in the day, trees behind me would have caused speckled shadows on the building. In this photo, you see the patchy light caused by the trees on the ground, where it isn't objectionable and even looks quite attractive.

The sunlight was softened by a light haze. This helped brighten the shaded areas enough so that the film could record some detail. The surrounding bright walls also acted as reflectors.

Remember that color-slide film cannot record the wide tonal range your eyes see. When you visualize a picture, bear this in mind. As I advised in the essay on *Exposure Control,* page 21, when in doubt, take meter readings from the brightest and darkest parts in which you want to record detail. The readings should not vary by more than about five *f*-stops. □

Location: Petra, Jordan
Time of Year: Spring
Time of Day: Late morning
Light Conditions: Clear sunlight
Lens: Standard
Film: Ektachrome 64
Exposure Metering: Reflected-light reading of left side of scene

This photo shows the Treasury, the most beautiful and best-preserved structure in ancient Petra, known also as the "rose-red city." The building is carved from solid rock.

The sunlight came from the left side and did not strike the front of the building directly. The facade was lit mainly by reflected light from a cliff directly opposite it.

The building is surrounded by steep cliffs on almost all sides. This means there are only short periods of time each day when you can make satisfactory photographs. I was fortunate to be able to be there at one of the ideal times.

The greater part of the scene was of low contrast. However, the sunny patch in the foreground, the highlights on the rockface on the right and the edge lighting on the figures and horses added sparkle to the image.

I asked two horsemen to stand near the edge of the scene and face inward. The third horseman, in the center and facing the other two, provides a nice counterbalance to the composition.

My reflected-light exposure-meter reading was made of the left side of the scene. I carefully avoided getting any sunlit surface into the metering area because it would have caused a misleading exposure indication.

This photo is another good example of a scene that is essentially monochromatic and yet appears very colorful and exciting. □

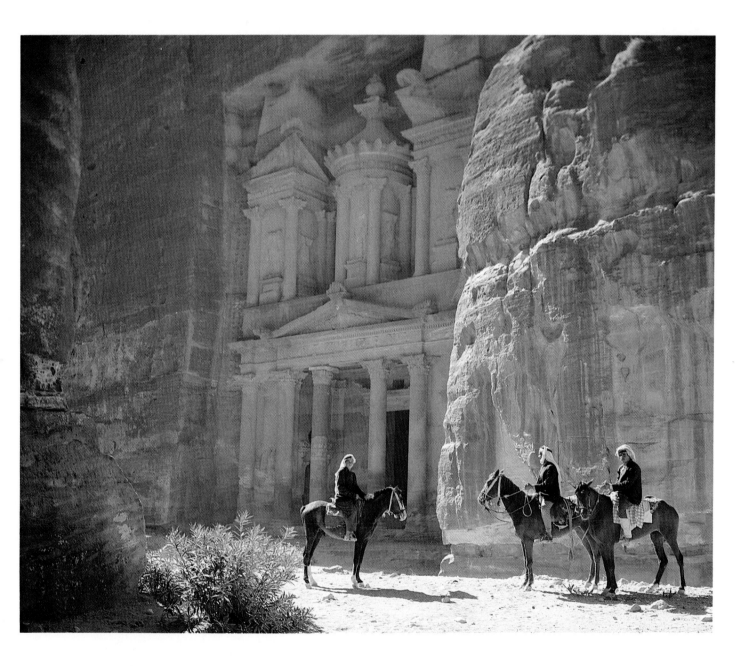

58

Location: Various locations in Arizona
Time of Year: Late summer
Time of Day:
This page, top—sunset
This page, bottom—before sunrise
Next page, top—sunrise
Next page, bottom—sunset
Light Conditions: See text
Lens: Standard
Film: Ektachrome 64
Exposure Metering: See text

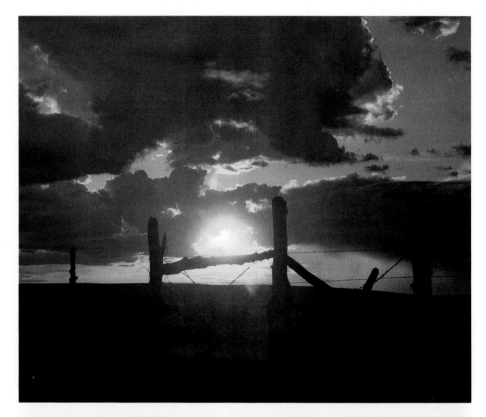

The four photographs on these two pages show what a wide variety of colors and moods sunrises or sunsets offer. I didn't use a filter for any of these pictures but simply recorded the natural colors in the scene.

Making an exposure-meter reading for a sunrise or sunset picture is not as difficult as it may seem. If the sun is partially concealed behind clouds, as in the top photo on this page, or causing a bright glow in the sky, simply take a reading of the sky area you want to record.

The resultant exposure will not give you a "correctly" exposed image, but one that is somewhat underexposed. That's exactly what you want—a slightly dark, dramatic sky with good, saturated colors.

For each photo except the bottom one on the next page, I gave the exposure indicated by my meter of the sky area. Normally, with this technique, you'll get very acceptable pictures. If you bracket your exposures up to one exposure step in either direction, you'll be sure of a fine image each time.

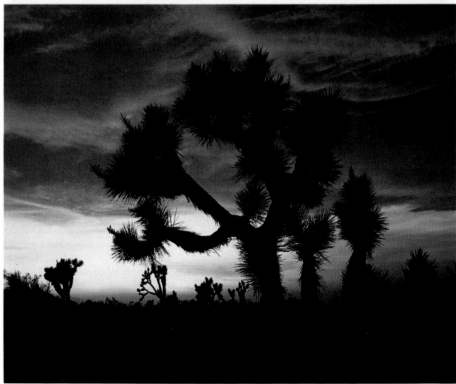

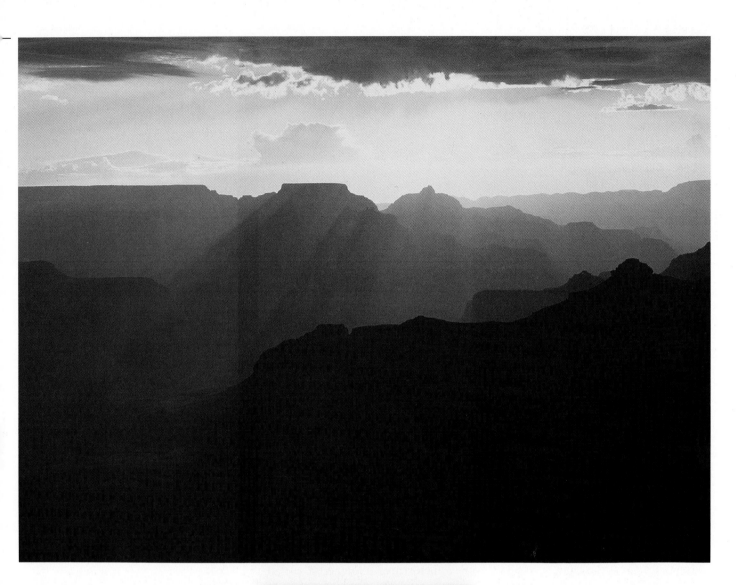

The sky in the scene on the right was so dark that an exposure based on a direct meter reading of the scene would have given too bright an image. This photo is not of a sunset but of a scene illuminated by the light of the setting sun. I took readings from the highlighted parts of a saguaro cactus and from the dark sky and exposed halfway between the two indicated exposures.

In a sunrise or sunset scene, foregrounds usually record most dramatically in silhouette or near-silhouette, so they present no special exposure

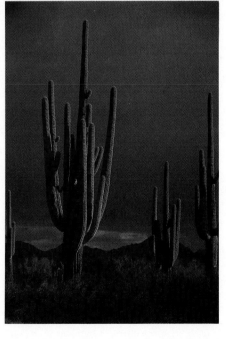

problems. Don't take readings from those areas.

As I've indicated in the essay on *Light and Weather,* page 17, be sure the silhouetted features are recognizable and not just arbitrary dark shapes.

You can sometimes indicate the presence of the sun without actually showing it. The upper photo on this page, taken at the Grand Canyon after sunrise, is a good example. The subtle shafts of light entering the canyon make the viewer aware that the sun has risen and is hidden behind the upper cloud layer. □

Location: Casablanca, Morocco
Time of Year: Spring
Time of Day: Early afternoon
Light Conditions: Clear sunlight
Lens: Standard
Film: Ektachrome 64
Exposure Metering: Reflected-light reading of upper two-thirds of scene, avoiding sunlit patch on ground

To show detail in the succeeding arches of the Law Courts in Casablanca, I chose a standard lens. A wide-angle would have exaggerated the perspective and made the place appear larger. However, it would have recorded the more distant arches too small.

I waited for the sun to shine down into the central courtyard, providing a spotlight effect. I placed the man in the spotlight, making sure his entire shadow would remain intact. Subtle rim lighting makes him stand out well from his background.

In high, direct sunlight, this scene was potentially very contrasty. However, all the walls were so bright that they acted as highly efficient reflectors.

The wall nearest the camera was lit by reflected light from a similar wall just behind the camera. The wall behind the camera and the one beyond the courtyard in front directed a lot of sunlight back into the covered area. The result is an image with detail in even the brightest and darkest areas.

In making my exposure-meter reading, I was careful not to include the spotlighted patch on the ground. It was bright enough to drastically mislead the meter's photocell and cause considerable underexposure.

To record as much information about the scene as possible, the camera position had to be fairly central. However, notice that I moved the camera just far enough from center to provide a little graphic impact. To emphasize this further, I placed the man off center, having him look in toward the larger part of the image area.

Strictly speaking, of course, this is not a landscape photograph at all. However, it's the kind of scene no landscape photographer should walk away from, any more than he should ignore close-up views of flowers, leaves or rocks. □

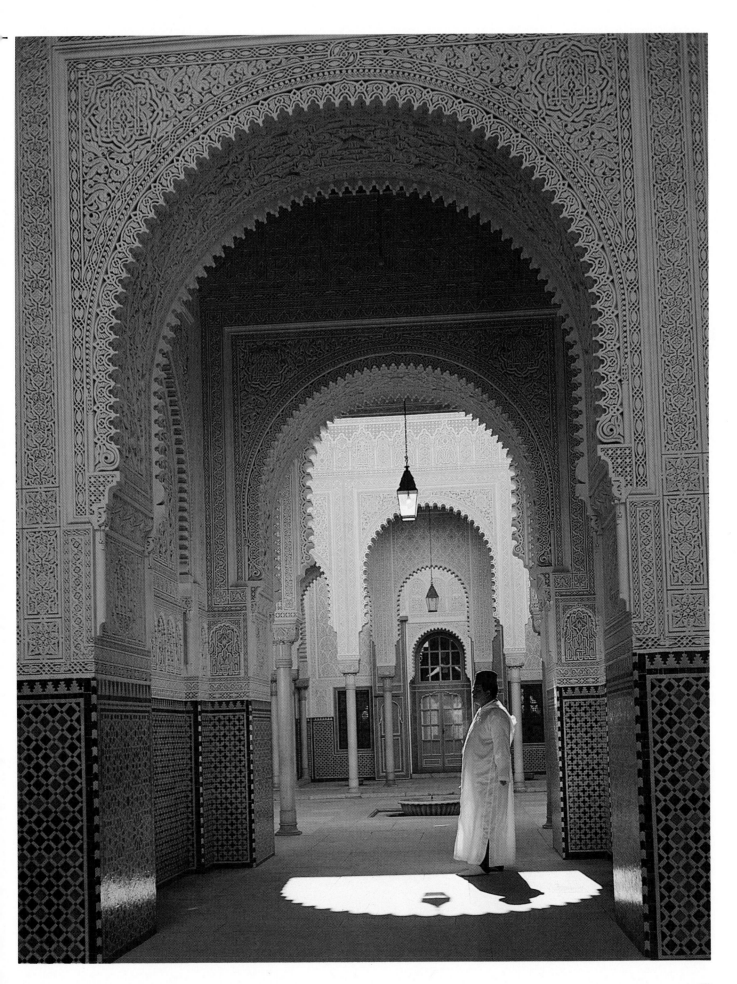

60

Location: San Francisco, California
Time of Year: Spring
Time of Day: Midday
Light Conditions: Direct sunlight through thin haze
Lens: Long telephoto
Film: Ektachrome 64
Filtration: Ultraviolet (UV) filter
Exposure Metering: Reflected-light reading (see text)

I was on Telegraph Hill, a long way from this scene, when I noticed the ship on the left gradually approaching the dock on the San Francisco waterfront. I quickly attached a long telephoto lens to the camera and mounted the camera on my tripod. To penetrate a slight bluish haze filling the considerable distance between me and the ships, I used an ultraviolet filter.

The liner Oriana, on the right, had already docked. My aim was to get the second ship in the best possible position for a pleasing composition.

I took several shots. This is the one I liked best. In some, the moving ship was too far from the dock to appear an integral part of the scene. In others, it was too close and too nearly parallel to the other ship.

The position of the two tugboats clearly indicates which way the liner is moving.

Be careful when you use a handheld exposure meter to determine exposure for a telephoto picture. Don't include features outside the image area that might cause a misleading meter reading.

When I pointed my meter at the ships, it also read a lot of foreground, a large expanse of water and some sky. I knew the bright sky would have misled the meter so avoided it in my readings. I made readings of the scene between me and the ships and of the water beyond.

Because the scene was uniformly lit and was mostly of uniform tones, the various readings I made were very similar. I set the camera for an average of these readings.

I could have determined exposure in another way, by simply taking a reading of an 18% gray card in the same direct sunlight as the scene. □

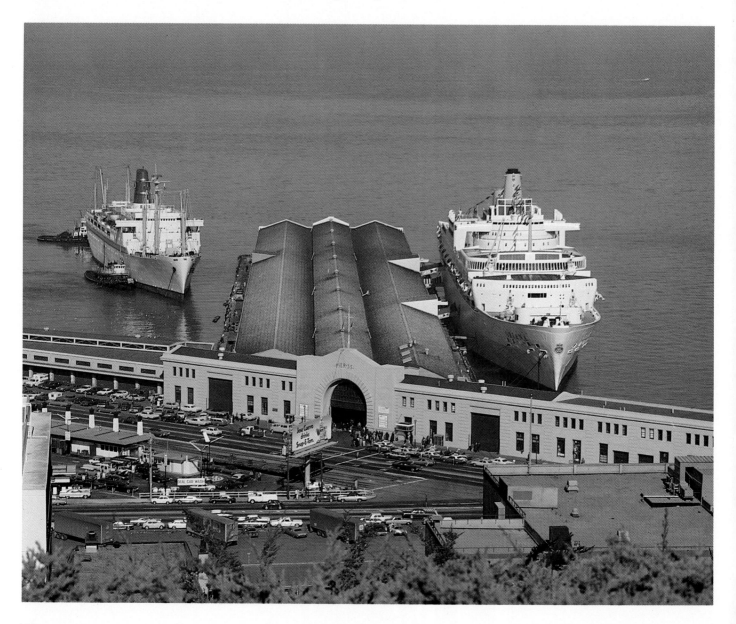

It's easy to make general-view photographs of Heidelberg because the city is hilly on both sides of the Neckar River. I shot this photo from high up on one side of the river, looking toward the town's famous castle. The castle is on the left, overlooking the old part of the city.

I was careful to include some foreground detail. This was important because the bridge needed a place to "come from." It's rarely wise to compose a picture so that a bridge is cut off at the edge of the image. A road is a different matter and can be permitted to run out of a picture. But a bridge is expected to have two ends, and a viewer tends to be disturbed by a lack of information about one of them.

The morning haze was attractive and seemed fitting for this ancient scene. It is also fairly usual in this location, being near the river and not far from cities that add industrial haze. I did not use a haze or UV filter to eliminate or reduce the slightly veiled appearance of the scene.

However, I was grateful for the distinct side lighting. The sun was shining from the right side, causing distinct areas of light and shade on the buildings and the woods beyond. This added some contrast and a feeling of depth. □

Location: Heidelberg, West Germany
Time of Year: Summer
Time of Day: 10:30 a.m.
Light Conditions: Soft, direct sunlight through haze
Lens: Standard
Film: Ektachrome 64
Exposure Metering: Reflected-light reading of scene as photographed

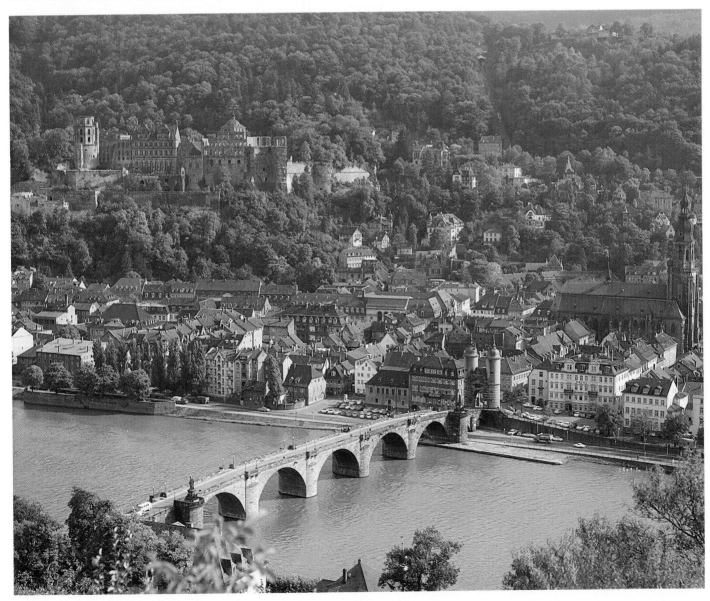

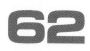

62

Location: Carlsbad Caverns, New Mexico
Light Conditions: Flash
Lens: Standard
Film: Ektachrome 64
Exposure Metering: Used flash guide number

This is an unusual "landscape" photograph because it was made in a dark, enclosed space, depending on flash for illumination. However, locations like this one are certainly within the legitimate realm of the landscape photographer.

The cave was large enough to be photographed with a standard lens. I resisted the temptation to move closer, use a wide-angle lens and get a more "dramatic" shot because I wanted to maintain some size and detail in the farther parts of the cave.

My camera was on a tripod. I composed the picture and focused by the tungsten lighting provided for tourists. However, I didn't want to shoot by that light. I carefully examined the cave to determine the best location for my flash illumination. I decided on five flash locations.

I set the camera lens between *f*-11 and *f*-16 and used the flash guide number to determine the best flash-to-cave-wall distance at each flash location. I didn't want all flashes to record with equal brightness.

When everything was ready and there were no tourists in the cave, a ranger switched off all lights except one weak one. It provided just enough light for me to find my way about.

I opened the camera shutter for a time exposure and ran to my first flash location. After flashing from the predetermined position, I ran to the next location and did the same. I continued until I had flashed from all five locations. At each location, the flash unit and I were hidden from the camera's view.

By the time I got back to the camera, the shutter had been open for about one minute—not enough for the small tungsten light to record on the film.

This lighting technique is called *painting with light.* It's not easy because you can't preview the final effect. With imagination and careful use of flash guide numbers, you can produce very effective pictures. If I had lit this scene with five tungsten lights, and moved them around until I got the best effect, I probably would have ended up with an image very similar to this one. In other words, I consider the photo a success! □

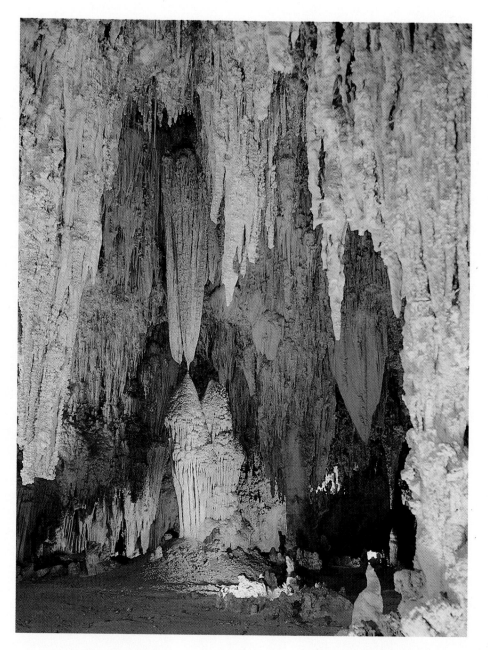

I took this photograph many years ago, before Glen Canyon Dam caused the water level to rise dramatically here, at the Glen Canyon National Recreation Area. This photo could not be taken again today because the entire arch is under water. The picture is an example of the historical value of some old landscape photos.

Although this and many other scenes are no longer accessible, the rising waters opened up many new and exciting locations.

In a scene such as this, where daylight has limited access, it's important to wait for a time of day when the sunlight enters most effectively. Notice the spotlighting of the water, highlighting the two boats. The lighting constitutes an integral part of the composition.

The inherently high contrast of the scene was lowered by reflection of sunlight from the brighter cliffs into the darker areas.

Instead of metering only the central cliff, which represents about an 18% gray tone, I metered both it and the shaded cliff on the right. My exposure was based on an average of these two readings. I did this to ensure detail in the shadow areas.

Photography on b&w film offers much more effective contrast control than does the use of color-slide film. I have always developed b&w films by inspection in the darkroom. This enables me to expose for the shadows and develop for best possible highlight detail. Further contrast control is available by selecting the appropriate grade of b&w enlarging paper and by dodging and burning-in while exposing the paper. □

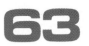

Location: Lake Powell, northern Arizona
Time of Year: May
Time of Day: Midday
Light Conditions: Direct sunshine
Lens: Standard
Film: Kodak Plus-X Pan
Exposure Metering: Reflected-light readings from cliff in center and cliff in shade on right

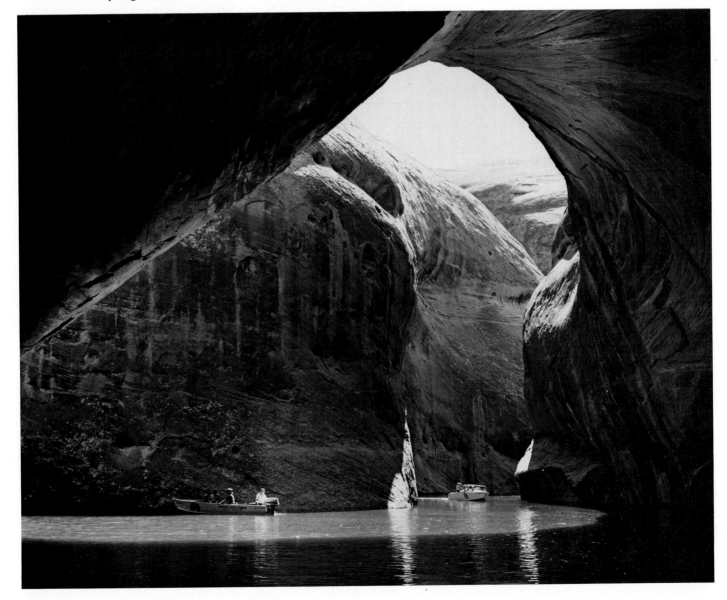

64

Location: Over Greenland
Time of Year: Summer
Time of Day: Early afternoon
Light Conditions: Bright sunlight
Lens: Standard
Film: Ektachrome 64
Filtration: Ultraviolet (UV) filter
Exposure Metering: Reflected-light reading of scene as photographed

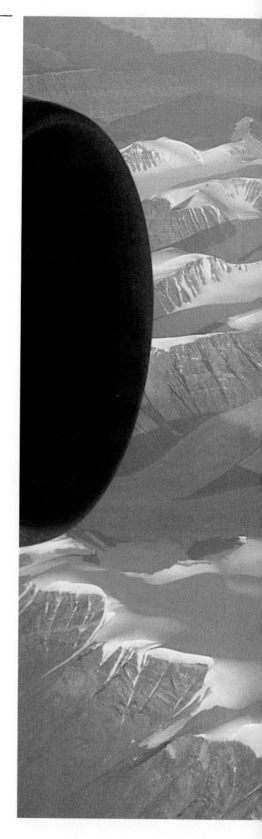

This striking view of a southwestern coastal region of Greenland in mid-summer gives me an opportunity to provide you with some basic tips on photography from airliners.

The first essential, of course, is to get a window seat. Be sure the seat is in front of the engines. The heat trail emitted at the rear of the engines causes distorting air currents, leading to fuzzy images. Also, be sure your seat is on the side of the plane opposite the sun. For example, if you're flying from New York to Los Angeles in the morning, select a seat on the right side of the plane. On the other side, you would be looking—and shooting—into the sun most of the way.

Before you shoot, be sure the window is clean. Don't touch the window with your camera when you expose. The vibration of the plane would be transmitted to the camera and possibly cause blurred images. However, get close enough to the window to avoid reflections from the plane's interior in your images.

When using a non-SLR with a separate viewfinder, allow for the parallax between the views seen by the finder and the lens. Otherwise, you may see an entire image in the viewfinder and later find that your pictures contain mainly window frame!

To show that you're flying and not mysteriously suspended in space, include part of the aircraft in your pictures. Include part of an engine, as I did here, or a wing.

The best time to shoot from an aircraft is soon after takeoff or during the final minutes before landing. At those times the plane is low enough for detailed photos. Rarely will you get striking photos from 33,000 feet, but it can happen—so keep your camera handy.

To make this photo, I used an ultraviolet filter to cut some of the blue haze and retain best image sharpness. I didn't want to use stronger filtration because I wanted to retain some of the characteristic blue associated with high altitude.

To enhance contrast in an inherently soft scene, I waited until I had a view in which there were distinct shadows on the snow.

To retain the brilliance of the snow, I doubled the exposure indicated by a reflected-light reading. Remember, exposing according to the meter reading would have given me an 18% gray image—pretty dull for a snow scene! □

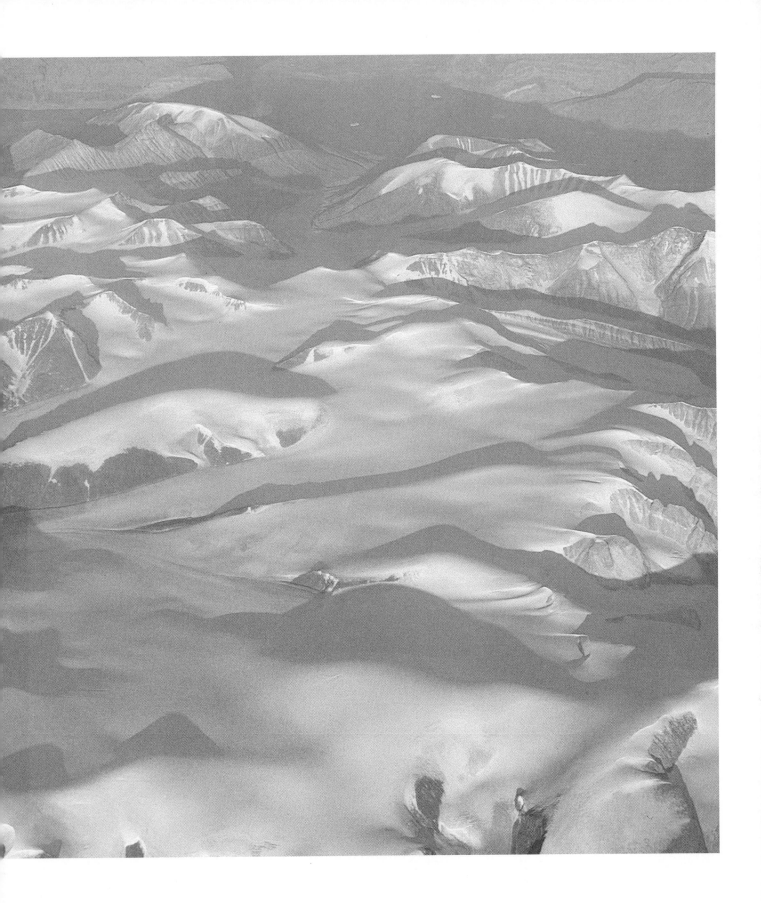

65

Location: Near Bullhead City, Arizona
Time of Year: Spring
Time of Day: Early evening
Light Conditions: Direct sunlight
Lens: Standard
Film: Ektachrome 64
Exposure Metering: Reflected-light reading of scene as photographed, excluding sky

Bullhead City, Arizona, is one of the hottest and driest places in the United States. Yet, each spring these arid and barren sand dunes come to life with colorful floral displays. I have always loved the Arizona desert because it inspires great respect for those animals and plants that manage somehow to survive against apparently impossible odds.

That survival, and the environment in which it occurs, are dramatically illustrated here, where the contrast of lush plants and dry sand are clearly evident.

In selecting my viewpoint, I was concerned with bringing as much color as possible to the foreground. Notice that the frontal clump of plants is in the shape of a shallow triangle which directs your attention up to the more distant plants.

Alternating light and shade caused by the low evening sun gave some modeling to the sand dunes and added sparkle to the image. □

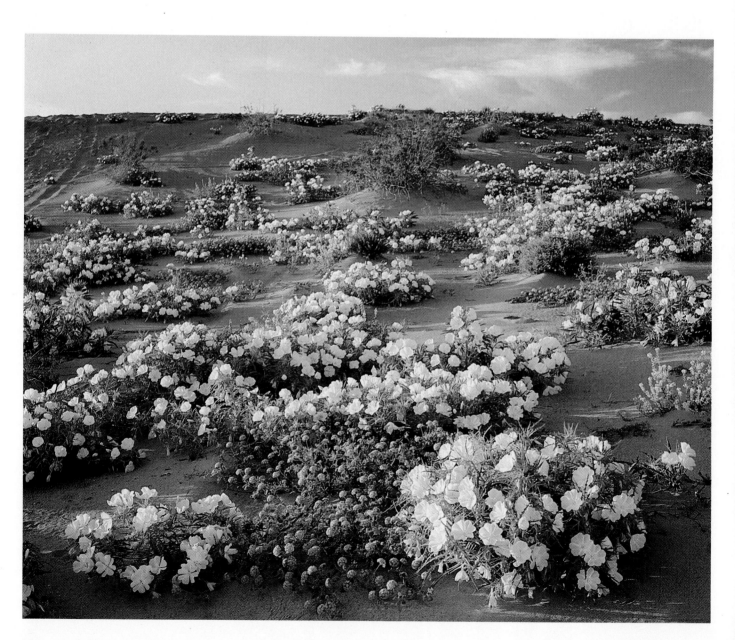

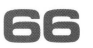

In southern Arizona, spectacular rain- and thunderstorms are common in the evenings during July, August and September. Some of the most spectacular skyscapes of the entire year occur during those months.

I photographed this storm in Tucson just before sunset. For a few brief moments, the sun was shining through a gap in the descending sheets of rain. I quickly positioned myself so I would have in my composition a typical southern Arizona desert scene, including saguaro cacti, hills and distant mountains.

In making a reflected-light exposure-meter reading, I pointed the meter at the sky, avoiding the dark land area in the foreground. I included the sun in the metered area. It caused the meter to indicate enough underexposure for a dramatic image.

I varied the exposure while taking several different pictures. As I shot, the rain clouds swirled and moved through the sky. The photo reproduced here was my favorite image. In it, bright areas occurred at just the right places to reveal the mountains and hills while a general darkness depicted the storm scene very convincingly. □

Location: Tucson, Arizona
Time of Year: Summer
Time of Day: Sunset
Light Conditions: Low sun shining through storm clouds
Lens: Standard
Film: Ektachrome 64
Exposure Metering: Reflected-light reading of sky, including sun

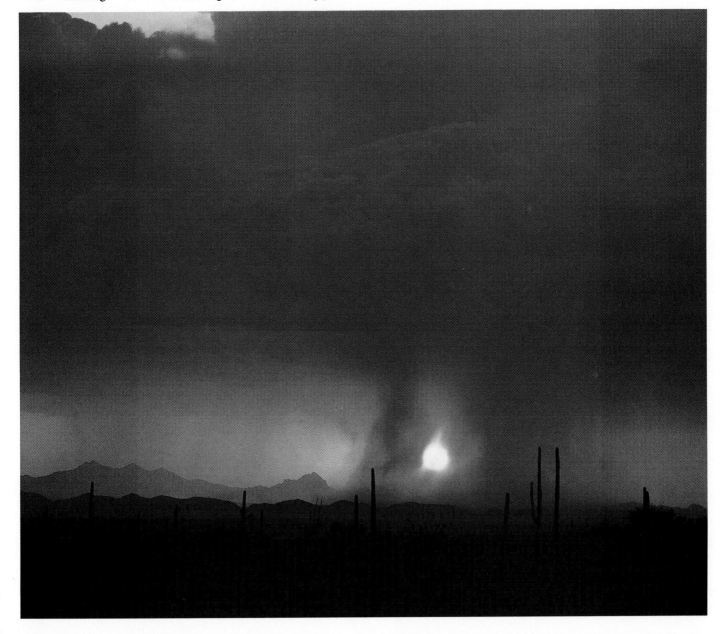

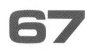

Location: Hallstatter Lake, Austria
Time of Year: Summer
Time of Day: Midday
Light Conditions: Hazy sunlight through light cloud cover
Lens: Standard
Film: Kodachrome 25
Exposure Metering: Gave exposure indicated by in-camera meter

The receding road, houses appearing progressively smaller, and a slight mountain haze all help to give this photograph a three-dimensional look. The V-shape formed by the houses and trees on the left side and the mountain slope on the right helps to enhance this feeling of distance.

Notice that I allowed a little space between the last buildings on the right and the edge of the picture. This reveals to the viewer that the foreground area represents only a cove and not the entire lake, which continues beyond the distant church and houses.

I was fortunate to have billowy clouds in the scene. A cloud-filled sky nearly always makes an image look more interesting than a sky that is uniformly gray or even blue. □

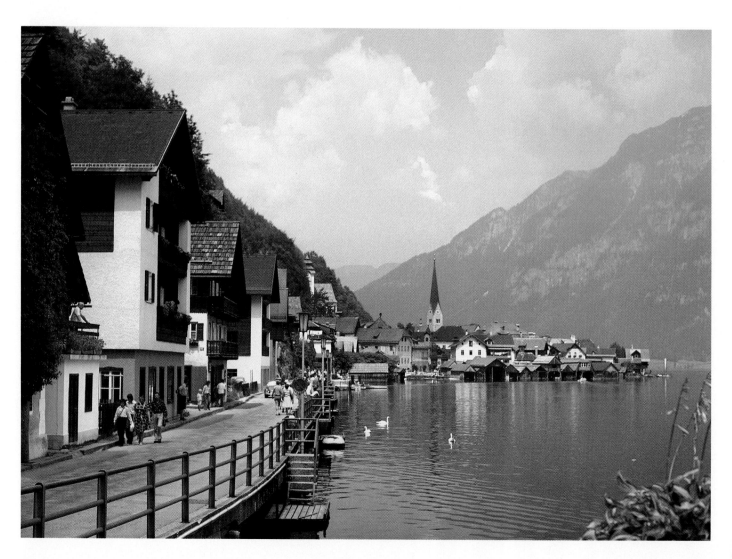

The white fence visually links the red roses in the foreground with the house in the background. Your attention is drawn toward the house by the lines of the fence and then back to the roses. Although the fence leaves the picture on both sides, it never causes your attention to be drawn beyond the borders of the image.

The converging lines of the fence provide a feeling of distance. The sun's high position at midday prevented long shadow lines that would con-flict with the white, diagonal fence lines.

The three-dimensional effect is further enhanced by the color arrangement. In the essay on *Creative Color Control,* page 24, I mentioned that blue tends to recede while red tends to advance toward you. Because of these characteristics, the red roses and blue sky in this photo look farther apart than they would in an identical photo shot on b&w film. ☐

Location: Cape Cod, Massachusetts
Time of Year: Summer
Time of Day: Midday
Light Conditions: Direct sunlight
Lens: Standard
Film: Kodachrome 25
Exposure Metering: Gave exposure indicated by in-camera meter

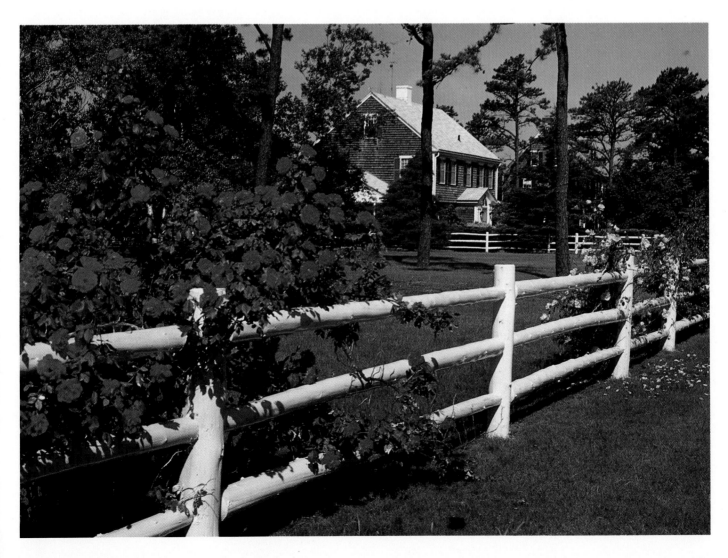

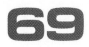

Location: Rothenburg, West Germany
Time of Year: June
Time of Day: Midday
Light Conditions: Clear sunlight
Lens: Standard
Film: Ektachrome 64
Exposure Metering: Reflected-light reading of wall at right

I was fascinated by the V-shape produced by the steep gable of the building on the left and the gently curving wall on the right. The V-shape contained and emphasized the tower in the center. A feeling of depth is provided by the second, distant tower.

The scene was too contrasty to be recorded with full detail from brightest highlight area to darkest shadow. My exposure was based on a meter reading from the wall on the right side. I knew that the lower, receding area of the house on the left would not record with detail. I couldn't afford to give enough exposure for that area because that would have rendered the remainder of the picture too light.

The sun highlighted the wheels, rims and plants by the front of the building, preventing a totally black patch there. This encouraged me to take the picture in spite of the high contrast.

In today's world, it's difficult to get away from automobiles, even in a quiet alley in a small town. This is one of the major problems facing photographers of the urban scene. Sometimes you can shoot over cars, sometimes you can get between them, and occasionally you can persuade an owner to move one. In this case, I waited until the car was in a shaded area and thus least noticeable. □

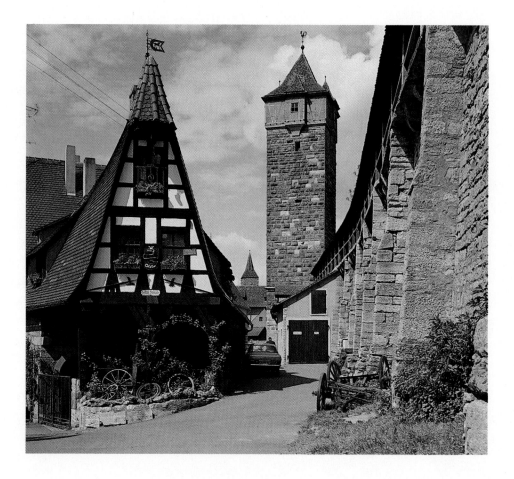

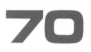

Location: Upper Truckee River, Sierra Nevada Range, California
Time of Year: October
Time of Day: Midmorning
Light Conditions: Sunlight filtering through trees from right side
Lens: Wide-angle
Film: Ektachrome 64
Exposure Metering: Reflected-light reading of lower two-thirds of scene

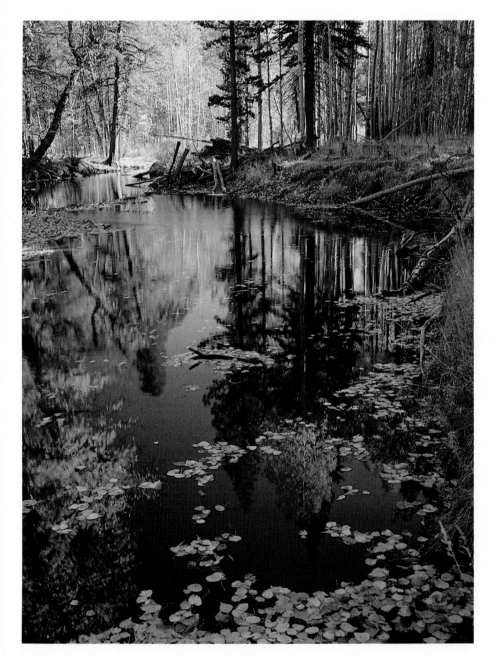

This quiet reflecting pool, off the Upper Truckee River, was created by industrious beavers, who had built a dam just behind my camera position.

Autumn leaves had fallen everywhere and there were plenty floating in the water. Sometimes, when a picture calls for fallen leaves where there aren't any, I give nature a helping hand and move some to where I want them. When you do this, be careful not to *overdo* it. The scene should look natural and not as if it had been tampered with.

Elsewhere in this book, I have advised you against cutting off part of a reflection. For example, if a person is reflected in a pond, don't crop so close that the reflected head and upper body will be missing from the image.

The opposite—cutting off part of the object itself—is sometimes acceptable, as in this picture. Notice the tree reflections at the lower, right side. The tops of the actual trees are not in the picture. I find this acceptable because, in this case, the reflections form the main theme of the picture.

In addition to darkening a blue sky and increasing color saturation, a polarizing filter can be useful to remove unwanted surface reflections from water. This helps you see objects such as swimmers or fish below the water's surface. However, don't be tempted to use a polarizer for a picture such as this one. After all, here the reflections *make* the picture. □

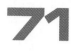

Location: South Rim of the Grand Canyon, Arizona
Time of Year: Winter
Time of Day: After sunset
Light Conditions: Light from the glowing evening sky
Lens: Standard
Film: Ektachrome 64
Exposure Metering: Reflected-light reading of snow and fog in foreground; excluded sky

On my more than 250 visits to the Grand Canyon, I have seen it only once like this. A blanket of fog turned the canyon into an apparent ocean for three weeks. For the entire time, the rim remained above the fog. Because of the rarity of this phenomenon, photographs of it can truly be regarded as having documentary value.

Although the sun had set and the scene was lit only by skylight, you can see considerable texture in the fog layer. This is because most of the light came from near the horizon, causing distinct edge lighting.

The sky above was dark blue, causing the fog and snow to appear blue also. This coloration helped give the scene a cold, wintery appearance.

Because the foreground snow and distant fog were so similar in tone, color and texture, I shot from a location where the two were distinctly separated by some shrubs.

Normally, when I take a reflected-light meter reading from snow or mist, I give more exposure than the meter indicates because I don't want to record those areas as dark as 18% gray. In this case, however, I wanted to maintain the atmosphere of dusk and, therefore, exposed according to the meter reading. □

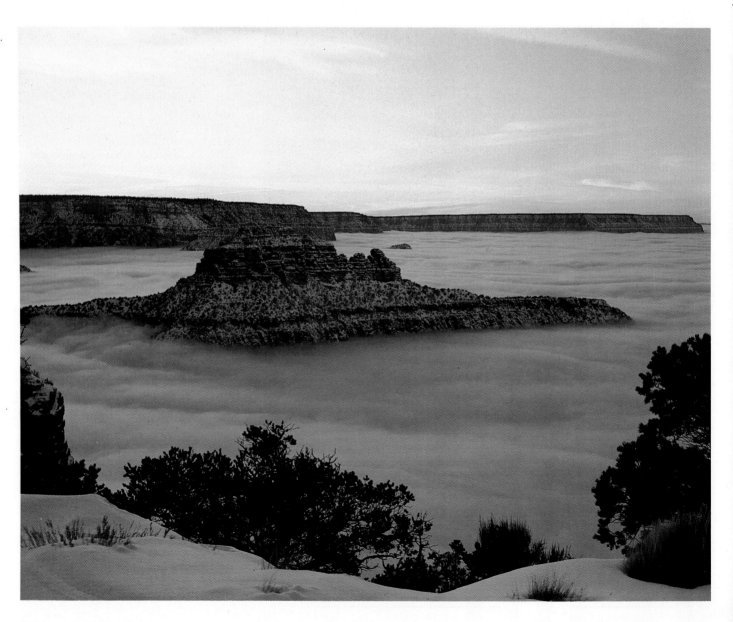

Location: King's Canyon National Park, California
Time of Year: Midwinter
Time of Day: 11 a.m.
Light Conditions: Direct sunlight from deep-blue sky
Lens: Standard
Film: Ektachrome 64
Exposure Metering: Reflected-light reading of lower half of scene

The 267-foot-tall giant sequoia in the center of this image is generally known as "The Nation's Christmas Tree." I visited this wintery scene nine times before I got what I considered a satisfying picture.

I don't like shooting snow scenes with bare trees. I always wait until after a snowfall and then shoot while branches are still covered with snow. When I came to this giant sequoia, I found that snow *on* the branches wasn't enough. Because I was looking at the tree and its tall neighbors from so far below, I also needed snow *below* and on the sides of the branches. Without it, the branches just looked too bare.

To satisfy my needs, I had to wait for *drifting* snow. Once I had it, I had to shoot quickly, before the warm sun caused the white mantle to fall.

To add foreground interest to this scene, I included some people. However, to emphasize the tree's size, I didn't have them in the near foreground, but close to the tree. To make the small figures stand out clearly at that distance, I requested that at least a couple of them wear something red. I also asked them to stand in a sunlit area.

The snow on the ground and on the trees formed efficient reflecting surfaces, so that there was adequate detail even in areas not lit directly by the sun. □

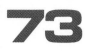

73

Location: Near Big Sur, Monterey Coast, California
Time of Year: Summer
Time of Day: Late afternoon
Light Conditions: Direct sunlight
Lens: Standard
Film: Ektachrome 64
Exposure Metering: Reflected-light reading of water in foreground

Just as cloud formations and atmospheric conditions are never duplicated precisely, so each ocean wave differs from all others. I set up my camera on this famous northern California coastline, near Big Sur, and watched and waited, with my finger always ready to press the shutter button.

I made a reflected-light meter reading of the water in the foreground and exposed accordingly. However, I made the reading at a moment when there wasn't a wave, so the deep shadow—which could have given a misleading exposure indication—was not present.

Most of the rock was in deep shade. However, light from the low sun on the right side provided enough rim lighting to avoid a total silhouette of the rock.

I exposed this photo at just about the best moment. The wave had crested and was about to break while water crashing against the rock created a dramatic white splash.

I never cease to be fascinated by the varied colors an alert viewer can find in sea and sky. Compare the greenish blue of the nearby water with the deep blue of the distant ocean. □

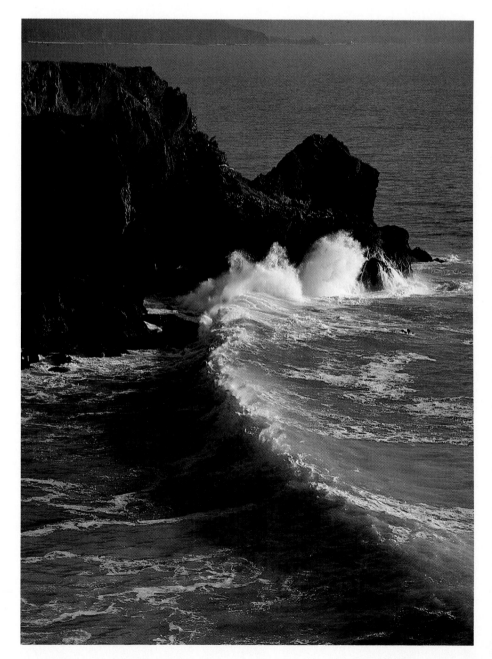

Location: Golden Gate Bridge, San Francisco, California
Time of Year: March
Time of Day: 10 a.m.
Light Conditions: Diffused light through heavily overcast sky
Lens: Short telephoto
Film: Ektachrome 64
Exposure Metering: Reflected-light reading of sky

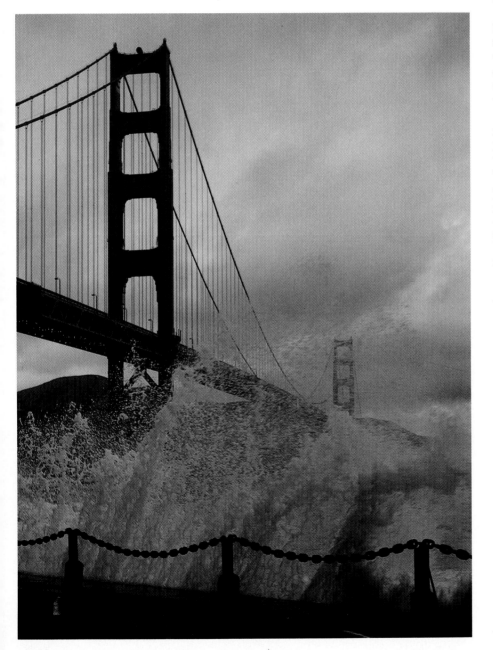

When the tide sweeps into San Francisco Bay on a stormy day, it's not uncommon to see large waves breaking against sea walls in a spectacular way.

I placed my camera on a tripod and framed in the viewfinder the bridge and the foreground area where the water was breaking. By including part of the sea wall in the foreground, I indicate to the viewer of the photograph the cause of the big splash.

I took a reflected-light meter reading of the gray sky, which had the approximate tonality of 18% gray. Although the clouds moved and swirled, the sky tone remained almost constant. To blur the flying water a little and produce a feeling of motion, I set the shutter to the relatively slow speed of 1/60 second. I then set the lens aperture according to the meter's recommendation.

I watched the activity of the splashing water from camera position. When a spectacular water display occurred, I made an exposure. As I made this photo, splashing water was partially obstructing the distant tower of the bridge. This helped to enhance the drama and also increased the feeling of depth in the scene.

The splashing water in this scene was salt water from the Pacific Ocean. Salt water is harmful to your camera and you should do everything possible to prevent it from reaching camera or lens. Put the camera in a suitable waterproof housing. If the lens is unprotected, put an ultraviolet or haze filter on it. Such filters won't affect color balance noticeably at low altitudes and when there's no haze. □

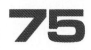

Location: Dal Lake, Vale of Kashmir, India
Time of Year: Spring
Time of Day: Early morning
Light Conditions: Direct illumination from low sun
Lens: Standard
Film: Ektachrome 64
Exposure Metering: Reflected-light reading of scene as photographed

This is a good example of a scene in which I deliberately *avoided* recording foreground area. I took the picture of the floating flower vendors from a lakeside houseboat on which I was staying. However, to create most effectively the illusion of being in the scene with the boat, I thought it best not to show any part of the "base" from which I was shooting.

The flower vendors complied with my request that they remain stationary long enough for the water to become totally calm. On a signal from me, the man at the rear lightly inserted the paddle into the water, creating a circular ripple. When the series of concentric ripples appeared large enough, I made an exposure.

A mixture of bright colors can be very effective in small areas of landscape photographs. However, I rarely like an entire picture full of a variety of saturated colors. Here, the cluster of brightly colored flowers stands out well from the relatively colorless surrounding water.

Low sunlight from the left provided fine side lighting on the two men and attractive rim lighting on the boat. The low angle of the light also brings out the texture of the flowers.

The diagonal position of the boat adds a feeling of motion to the picture.

This scene represents a typical example where you must be careful about selecting to use a polarizing filter. If the flowers had not already appeared so bright, I might have been tempted to enhance color saturation by using a polarizer. However, this could also have reduced the reflections on the water surface to the extent that the scene looked dull and lifeless. □

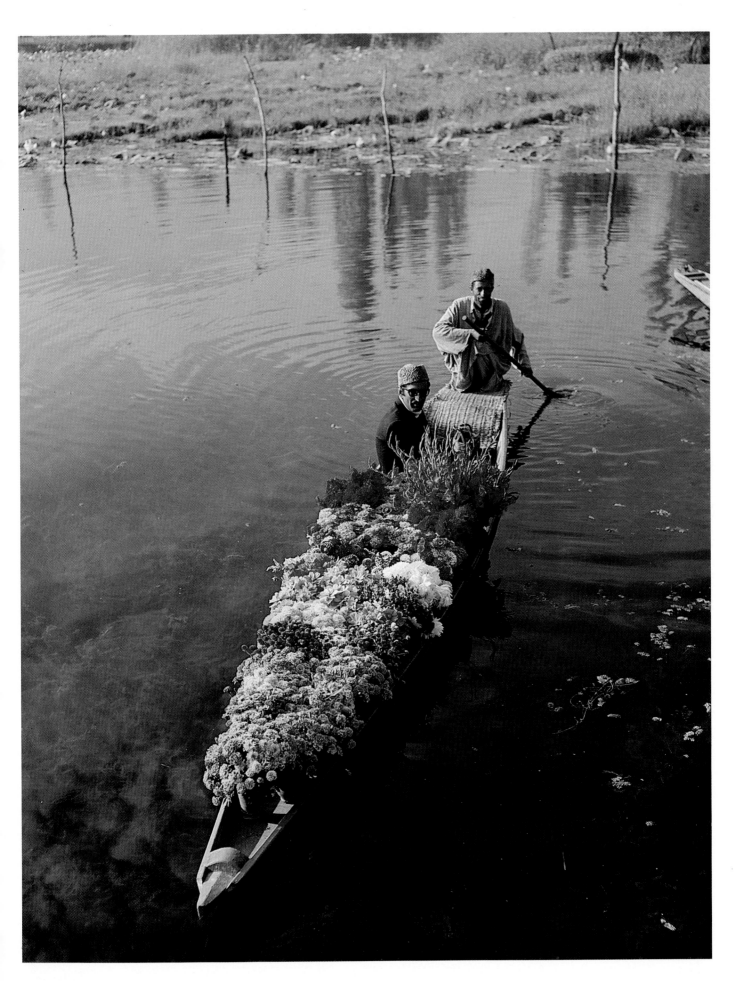

76

Location: City of Chechaouen, Morocco
Time of Year: May
Time of Day: Midmorning
Light Conditions: Veiled sunlight through light overcast
Lens: Standard
Film: Ektachrome 64
Exposure Metering: Reflected-light reading of scene as photographed

I took this photograph in the central square of the Moroccan town of Chechaouen on market day, when people from surrounding villages bring their varied wares for display and sale.

This is more an informative picture than an esthetically pleasing one. It tells you something about the architecture of the town, the characteristics of the surrounding countryside, the dress of the people and even the common method of transporting goods. It's a documentary photograph of considerable detail.

The sunlight filtered through a light overcast to provide soft illumination with delicate shadows. This lighting was ideal for a high-contrast subject such as this, with white buildings at one end of the tonal scale and dark clothing at the other. As you can see, the film has recorded detail in virtually all parts of the scene.

In bright sunlight, I would have had to expose for the highlight areas and let some of the shadows go black. That would be better than having good shadow detail but washed-out highlight areas.

It was easy to show a lot of architectural detail because the houses readily reveal themselves on the sloping hill. To get detail in the foreground area also, I chose a slightly elevated camera position. □

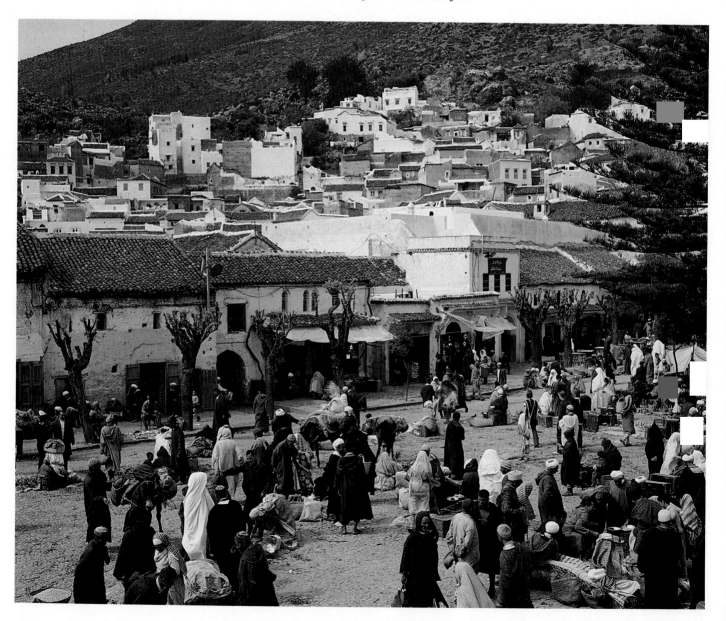

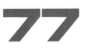

Although much of this scene featured uniformly green grass, the locations of the trees and buildings added a convincing feeling of distance to the image. The feeling of depth was further enhanced by the abrupt upward incline of the land behind the church.

Notice that the "weight" of the dark-green, tree-covered areas nicely counterbalances that of the lighter-green areas of open space. Neither overpowers the other.

Fluffy clouds added interest to the distant sky in this typical New England scene. Similar clouds above the scene itself helped to soften an inherently contrasty scene.

To reduce a slight bluish haze in the air, I used an ultraviolet filter. □

Location: East Corinth, Vermont
Time of Year: Late summer
Time of Day: Midmorning
Light Conditions: Clear sun from partly cloudy sky
Lens: Standard
Film: Kodachrome 25
Filtration: Ultraviolet (UV) filter
Exposure Metering: Gave exposure indicated by in-camera meter

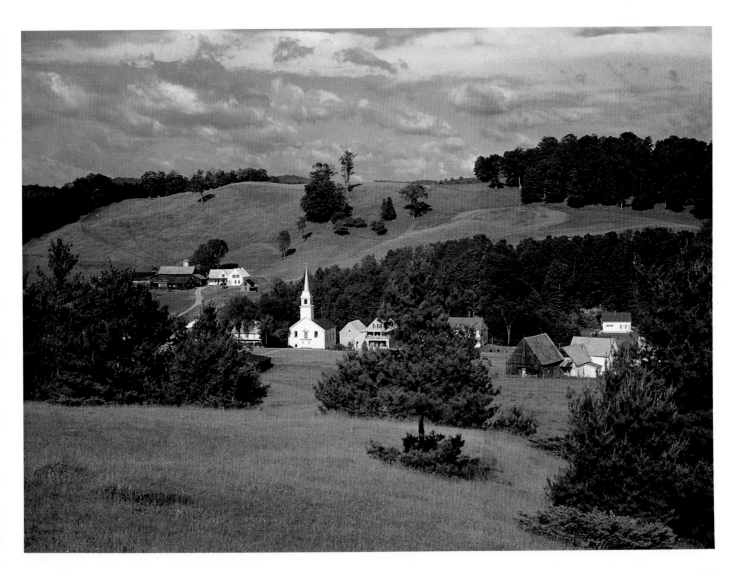

78

Location: San Carlos Bay, Sonora, Mexico
Time of Year: Early winter
Time of Day: Just after sunset
Light Conditions: Glowing evening sky
Lens: Standard
Film: Ektachrome 64
Exposure Metering: Reflected-light reading of scene as photographed

For the best sunset pictures, you generally need some clouds in the western sky. When I took this photo, the sun had already set and all the illumination came from the glowing sky and light transmitted by, or reflected from, the delicate cloud layer.

The water surface was sufficiently rippled to cause subtle, unsharp reflections of the mountain silhouette and glowing sky. In my opinion, this makes for a much more attractive picture than mirror reflections resulting from absolutely still water.

Notice that I composed the image so that the tall peaks were off center. I would have loved to have a rowboat in the water, about a third of the way in from the left border. However, this time I wasn't lucky enough!

One of the exciting things about photographing sunsets is that you can never tell in advance what the dominant color will be. It may be orange, yellow or even a deep red. There are also occasions when the cloud formations are startling but there is little color in the sky. You can then enhance the coloration of the sky by using an orange filter.

For this photo, I needed no filter. Nature provided everything I could have wished for! □

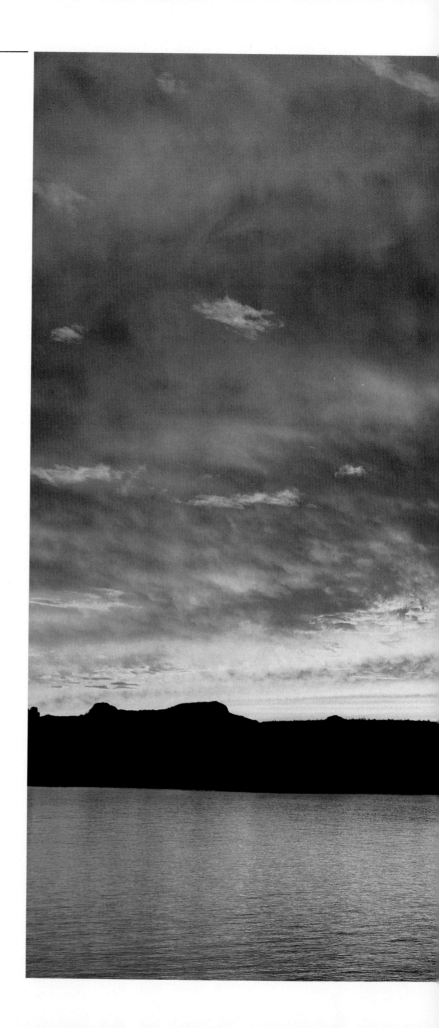

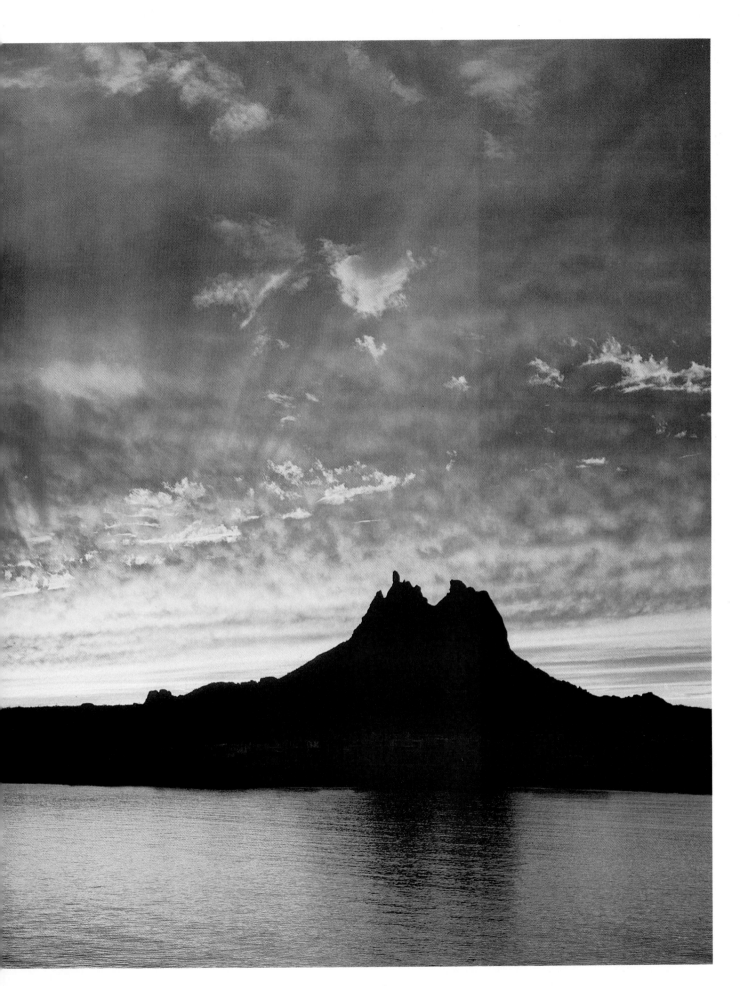

79

Location: Venice, Italy
Time of Year: May
Time of Day: Midday
Light Conditions: Direct sunlight
Lens: Standard
Film: Ektachrome 64
Exposure Metering: Reflected-light reading of water area in foreground

I was on a footbridge spanning the Grand Canal in Venice. This location offered me a lot of scope in selecting the best viewpoint. I composed the image so the buildings on the left would occupy about half the picture area and the church would form the dominant part of the right half. The gentle sweep to the left of the approaching canal, which is emphasized by the positions of the gondolas, made for a well-balanced composition.

Avoid compositions that look unbalanced. One side should not *appear* to contain more "weight" than the other, even if it *does*. Although there is a much larger building mass on the left side of this photo, the graphic design keeps the image well balanced. Of course, this balance cannot be weighed or measured quantitatively. You must rely on your eye and your judgment to achieve the desired effect.

To record the atmosphere of tranquility and romance with which Venice is traditionally associated, I made sure the picture area contained no motorboats with their following wakes.

I made my meter reading from the water surface, which appeared to have a tonal value about equivalent to 18% gray. The subject brightness range was sufficiently limited to ensure detail in all image tones. □

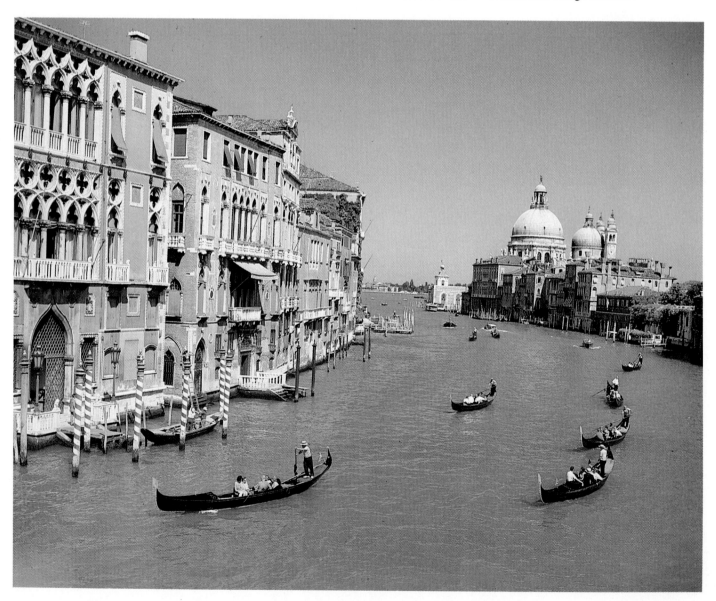

This photo shows the old mining town of Silverton, nestling at an altitude of over 9,000 feet in the San Juan Basin in southwestern Colorado. The isolation is evident from the surrounding, snow-capped mountains.

However, the isolation of the town is brought out even more dramatically by the abruptly ending streets. You're either in town or you're out of it. There's no in between. I wanted to emphasize this feeling.

I chose a position high on a hillside that gave a clear view of the four major thoroughfares. The trees in the foreground and at the sides formed a fine frame for the image. However, I was careful not to conceal the abrupt town limits behind the trees.

I used a No.8 yellow filter on the camera lens. It darkened the blue sky, making the white clouds stand out more dramatically. It also enabled me to penetrate a slight bluish haze to give an image with higher contrast. □

Location: Silverton, Colorado
Time of Year: Late May
Time of Day: About midday
Light Conditions: Diffused sunlight through thin cloud layer
Lens: Standard
Film: Kodak Plus-X Pan
Filtration: No.8 (yellow) filter
Exposure Metering: Reflected-light reading from town area in center

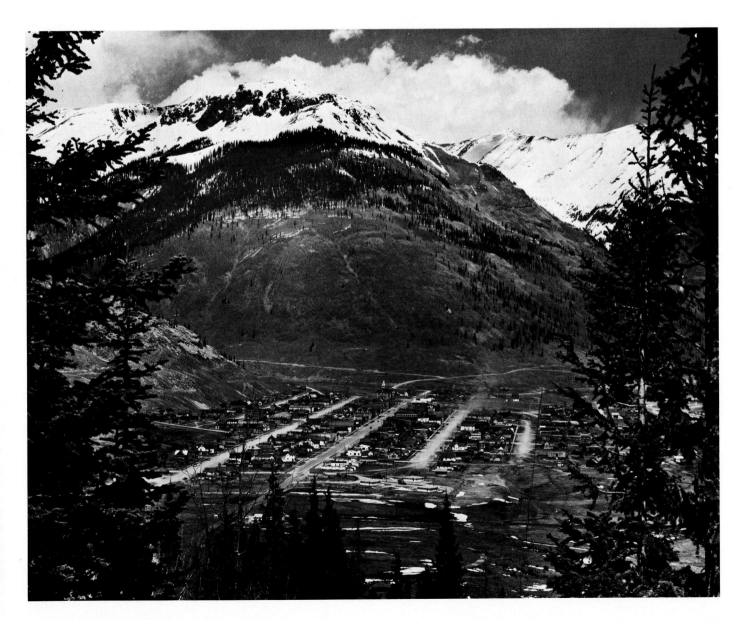

81

Location: Near the San Francisco Peaks, northern Arizona
Time of Year: Autumn
Time of Day: Early morning
Light Conditions: Direct sunlight from low angle
Lens: Standard
Film: Ektachrome 64
Filtration: Polarizing filter
Exposure Metering: Reflected-light reading of lower half of scene

I photographed this scene in early-morning sunlight. The warm tone of the low sun enhanced the golden glow of the fall foliage in this aspen grove. To get the best possible color saturation in the trees, I used a polarizing filter. The filter also darkened the blue sky to a deep, dramatic tone.

To give the impression that I was among the aspens, I framed the scene with one of the trees in the foreground. Notice that I broke the uniformity of the blue sky by having some highlighted leaves enter the picture from above.

The shadow area in the foreground provides an effective counterbalance for the dark sky and helps direct viewer attention to the trees.

I made my exposure reading from the sunlit trees and a section of the foreground area. To allow for the filter factor of the polarizer, I increased the indicated exposure by about two *f*-stops. □

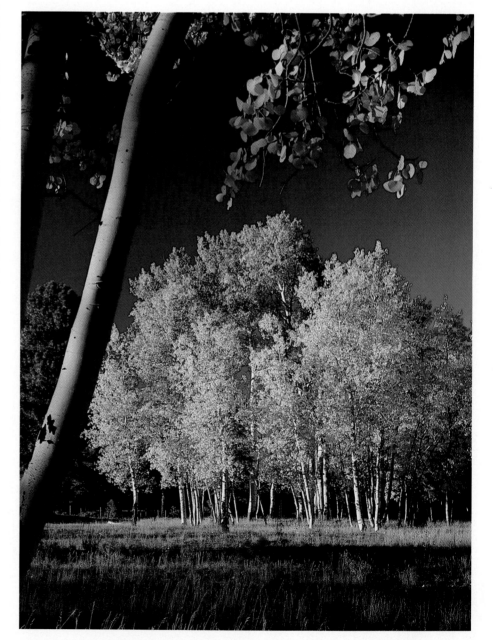

The border between the road surface and the buildings forms a distinct curve from the left side of the image to the right. The border between the sky and the roofs forms another curve. These mutually inverted arcs contribute to the formation of a pleasing composition. Because they approach each other at the center, the curves also help to create the illusion of depth in the photo.

The horses, or some other forms of life, were necessary to give vitality to this pleasant, but static, scene. Also necessary were the clouds. Without them, there would have been too much uniform and uninteresting blue sky.

Incidentally, the depth of blue in a sky depends on the position of the sun. With the sun almost directly overhead, the sky beyond these clouds was a dramatic dark blue, even without the help of a polarizing filter.

My exposure was based on a reflected-light reading of the general scene. However, because the scene was fairly contrasty, I made separate readings of the lightest and darkest parts to ensure that the subject brightness range was not greater than the equivalent of five *f*-stops.

First, I metered the shaded area on the right. Because I did not want to approach the horses and possibly cause them to move from an ideal position, I made the second reading of the sunlit palm of my hand—a tone about similar to that of the horses. These two meter readings indicated that the film could record the scene satisfactorily. □

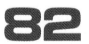

Location: Truchas, New Mexico
Time of Year: Summer
Time of Day: Midday
Light Conditions: Bright sunlight from partially cloudy sky
Lens: Standard
Film: Ektachrome 64
Exposure Metering: Reflected-light reading of scene as photographed and separate readings of lightest and darkest areas

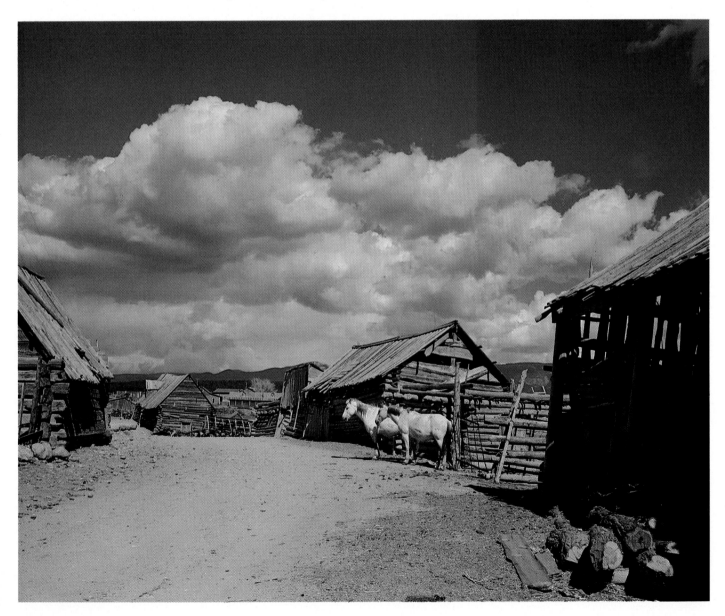

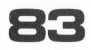

83

Location: Mount Rainier National Park, Washington
Time of Year: June
Time of Day: Early afternoon
Light Conditions: Weak, diffused sunlight through drifting clouds
Lens: Standard
Film: Ektachrome 64
Exposure Metering: Reflected-light reading of foreground area

I took this photo at an altitude of about 8,000 feet, not far from Mount Rainier. It was early summer, and the mountain meadows were full of flowers.

As is common at this altitude, misty clouds were swirling and rolling about me. One moment the sun was visible and the next it was almost dark. Suddenly, the view would open up in one direction. A few moments later, it would close again and the vista in the opposite direction would reveal itself. At times, all I could see were the boiling clouds about me.

I wanted to record the feeling of literally "having my head in the clouds." I thought that I could do this most effectively by showing some clear detail nearby, gradually thickening mist in the middle distance and ultimately a solid wall of gray.

I made my exposure-meter reading of the foreground area in the conditions in which I intended to shoot—without direct sunlight. I waited for similar conditions to return before I photographed the scene.

I particularly like this photograph because it shows what wonderful pictures, full of atmosphere and charm, can be taken under far-from-ideal conditions.

To be sure of good results in similar conditions, follow this basic guideline: Always have some foreground detail that's close enough to record sharply and with adequate contrast. If you cover up all of this picture except the meadow in the foreground, you wouldn't know there was a mist in the area. If the entire scene were veiled, the picture would look flat and uninteresting. □

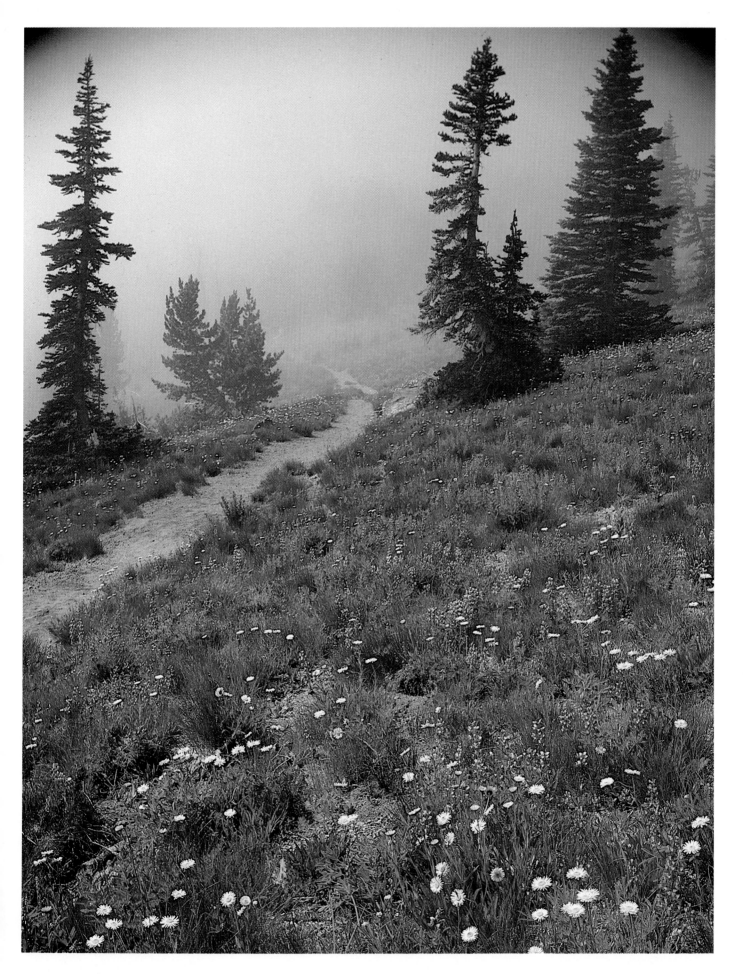

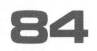

84

Location: Bhutan, a small kingdom in the Himalayas
Time of Year: Spring
Time of Day: 2 p.m.
Light Conditions: Sunlight through a slightly hazy sky
Lens: Standard
Film: Ektachrome 64
Exposure Metering: Substitute reflected-light reading from nearby rocks that resembled rock on which building sits

My companions and I climbed a zigzagging path about 1,000 feet up a steep and rocky mountain to reach the solitary Buddhist monastery shown in this photograph. When we arrived, we were greeted by the only monk in residence at the time.

To make an effective and informative picture, it was necessary to show more than the monastery. I had to show that there was sheer rock below, a rugged rock face above and densely wooded mountains all around. Therefore, I chose a viewpoint that allowed me to leave plenty of space around the building while using my standard lens.

I did not want to come closer and use a wide-angle lens. First, I had little choice of movement on the path and would have had to shoot from a location that gave a view excluding most of the rock towering over the building. Second, a closer viewpoint, together with a wide-angle lens, would have emphasized the size of the building rather than that of the rock—the exact opposite of what I wanted to achieve.

My exposure was based on the rock formation just below the building. Because I could not get close enough to make an exclusive reading of the rock, I metered a similar rock formation near me. That's called *substitute metering.* I selected a substitute rock in identical lighting to that on the rock face in the scene.

Light from the blue sky illuminated the shaded rock face sufficiently to permit some detail to be recorded there. □

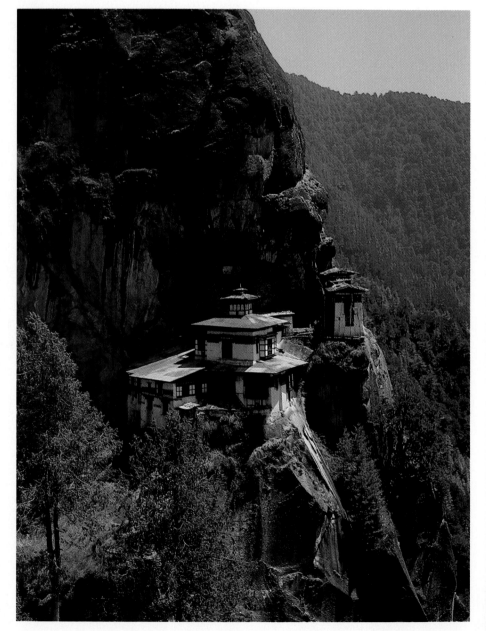

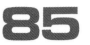

Two Afghan shepherd boys admire the deep-blue water of a tranquil lake. Reflected in the water are ruggedly beautiful geological formations that make up part of the Hindu Kush range.

Strong side lighting makes the boys stand out clearly against the dark water. The only other indication of human presence in this desolate scene is the Moslem temple near the right edge of the picture.

This photo shows a typical scene in which the use of a polarizing filter could have destroyed most of the impact of the image. The reflections of the dark-blue sky, white clouds and rugged cliff tops "make" this picture. Removal of these reflections would spoil it just as decisively. □

Location: The Hindu Kush, Afghanistan
Time of Year: April
Time of Day: Afternoon
Light Conditions: Direct sunlight
Lens: Standard
Film: Ektachrome 64
Exposure Metering: Substitute reflected-light reading of nearby terrain, similar in color, tone and illumination to the mountains

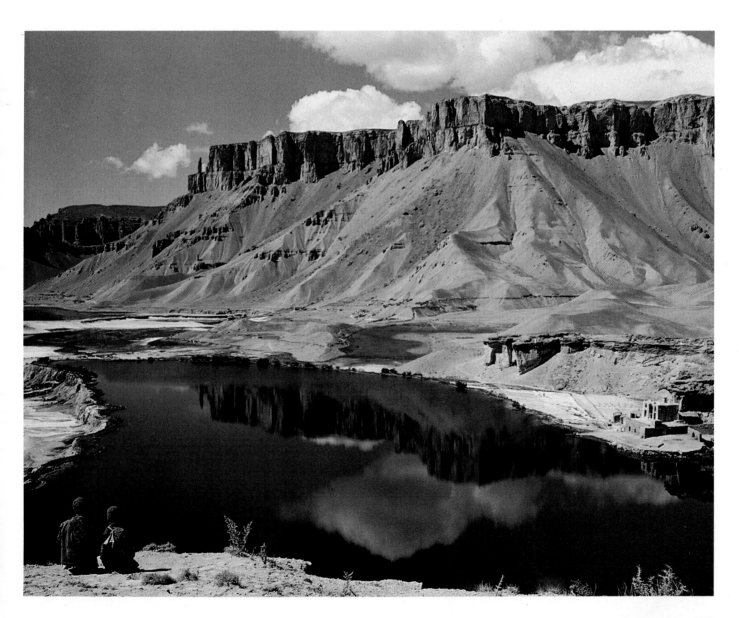

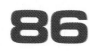

86

Location: Mount Rainier, Washington
Time of Year: Late May
Time of Day: Midmorning
Light Conditions: Direct sunlight through light haze
Lens: Standard
Film: Ektachrome 64
Filtration: Ultraviolet (UV) filter
Exposure Metering: Reflected-light readings from green foreground and distant mountain scene. Gave exposure midway between these.

The snow on Mount Rainier depicted here is not winter snow but permanent glacier. This "eternal snow" is in striking contrast with the green meadow in the foreground, full of spring flowers.

Several features work together here to make the mountain appear massive. The *graphics* of the picture alone don't tell you anything about the height of the mountain. It's the *information* in the picture that suggests height. This information includes a summit partially hidden in clouds, a mass of snow and, as already mentioned, the striking transition from apparent spring in the foreground to apparent winter just beyond.

The visual contrast between foreground and background is further enhanced because the image is divided into two distinct monochromatic areas. The foreground is predominantly green while the mountain scene is a cold, bluish white and gray.

I used an ultraviolet filter to prevent excessively blue shadows in the snow and to get the sharpest possible image by penetrating the mountain haze.

The slightly veiled sunlight was to my benefit because it lowered the subject brightness range in an inherently contrasty subject. □

Like the preceding photograph, this picture shows a scene of eternal snow and ice. In the center, you can see the mighty Portage Glacier in Alaska making its slow way toward the sea. On reaching the water, pieces of the glacier break away to form icebergs. These white, floating islands assume strange shapes as the sea slowly erodes them.

This picture is another typical example of my deliberate exclusion of foreground detail. I was standing on the shoreline. However, because I wanted to give viewers the impression that they were truly among the icebergs, I didn't include any signs of dry land.

I chose a viewpoint high enough to graphically separate the ice formations in the foreground. Otherwise, because of their uniform tonality, they would have appeared to merge with each other.

My exposure-meter reading was of the water surface near me. It had a tonality approximately resembling an 18% gray tone. I avoided ice formations in the metering area. □

Location: Kenai Peninsula, Alaska
Time of Year: Summer
Time of Day: Midday
Light Conditions: Clear sunshine from partly cloudy sky
Lens: Standard
Film: Ektachrome 64
Exposure Metering: Reflected-light reading of ice-free water surface

88

Location: Ramsau, Bavaria, West Germany
Time of Year: Summer
Time of Day: Midday
Light Conditions: Direct sunlight
Lens: Standard
Film: Ektachrome 64
Filtration: Ultraviolet (UV) filter
Exposure Metering: Reflected-light reading of scene as photographed

Repetition of lines and patterns in a composition can often strengthen the picture's impact. This example contains several repeated lines. The downward slope from left to right of the house on the left accompanies a similar slope of the hillside behind the house.

The horizontal lines of the house on the right are repeated by the plateau of the little hill, the tree line above that, and the nearly horizontal tops of the hill and mountain on the right.

The dip in the hills toward the church spire is paralleled by a similar, although less marked, dip in the mountains in the distance.

The nearby house has a convincing three-dimensional look, largely because each of its three major planes—front wall, side wall and roof—has a distinctly different tonal value.

The haze in front of the distant mountains gives depth to the scene. However, to prevent an excessively blue image, I used an ultraviolet filter to reduce the haze effect a little.

Bavaria, where I took this photo, is the place of my birth and childhood. When you look at this scene, I'm sure you'll understand why I have loved nature ever since I can remember. □

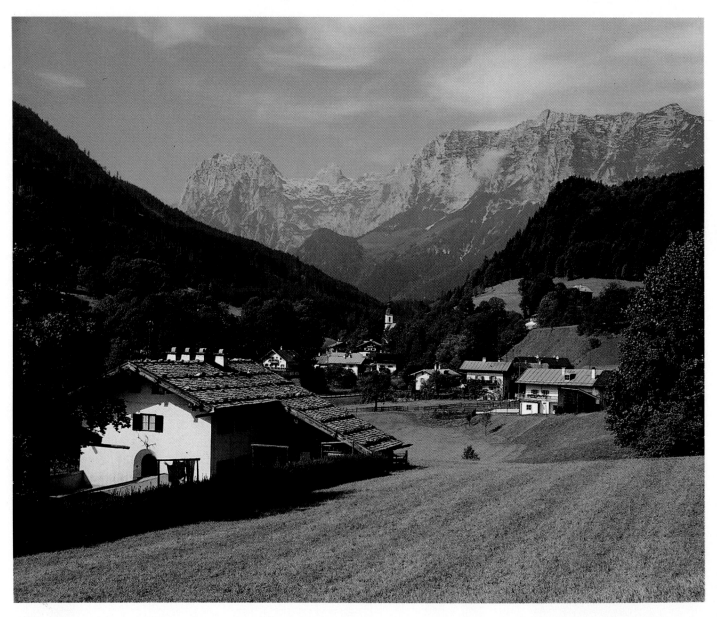

The sunlight was shining from the left side. This helped to give modeling to the hills and bring out texture in the foliage of the cottonwood trees. Side lighting also enhanced contrast in the sheep, making them stand out clearly from the grass.

The feeling of distance was emphasized very effectively by the two distinctly separate planes of sheep.

I used a polarizing filter, primarily to enhance color saturation in the golden autumn foliage of the trees. The filter also darkened the sky to a dramatic, deep blue.

My reflected-light exposure-meter reading was deliberately limited to the area below the treetops. That part of the scene seemed to have an average tonal value of about 18%, ensuring an accurate exposure indication for that area. Of course, I had to allow for the filter factor of the polarizer when setting the camera exposure. □

Location: Sierra Nevada foothills, California
Time of Year: Autumn
Time of Day: Early afternoon
Light Conditions: Direct sunlight from clear, blue sky
Lens: Standard
Film: Ektachrome 64
Filtration: Polarizing filter
Exposure Metering: Reflected-light reading from foreground to tops of trees

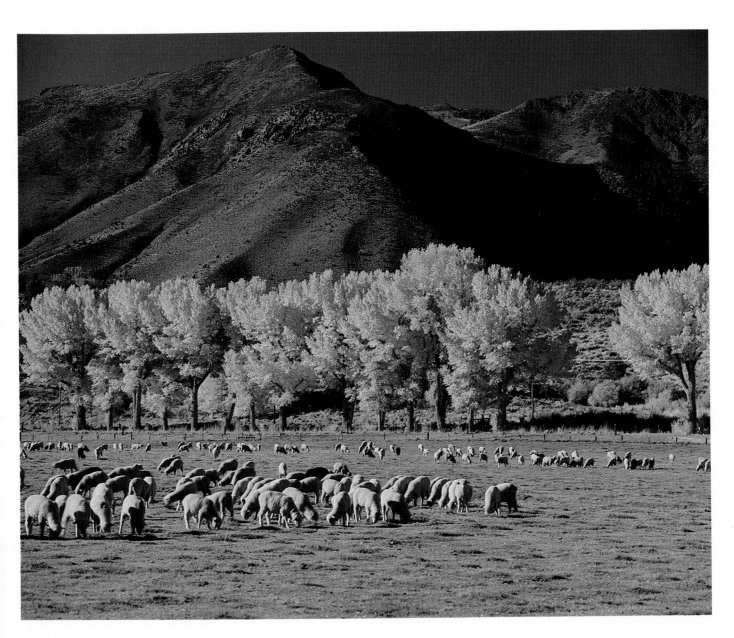

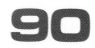

90

Location: White Sands National Monument, New Mexico
Time of Year: Spring
Time of Day: Late afternoon
Light Conditions: Clear sunlight
Lens: Standard
Film: Ektachrome 64
Exposure Metering: Reflected-light reading of area as photographed

To make successful photographs of sand dunes, the scene must contain shadows. There are two kinds of shadows. Large shaded areas help provide modeling to the scene and are compositional aids. Small shadows provide texture to the sand surface. Each kind of shadow depends on direct, low sunlight.

I took this photograph in late-afternoon sunlight. I chose my viewpoint so that both the composition and the light effect were as I wanted them. To add foreground interest, I included the two plants.

A feeling of distance is conveyed effectively by the gradual decrease in the apparent size of the sand ripples.

When you use a reflected-light exposure meter in uniformly bright snow or sand scenes, remember that the meter reading will indicate an exposure that gives an 18% gray image. If you want the snow or sand to appear natural and bright, you must increase the metered exposure.

I took a reflected-light reading of the entire scene. To ensure adequate brightness of the sand, I increased the indicated exposure by about two-thirds of an *f*-stop. □

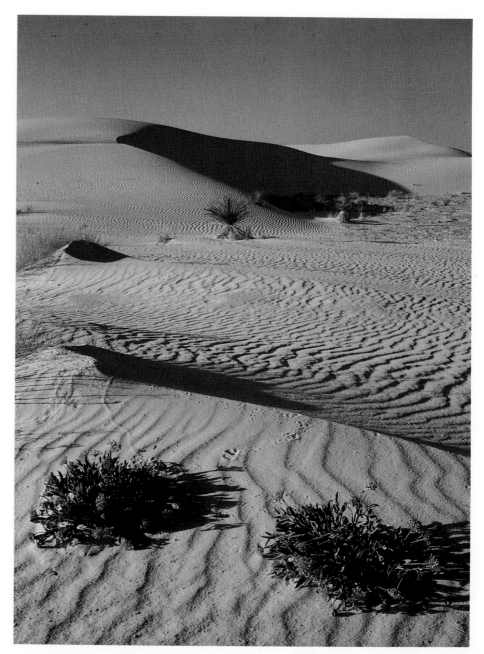

A row of columns or arches nearly always looks best when photographed at an angle. The gradually diminishing widths of the spaces visible between columns toward the distance makes for an attractive composition. Notice how I used the first arch to frame another, more distant one on the other side of the ruins.

Shooting at an angle also provided the greatest possible information in this scene because two sides of each of the square columns are visible.

The sun was to my right, shining through the arches from the far side. This provided an attractive tonal difference between the side and front faces of each column. Contrast was reduced by an abundance of white clouds, which reflected sunlight into the shaded areas.

To make a reflected-light meter reading of the columns on the left side and nothing more, I walked toward them from camera position. I took a reading of the columns, avoiding the sky and the shaded steps in the foreground. □

Location: Roman ruins of Volubilis, Morocco
Time of Year: Spring
Time of Day: Midmorning
Light Conditions: Clear sunlight from partly cloudy sky
Lens: Standard
Film: Ektachrome 64
Exposure Metering: Reflected-light reading of left half of scene, avoiding sky

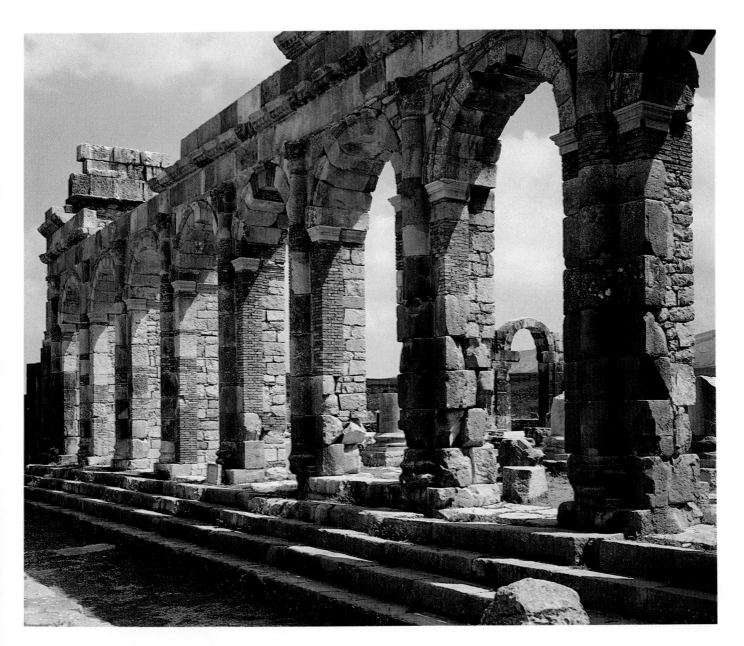

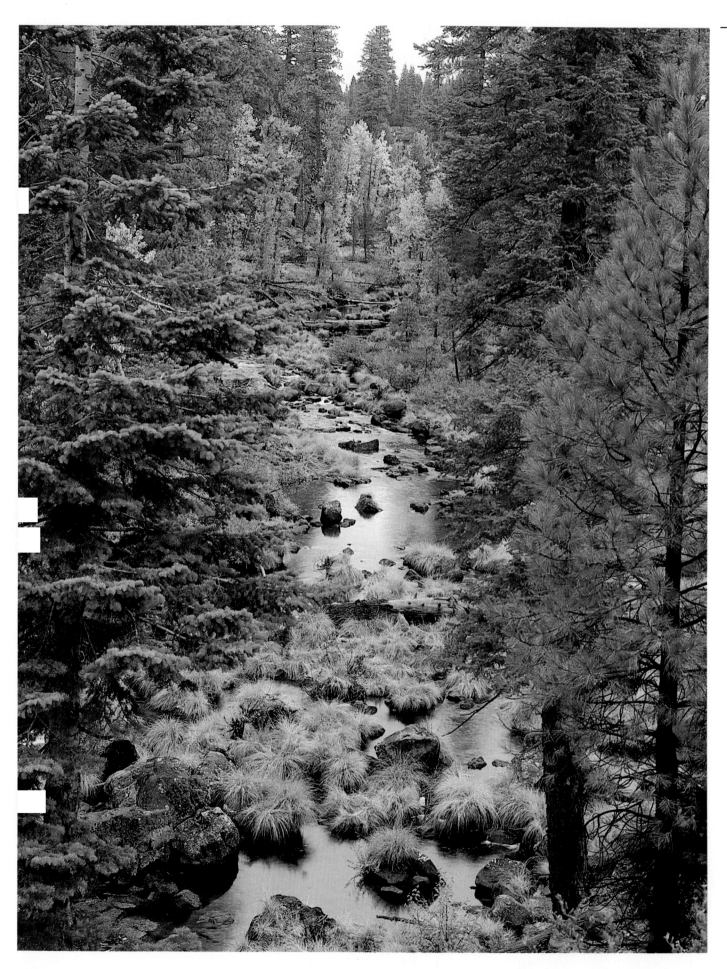

Location: Hamilton Creek, northern California
Time of Year: Autumn
Time of Day: Midday
Light Conditions: Uniform, light overcast
Lens: Standard
Film: Ektachrome 64
Exposure Metering: Reflected-light readings of darkest and lightest parts of scene

Rarely could a scene like this be photographed satisfactorily in bright, direct sunlight. The tall, closely spaced trees would obstruct the sunlight, causing deep shadows. The sun would penetrate in a few areas to cause bright patches of light. As a result, the illumination would look patchy, and contrast would be excessive.

I shot this tranquil scene on a day when the sky had a uniform cloud cover. The overcast was thin enough to allow the sun to barely peep through. This condition gave soft lighting with just a little sparkle and some weak shadows. Notice that there isn't a black shadow or a burned-out highlight to be seen.

The uniformly gray sky was reflected fairly evenly in the water, causing the stream to be subtly highlighted. The yellow-green vegetation in the foreground and the autumn leaves of the same color in the distance make up a uniformly colored streak, running vertically through the picture. This helps to keep your attention on the stream.

I took reflected-light meter readings from a couple of dark areas, including the tree in the left foreground. I also took readings of some of the brightest areas, including the reflection in the water. Exposure was based on an average of the darkest and lightest readings. As an additional check, I took a general reading of the entire scene. The exposure it indicated was almost exactly equal to the average of the extremes.

I did not want the gray sky to have a prominent place in the photograph and included just enough of it to indicate where the skyline was.

The softness of the light helps to convey the feeling of autumn. Yet, in spite of the general softness, the image has sparkle, thanks to the highlighted stream. □

93

Location: Yosemite National Park, California
Time of Year: June
Time of Day: 9:30 a.m.
Light Conditions: Direct sunlight
Lens: Standard
Film: Ektachrome 64
Exposure Metering: Reflected-light reading of scene without sky

In Yosemite National Park, always full of tourists, deer and other wildlife are accustomed to mingling with people. I took up my position, sat down quietly in the meadow facing Upper Yosemite Falls, and waited. Soon these mule deer were grazing happily, with little concern for me.

When the nearest deer turned to look at me, I exposed from his eye level. I shot with the standard-focal-length lens on my camera. That tells you how close the animals came to me.

In places that are less frequented by human beings, wildlife tends to be much more easily frightened away. Always move slowly and quietly. Talk as little as possible. Avoid smoking or wearing strong perfumes. In short, do everything possible to render yourself unnoticed by the animals.

If you intend to take wildlife photography seriously, you must be prepared to hide quietly for hours on end, camera always at the ready. You will also need a long telephoto lens for most situations. □

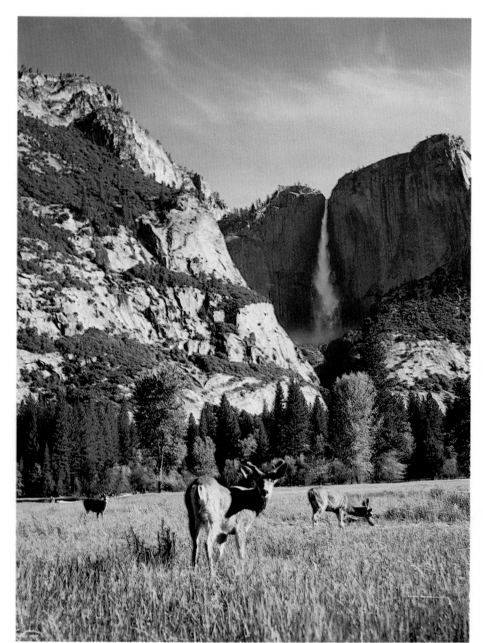

This picture shows the *Yebechai,* the most sacred dance of the Navajo Indians. Photography of the dance and the attendant religious ceremony, traditionally performed in the autumn, is not permitted. How, then did I make the picture? If you look closely, you'll notice that the "dancers" are not real people but small, hand-made figures.

The figures, borrowed from the Navajo Tribal Park Observatory, near my shooting location, are 10 inches tall. The little building is of about the same height. In effect, this is a still-life photograph with a real-life, natural background of Monument Valley.

I used a wide-angle lens and shot from a low viewpoint to make the figures look life-size and realistic.

I deliberately made this photograph in diffused sunlight. The soft lighting did not reveal as much minute detail in the figures as direct sunlight would have and, therefore, made their artificiality less obvious. Notice also that I showed only one face—the part that would most readily give away the fact that these are, indeed, only figures.

To add a final touch of realism, I even "planted" the tiny shrubs in the foreground! □

Location: Monument Valley, Arizona/Utah border
Time of Year: Spring
Time of Day: Midday
Light Conditions: Hazy sunlight
Lens: Wide-angle
Film: Ektachrome 64
Exposure Metering: Reflected-light reading of scene without sky

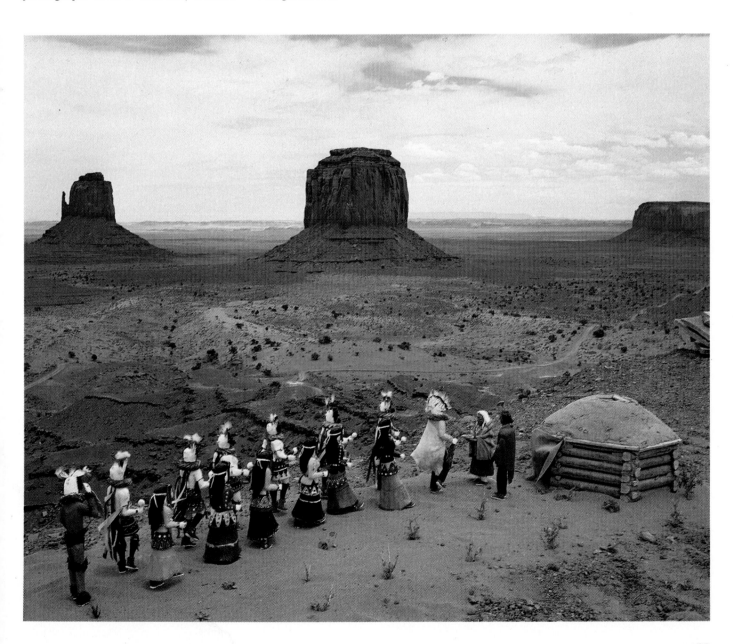

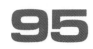

95

Location: Grand Teton National Park, Wyoming
Time of Year: Midwinter
Time of Day: Afternoon
Light Conditions: Direct sunlight from clear, blue sky
Lens: Standard
Film: Ektachrome 64
Filtration: No.81 (pale amber) filter
Exposure Metering: Reflected-light reading of equal areas of sunny and shaded snow

In a photograph, snow should appear white but not washed out. Notice the subtle tonality in the distant snow and the texture in the snow just beyond the shadow on the right side. Achieving this rather than a uniform, white sheet demands accurate exposure.

I made a reflected-light meter reading from an area of snow that was half in direct sunlight and half in shadow and set the camera accordingly. A reading from sunlit snow only would have indicated an exposure for an 18% gray image. Therefore, if you meter sunlit snow, you must increase the meter's indicated exposure by about three *f*-stops to get the proper snow tonality.

Alternatively, I could have taken a reading from an 18% gray card in direct sunlight. That would have given a fairly accurate exposure indication for the scene. However, because snow scenes tend to be contrasty, it's also a good idea to meter the subject brightness range. If this range is greater than a ratio of 1:32, or five *f*-stops, expose so you get a little detail in the snow, even if it means that some shadow areas will go black in the picture.

To get a fine photo of a snow scene, snow on the ground is not enough. I like to have snow on the branches of trees and a blue sky above. Very often, the day after a snowstorm is sunny and bright. I try to shoot early in the morning, while the branches are still laden with snow.

This photograph was made at an altitude of about 7,000 feet. To reduce the excessive blue in the atmosphere and in the shadows on the snow, I used a No.81 "warming" filter. □

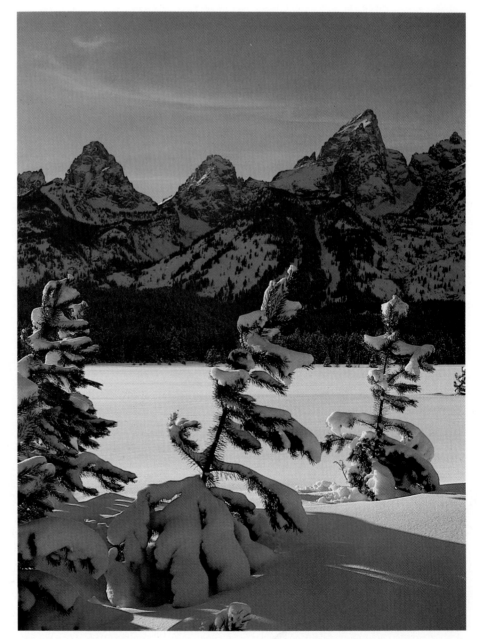

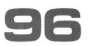

I positioned my camera so the sun would be hidden behind a tree. This way, I avoided excessive flare in the picture. I took a reflected-light meter reading from the same location, making sure that the sun remained hidden from the meter's view, and exposed accordingly.

Silhouetted images often have a two-dimensional appearance. However, in this scene the sun had risen high enough to cause dramatic shadows of the trees to advance toward the camera. This added a very effective sense of depth.

The colors evident in a sunrise can vary from day to day. On this morning, I liked the scene and the lighting effect but found the sky somewhat colorless. To add a little excitement to the image, I used a No.81B filter. It didn't *change* the color I saw but *enhanced* it a little. □

Location: Monterey Peninsula, California
Time of Year: March
Time of Day: Sunrise
Light Conditions: Direct sunlight
Lens: Standard
Film: Ektachrome 64
Filtration: No.81B
(pale amber) filter
Exposure Metering: Reflected-light reading of scene, with sun hidden by tree

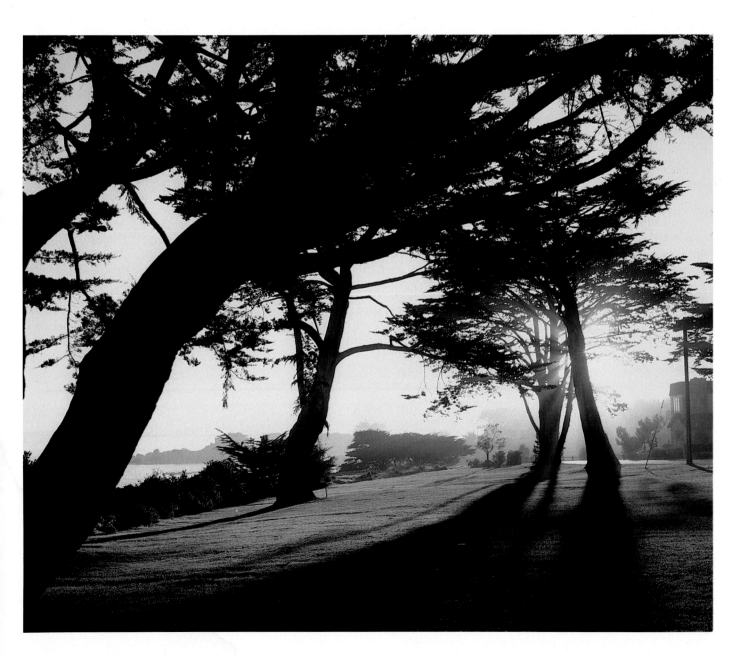

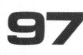

97

Location: Navajo Indian
Reservation, Monument Valley,
Arizona
Time of Year: Late spring
Time of Day: Afternoon
Light Conditions: Direct sunlight
from partly cloudy sky; foreground
shaded by shelter
Lens: Standard
Film: Ektachrome 64
Exposure Metering: Reflected-
light readings from sunlit desert
area and from rug on loom

The art of posing involves the ability to make people look natural, but on your terms. This picture is a good example. When I came across the scene, this Navajo family was not organized in the way they are shown here. They made an attractive group to look at but not to photograph.

There's a difference! In real life, you have constant movement through three dimensions. In a photo, you must capture one moment in a two-dimensional medium. That one moment must tell a meaningful story. The two dimensions must convey something of spatial depth.

To make this group look natural on my terms, I had to deliberately direct them into poses that appeared believable. I also had to satisfy specific graphic and compositional requirements.

The focal point of the picture is the rug on the loom. The woman at work, the child by the fire and the man to the right are all looking in the direction of the loom. They are all shaded by the shelter covering them and are thus recorded almost in silhouette.

The boy on the donkey was carefully placed where he would graphically link the foreground with the distant scene.

Notice the careful framing and "weight" distribution in this picture. The area from the left picture edge to the central post could easily make a separate picture. So could the area to the right of the central post. Furthermore, the right half could be cropped either vertically, to include the shelter top, or horizontally, from below the people to just above the distant towers.

In spite of this multiple framing, the total picture holds together as an integral unit.

Exposure was based on a reading made from the sunlit desert. I also took a close-up reading of the rug on the loom. Both exposure indications were the same. This was the exposure I set on the camera. I knew that the Indians would record almost in silhouette, but that was precisely what I wanted.

A landscape photographer often brings home many precious memories and mementos besides his photos. This photo is an excellent example and is, therefore, an appropriate one to end my book.

On this day I took several photographs that truly satisfied me. I also made some new friends. I learned something about fascinating Navajo traditions relating to marriage, children, their animals, their work, death and many other aspects of their lives. I also traded with them. The rug that you see in the loom in this picture is now in my brother's home.

On this day I also took the time to sit on a high overlook and watch the shadows of the tall rock monuments grow as evening advanced. At first, they grew almost imperceptibly. As they lengthened, they grew faster. Eventually, their tips were nearly 30 miles away. As the sun approached the horizon, the shadows suddenly disappeared. It was the end of another day in the most fascinating life I can imagine—that of a landscape photographer! □

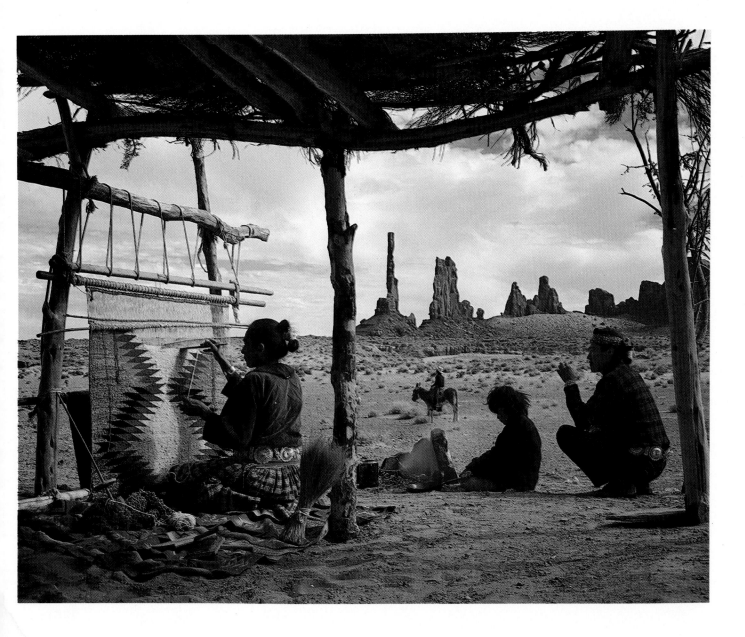